COLOUR
IN YOUR
CAMERA

COLOUR
IN YOUR
CAMERA

A book of colour photographs
to show
how to make colour photographs

Gösta Skoglund

Focal Press London and New York

Copyright 1975 P. A. NORSTEDT ET SOENERS FORLAG, Stockholm

English translation © 1975 **Focal Press**

ISBN 0 240 50847 5 OR·8·7·93

1st English Edition 1960
2nd English Edition 1961
3rd English Edition 1962
4th English Edition 1966
5th Revised Edition 1969
6th Fully Revised Edition 1975

ALL INQUIRIES
relating to this book or to any photographic problem
are answered by Focal Press without charge if a stamped addressed
envelope is enclosed for reply.
FOCAL PRESS, 31 FITZROY SQUARE, LONDON, W1P 6BH

Filmset by BAS Printers Limited, Wallop, Hampshire
Printed by Colour Reproductions, Billericay, Great Britain

Contents

Introduction

There is really very little you can do to change the appearance of a processed colour transparency. On the other hand there are all sorts of ways you can influence the image up until the moment of exposure :
You can restrict yourself to just the right area of subject to convey what you want to say to the viewer.
You can arrange to be in the right place at the right time. Of course, when something is going to happen quickly you must also be ready with the right exposure time and aperture, and preferably have the lens focused for the correct distance.
You can choose the best camera viewpoint and lighting to suit the subject, or move the subject so that it receives the best lighting, and has an appropriate foreground or background. You are your own director. You might get up early and work with the red light of dawn, or choose some other interesting time of day. At night you can make photographs of lamps and people in the street. You may choose to work in bright sun, or take pictures in mist or rain.
You can decide to 'freeze' movement by using a short exposure time or shooting with electronic flash . . . or deliberately produce a blurred picture, for example by 'panning' a trotting horse and shooting with a relatively long exposure time.
You can distort colour reproduction, for special effects, by using the 'wrong' type of film or wrong light source, or by using coloured·filters.
You can change lenses if your camera allows this, and look at your subject matter with a new perspective. You can make a bigger image of a distant subject, or decide to shoot a flower in close-up.
You can choose between films—transparency films for projecting large size images, or negative films for colour prints ; fast films for dull days or slow films for fine reproduction.
You can vary the amount of exposure to produce 'normal' picture density, or make pale images by overexposing, and dark colour rich pictures by underexposing.
 You can read about these controls—and others—in this book, and so avoid wasting film on the 'trial and error' experiments the author has done for you. Here are·about 300 pictures offering you advice, and suggesting new ways of taking snaps that you may not have thought about before.

Good luck with the colour.

Gösta Skoglund

Transparencies or Prints?

Even when photography was limited to black and white materials, people realised that if a negative was printed as a positive transparency (i.e. on film) instead of onto photographic paper; the projected image had a far superior tone range. In the same way, colour transparencies today have a much richer range of tones than have colour prints. Whereas the contrast range between darkest and lightest tones in a transparency can reach 200: 1, a paper print can offer only 30 :1 or 20 :1. This is an inherent limitation of a colour print, when subject contrast may be as high as 160 :1.

During the black and white era, few people—except teachers and lecturers—used slides, because in those days you had to make transparencies by prints from negatives. Todays colour transparency is much easier for the photographer to handle. The actual film used in the camera is returned from processing. It is now a transparency, ready for shooting, and in many cases already mounted. This and other advantages explain the tremendous growth of photography with colour transparency films. The disadvantage is that you still need a projector.

Prints can be mounted into an ordinary album (but remember not to use water-based glue, which may cause the picture to stain). You can also have the image enlarged, perhaps for·framing and hanging on the wall. But the coloured dyes forming the image are not everlasting, so you should avoid allowing colour prints to remain too long in direct daylight, especially sunlight.

Prints are at a disadvantage relative to transparencies, because the latter are usually seen under much more favourable conditions. You project a slide in a darkened room and the viewer's entire attention is directed at the bright image on the screen. The·situation is practically devotional ! A colour print on the hand is treated as any other image on paper. The eye can be greatly influenced by surrounding lighting conditions. Only if we viewed an illuminated print placed at the bottom of an opaque cone, would it begin to approach a transparency for impact. Prints are often regarded as more ordinary almost 'throw-away' articles (although carefully kept in an album they are more accessible documents than transparencies).

For the photographer the colour print has advantages. It allows a greater margin for exposure error than the transparency. The action of printing allows some adjustments to exposure variations on the film. The photofinisher can use his experience and

electronic equipment to decide how to manipulate exposure time and filter corrections. The larger margin of error in exposure acceptable with negative film is one of the main reasons why colour photography has become popular, particularly with simple cameras.

Lighting for Colour Prints

Colour prints have a 'soft' or low contrast. Photographers who use negative film and want results above the ordinary should not choose flatly lit subjects with subdued colours. Thanks to the girls clothes and the colour of the surroundings (that is to say the contrasts within the subject itself) even the flat lighting gives an interesting picture (left). Light was directed towards the girl's cheek from a flash attached to the camera. This explains why the picture has practically no shadows. However, when the lighting was directed towards the front of her face from the left (right-hand picture) this formed shadows and made the picture more interesting. The girls face has a greater range of tones and appears more sculptured. Her sweater also has more modelling. The flash was connected to the camera by a long extension cord for this shot.

With these two pictures—originally aimed to show the results from colour negative film—we have started a discussion on lighting with flash. You can read more about this on page 125.

9

The Camera

Focal Length

Engraved round the front of your camera lens you will find some figures followed by 'cm' or 'mm'. This denotes the focal length—the distance between lens and film, when it is focused on a far distant object.

Most cameras have only one, fixed camera lens. Its focal length is a compromise chosen by the (camera) manufacturer to suit most amateur snaps. 'System' cameras such as Leica, Hasselblad, Nikon etc, offer a number of lenses of different focal lengths. With equipment of this kind the photographer may choose the best focal length for each picture.

Remember that colour transparencies and, usually, colour prints are returned from the photofinishers ready for showing, and the amateur has no chance to influence his pictures thereafter. His entire photographic effort has to be made before the moment he presses the button. After that it is too late.

Black and white pictures on the other hand, can be influenced in various ways during darkroom work. This is one of the great attractions to the amateur of black and white photography. He can pick out the most interesting detail from the negative and enlarge it into a print. This is not possible with colour transparencies (at reasonable cost) and is limited with commercially made colour prints. Right from the beginning the transparency must be filled with just

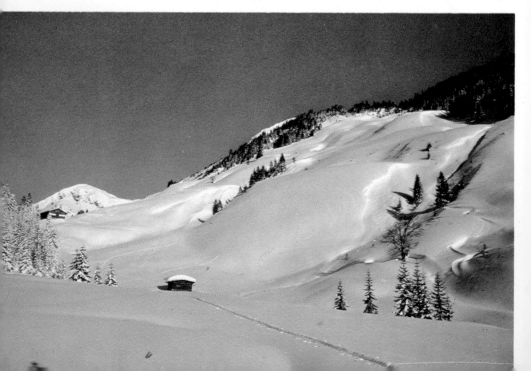

what you want to show. Consequently the photographer may have to move closer to his subject, or by using a lens with a longer focal length, *do his 'enlarging' at the shooting stage*. If you concentrate on colour transparencies you will therefore find a selection of lenses—or a zoom lens—very useful.

If you work with colour negative film you can, of course, have your pictures enlarged, but still try to fill the frame with your subject matter. If you do your own colour printing, you can choose parts of the negative just as you do with black and white pictures.

Focal Length and Perspective

The two pictures on these pages were taken from the same position, using two different lenses. The right hand picture (135 mm lens) includes part of the left hand picture (50 mm lens) between the tourist station (at the top) and the barn (at the bottom). If you measure the distance on the page between these two buildings you will find in the right hand picture this is about 2·7 times the distance in the left hand picture. You will get the same proportions if you compare the two focal lengths; 50 mm and 135 mm. In other words, the focal length determines how large details will be recorded on the film, that is, the image magnification.

It may seem possible to achieve the same result by keeping to the same lens but going in closer to the subject. But in this case, walking towards the subject would show you that the barn grows in size faster than the tourist station, perhaps dominating the picture more than is desirable. One of the advantages of a long focus lens is that it reproduces a subject with the perspective that first attracted the photographers interest. Saalbach, Austria, 250/5·6 mid-day in early January, Kodachrome II.

11

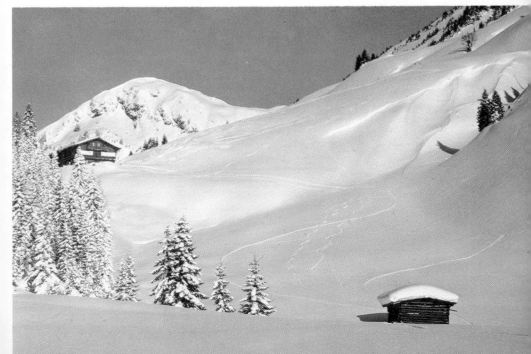

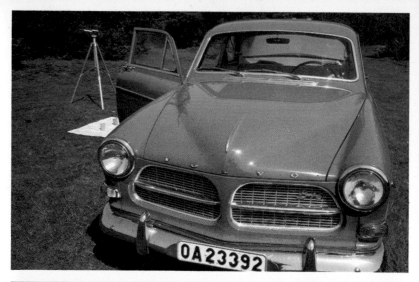

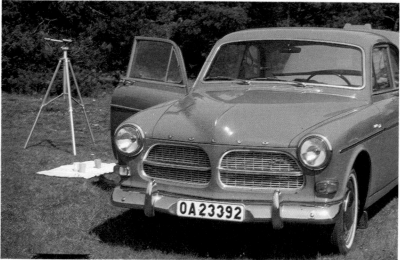

The Camera is One-eyed

Notice how broad the front of the car becomes when it is photographed from a short distance away using a 35 mm wide angle lens on a 35 mm camera. The picture below was taken with a 90 mm lens from further back. This was done in order to show the correct proportions of the car, while reproducing the front the same size. The distance from the camera has affected the perspective.

The tripod shown in the pictures stood on the same spot in both cases. Yet it seems to be far away from the car in the wide angle shot, and quite close to it in the 90 mm picture. This 'constriction' of apparent distance between near and far parts of the subject is sometimes called flattening of perspective. People often think that this depends upon the way the lens 'sees', but this is not quite true. Your eyes see the image in the same way when you look through a telescope, or even through a paper tube. This is

because perspective depends solely on the distance from which the scene is viewed, not on the size of the image. If the nearby objects are concealed, by using a narrow angle (long focus) lens or a paper tube, the eye has no reference point, and may assume that the distant scene is nearer, and thus see the object with flattened perspective. Furthermore we are looking with only one eye—not making use of our stereoscopic vision which is essential for judging distance. The camera too is one-eyed!

In the two pictures, compare the positions of the cloth relative to the mugs. The cloth has 'sunk' in the 90 mm photograph. This is because the picture was taken from further away, and the camera angle was less steep than when the photograph was taken close to the subject using a wide angle lens.

If lenses with long focal lengths 'constrict' the apparent distances between different parts of the image, wide angle lenses have the opposite effect and exaggerate front to back separation. Sometimes a ballet dancer on TV approaches the foreground of the picture very rapidly, taking only a few steps. The reason for this could be that the scene is shot through a wide angle lens on what is really quite a shallow stage. The least movement towards the foreground (and audience) makes the figure grow rapidly in size —something we automatically interpret as accelerated movement.

Focal Length and Picture Size

The size at which the subject is recorded on film is determined by the lens focal length, not the size of the film. These two pictures of Eriksbergs shipyards in Gothenburg were taken from the same position with two 135 mm lenses—one in a Leica, the other in a Hassleblad. You will notice that the crane is the same size in both pictures. The difference between the two pictures is simply that the 6 × 6 camera 'sees' more.

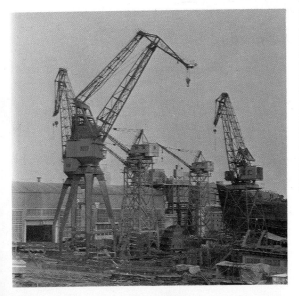

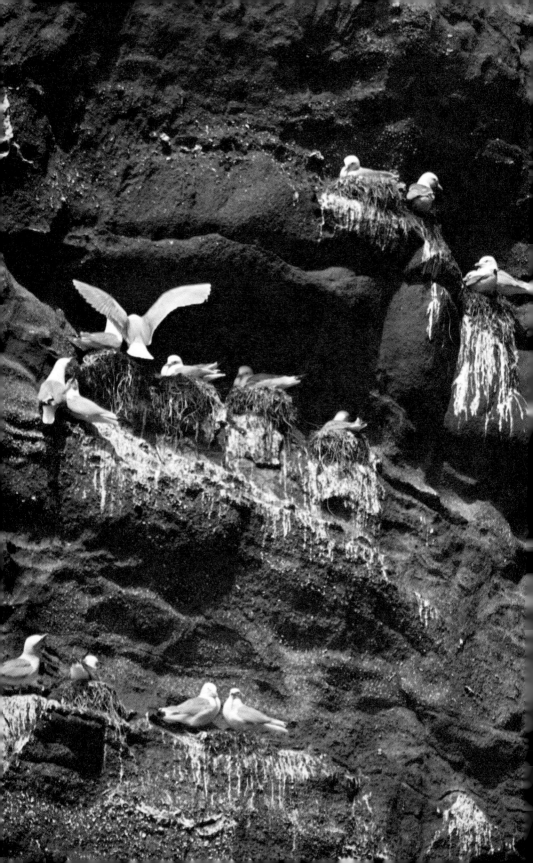

Bird Photography

Long focal length lenses are often used for sport and natural history photography. This picture of a colony of Kittiwake on the bird cliffs at Waestmanna, in the Faroes, was shot with a 250 mm lens on a Hasselblad 1000/5·6 on High Speed Ektachrome. The short exposure time was chosen because the photograph was taken from a motor boat at sea.

Do not, however, over-estimate the importance of long focal length lenses. We shall be returning again to focal length and picture size on page 163.

Lens Aperture

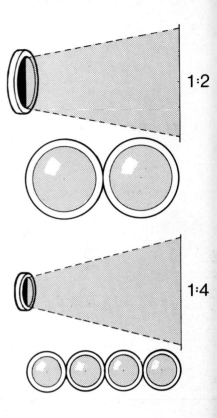

The maximum aperture of a lens tells you how many times the effective diameter of the lens will divide into its focal length. Look at the diagram of the two lenses (right). In one case the lens diameter will divide twice into the focal length and the aperture is therefore 1 : 2 (focal length = two lens diameters). In the other case lens diameter divides into focal length four times, and the aperture is 1 : 4.

The aperture is normally expressed as 'f2' for the upper lens and 'f4' for the one below. To the un-initiated this is a bit confusing, because the smaller lens diameter is given the larger number. If we used the expressions 'half' or 'fourth' it would be more obvious which lens has the largest aperture. Sometimes the dimension is shown as f divided by a number, as $f/2$. On most lenses the aperture is engraved as, for example, 1 : 2 or f2.

It is not always convenient to use the largest aperture the lens offers every time you photograph. Most lenses therefore have a mechanism by which you can reduce the area of the light beam passing through the lens to half the amount, or one quarter . . . and so on. Each 'shrinking' by half (or 'doubling' if you turn the control the other way) is called changing by one stop. Every stop is indicated by a number, for instance 2–2·8–4–5·6–8–11–16–22.

You may find some or all of these figures on your lens. As we said before, f16 is a smaller aperture setting than f2. You can find out just how small by setting your own lens to f16 and looking through it. The smaller aperture allows less light in through the lens than the larger ones (just as a shop would be more dimly lit if you replaced its large plate glass windows with a little cottage window).

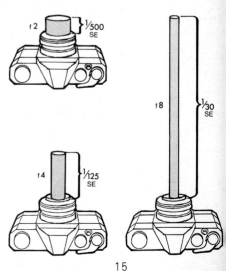

Time and Intensity

In order to record an image onto film the sensitive material has to receive *a certain amount of light*, which is called 'correct' exposure. If the lens aperture used is large, the required amount of light reaches the film rapidly, but if it is small, more time will be needed to achieve the same degree of exposure assuming the same level of illumination.

The top diagram shows a set at three different stops f2, f4 and f8—and the times needed for producing the same exposure effect on the film.

If we could physically 'hold' the light it would be

easier to appreciate the situation. Here we have made a model assuming that light can be manipulated like potter's clay. In other words, the 'short thick' amount of light passed through the large aperture f2 is moulded to become the 'long thin' amount through the narrower f8.

The table below shows how a number of different levels of exposure (exposure values) can each be given to the film by a number of different combinations of time and aperture.

Aperture	Exposure Value																
	2	3	4	5	6	7	8	9	10	11	12	13	14	15	16	17	18
22								1	1/2	1/4	1/8	1/15	1/30	1/60	1/125	1/250	1/50
16							1	1/2	1/4	1/8	1/15	1/30	1/60	1/125	1/250	1/500	1/10
11						1	1/2	1/4	1/8	1/15	1/30	1/60	1/125	1/250	1/500	1/1000	
8					1	1/2	1/4	1/8	1/15	1/30	1/60	1/125	1/250	1/500	1/1000		
5·6				1	1/2	1/4	1/8	1/15	1/30	1/60	1/125	1/250	1/500	1/1000			
4			1	1/2	1/4	1/8	1/15	1/30	1/60	1/125	1/250	1/500	1/1000				
2·8		1	1/2	1/4	1/8	1/15	1/30	1/60	1/125	1/250	1/500	1/1000					
2	1	1/2	1/4	1/8	1/15	1/30	1/60	1/125	1/250	1/500	1/1000						

On the bottom line, for f2, you will find (among others) the 1/500 sec illustrated in our 'three aperture model' diagram. If you look above in the same column you will also see the exposure time of 1/125 at f4 and 1/30 sec at f8. Time and aperture information in this book are put together for instance, 500/2, 125/2 and 30/8 in the three examples above.

Automatic Aperture Cameras
Cameras offering automatic exposure usually set the lens aperture after the photographer has decided the exposure time to suit the type of subject—for instance 1/60 for a stationary subject or 1/250 for one which is moving. There is more information on moving subject matter on page 24.

Sometimes an automatic camera gives information about the aperture it has selected—in the viewfinder for instance. To avoid the risk of blur caused by camera shake you would choose the shortest exposure time possible. Some automatic cameras do not give the user any information at all about the exposure settings they 'choose'. Such cameras are a great relief to people who get confused by all this technical talk about time and aperture.

Aperture and Sharpness
There are many ways in which a photograph may be blurred. An entirely unsharp picture can be the result of shaking the camera during the exposure, or because the lens is damaged or very poor (see page 184). A subject which is moving can appear unsharp because the exposure time given is too long or the camera has not been moved in the same direction 'panned' with the subject. If only some parts of the picture are sharp this probably will be due to the focus setting of the lens and the aperture used. Blur is thus caused by

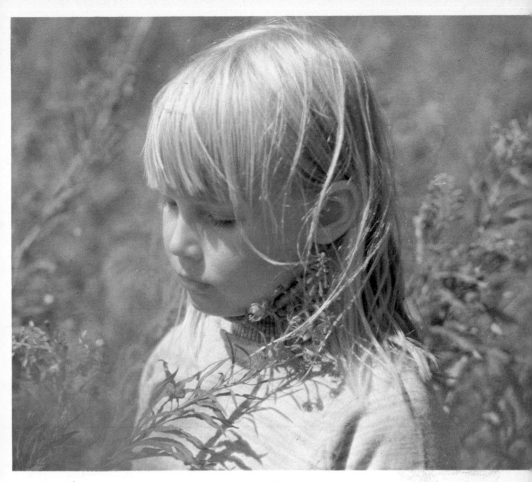

shaking, subject movement and lens settings. The unsharpness introduced by the lens settings is often used intentionally.

The larger the lens aperture you choose the shallower will be the zone of subject sharply recorded. Parts of the subject in front of or behind the actual focusing setting are reproduced more or less blurred. This feature is used in the picture of this little girl among the pink flowers. Sharpness begins at her left shoulder and ends at the outline of her cheek. The flowers in front of her and behind her have in some cases dissolved away into blurred spots of colour. To get this effect, this picture was taken with the lens aperture set between f2·8 and f4. Exposure time 1/500 sec on Kodachrome II (25 ASA).

The technical explanation of this effect and depth of field tables will be found on page 186. Read the text and tables before you go on with this chapter.

The blur you see on a black and white picture is greyish, but on a colour picture it records as coloured spots which may be much more distracting. A photographer who has a good sense of colour can use these as part of his composition, but a picture does not become artistic just because it has blurred colour spots ! They must form part of the overall composition.

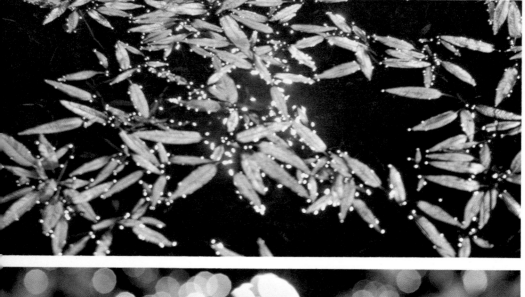

Focus and Sharpness

These three pictures show how the blur increases as the lens is set further out of focus. Notice how the light patches of blur are widening over the dark areas. The camera was on a tripod and the pictures taken with a 90 mm lens at its widest aperture (*f*2·8). The only change made during the experiment was the distance setting of the lens. The exact degree of blur was checked in the viewfinder of the single lens reflex.

Top picture: The back-lit leaves of Polygonum Amphibium, with glittering reflections of the sun were shot with the lens focused on the correct distance.

Centre picture: Camera lens set for a longer distance than above. The glittering points have broadened into circles of light.

Bottom picture: The lens is now set for an even longer distance and the light circles have grown still larger. When projected it was found that they were not circular, but multi-cornered reproductions of the diaphragm opening.

These 'circles of confusion'—as they are called technically—do not just cover each other wholly or partly, they even cover dark parts too (because dark circles are underexposed). As you will soon learn, this can be used in practical photography for special effects.

If you have a single lens reflex camera and are keen to experiment, you can easily discover how circles of confusion are formed by setting the focus to a short distance, and looking at distant objects such as street lights and other light sources, at night.

The smaller the lens aperture you use the smaller the circles of confusion you get. This is connected with the increased depth of field you create when using small apertures.

Controlling Unsharpness

When all your subject matter is a long distance away and the lens is used at a small aperture and properly focused, least out-of-focus blur will occur. See table on page 186.

On the next page is an old cottage in a meadow where wild chervils are growing. The top picture was taken using 1/125 sec at *f*8, and sharpness extends throughout the entire image.

The other picture of the cottage was taken from a low viewpoint near one of the tall plants. By focusing on the nearby plant, and using *f*2·8, only the plant records sharply, while the meadow, cottage and woods are rendered unsharp. Exposure time was 1/1000 sec.

Compare the windows of the cottage in the two photographs. In the right hand picture you can see how the white painted corners of the house together with window frames and window bars have all 'swollen' up and spread over the darker panes, which have consequently become smaller. This a practical example of what was shown more theoretically in the pictures of the flower in water.

19

You should remember this blur effect whenever there is an appreciable distance between the foreground and background of your picture. Zonal unsharpness can be a disadvantage, but used in the right way it can also make a picture more attractive and interesting. Using a single-lens reflex camera makes composing such pictures much simpler, as it allows you to check the exact degree of blur before exposing the picture. Unsharpness is also an important factor when recording close ups of, for example, plants in their natural environment. It may so happen that one or two light toned or sun-lit glossy leaves just behind the main subject record with too much emphasis, particularly when blur causes their highlights to encroach on the main subject. Quite often (even though 'adjusting' natural history subjects is undesirable) you will have to remove the interfering leaves together, but it may be possible just to hold them out of the way.

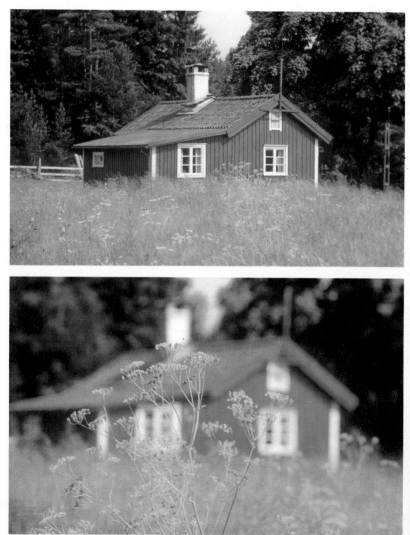

Why Not Small Apertures Always?

Why not always use the lens at a small aperture, since it then gives a large depth of field? The trouble is that in any given lighting a picture exposed at 1/1000 sec at f2·8 needs 1/15 sec when the lens is stopped down to f22. Furthermore good lenses often produce their sharpest pictures when used at around f5·6 or f8. The fact that you are sometimes recommended to use smaller apertures is a matter of compromise between maximum detail sharpness and maximum depth of field.

Background Sharpness

Having chosen your aperture you can also control the degree of background unsharpness produced in your pictures, simply by placing your subject *nearer* or *further* from the background (e.g. a brick wall). When the girl in my picture stands right up close to the wall her face and the bricks appear equally sharp. But if

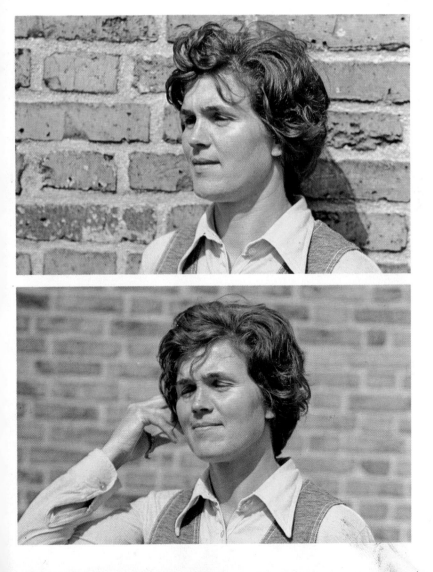

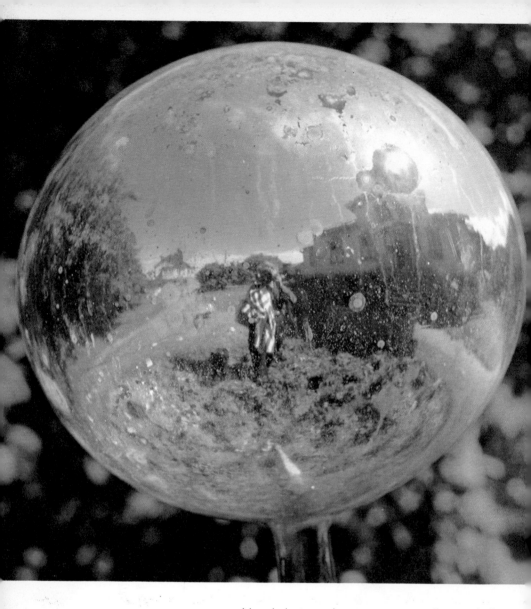

girl and photographer move to some distance in front of the wall her face remains sharp but the bricks now appear unsharp. (They also, of course appear smaller, because they are now further from the camera.)

The simplest cameras have fixed focus lenses set to one aperture—about f11 as a rule. This gives acceptable focus from about 1·25 m (4 ft) to infinity, providing the film is not over enlarged. Without accessory close-up lenses, you cannot do close-up work, which demands critical focusing. See page 190.

Sharpness and Mirrors
If you use a single lens reflex camera set to a large aperture and focus on the frame of a mirror, you will see that reflections in the mirror appear unsharp. This is because the image formed in the mirror is not

located on its surface. Controlling this focusing problem is discussed on page 140.

If you try the same experiment using a spherical (reducing) mirror you find that the reflection has the same sharpness as the frame, even at full aperture. Therefore there are no problems when photographing say, into a chromium hub cap, or convex driving mirror. This stained old mirror ball was photographed in the garden of a boarding house at Käringön, Bohuslån, Sweden.

Photographing Moving Subjects

When you are photographing a moving subject, its actual speed relative to exposure time is less important than the *speed of its image moving across the film*. This depends upon the distance between camera and subject, and at what angle the subject is moving relative to the camera lens, as well as on its actual

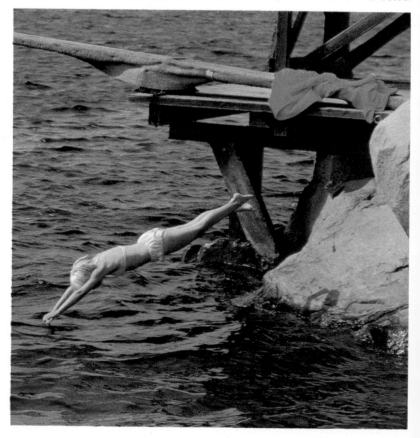

speed. Owners of long focus lenses must remember that not only will the image of their subject be enlarged, but also its relative speed will be increased.

A subject travelling directly towards or away from the camera stays in about the same place on the film even during quite a long exposure time. On the other hand the same subject produces a very fast moving image when its direction of movement is directly *across* the camera's field of view, and this will cause considerable blur. Thus a person 15 ft away walking towards the camera can be photographed at 1/125

sec, but if he goes at right angles to this direction you must choose at least 1/500 sec to achieve a sharp image. The reason why distance is quoted here is because image movement on the film—and in our eyes—is always slower the further away the subject happens to be.

Of course if you intend to 'freeze' a moving image by using a short exposure time you will probably have to use a large lens aperture, and therefore be more careful with your focusing. The picture of the diving girl was taken at the very moment her finger tips entered the water. Exposure was 1/1000 sec at f2 on Kodachrome II. 'Frozen' images of this kind can be useful for studies of style in diving and other fast moving sports.

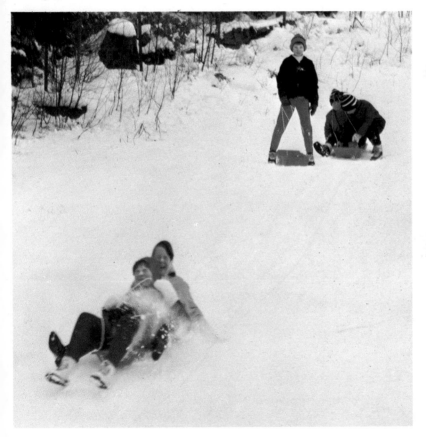

Emphasis Through Movement
Slight blurring gives an impression of movement. This picture was taken 100/8. The girls on the plastic sleigh are going over a bump, and the spurting snow, the facial expressions and the blurred sleigh all contribute to the impression of high speed. The people shown standing near the top of the picture create a contrast to the movement. You sometimes see this contrast in movement in pictures taken in the street, where the photographer has arranged for one person to stand firm like a rock in a stream of passers-by.

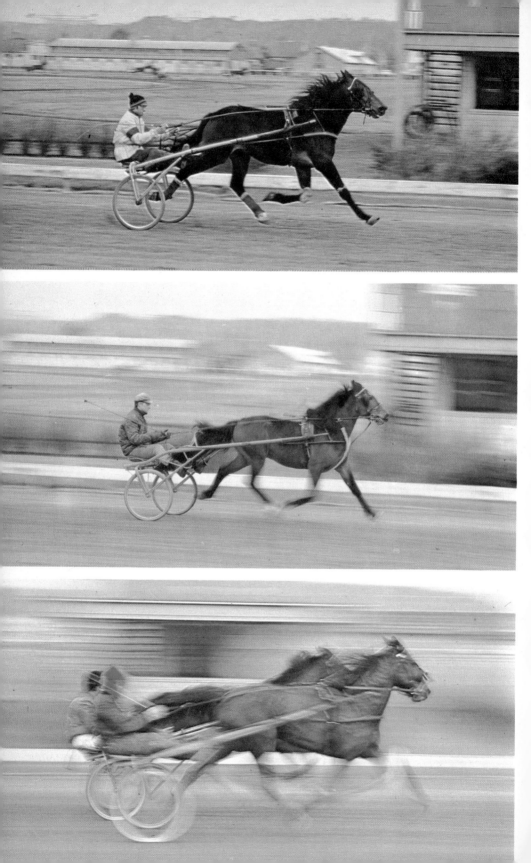

'Panning'

One method of recording fast moving subjects is to 'follow' the subject with your camera. The aim here is to reproduce the subject fairly sharply, but cause the background to blur by movement of the camera during exposure.

Firstly, you have to determine where the subject, for instance a trotting horse, will pass and set the lens for that distance. You sight the horse in the viewfinder as it comes running. Try to keep it in the middle of the viewfinder the whole time as it passes—following its movement by turning your body. Just as the horse reaches the predicted position you press the shutter release, still following with the camera and continuing its smooth swing or 'pan'. The secret is to rotate the trunk of your body in one smooth movement from the moment you first frame the horse in the viewfinder until after the exposure is made. This will produce a sharp picture of the horse against a blurred background, which gives an excellent impression of movement.

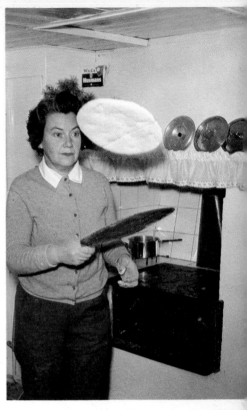

The three pictures taken during a training session in a trotting ring show the effects of different exposure times. As always, you can choose between various time/aperture combinations that film speed and lighting conditions allow. Here the combinations were 100/4, 25/8 and 10/11, which (according to the table on page 16) all give the same exposure level. All pictures were taken from a distance of about 38 ft, using a 90 mm lens. (A 50 mm lens would give the same result if the distance between horse and camera had been about 21 ft.)

The picture taken at 1/100 sec seems to 'freeze' the horse with all four hoofs in the air (although one had no time to notice that at the moment of shooting). It is only when we come down to the picture shot at 1/25 sec that the background begins to show notice-able movement. Since the camera has been panned in the same direction as the horse and trap these items are fairly sharp. But, because the horses legs are not all moving at the same speed and direction along the track, they appear quite blurred.

In the 1/10 sec exposure one leg is still fairly visible. The picture was shot as the horses passed the same blue tower that appears on the other two pictures. But because the camera has moved much more during the relatively long time of 1/10 sec, all that remains of the tower is a bluish sweep.

'Frozen' by Electronic Flash

The reason this pancake appears to be hanging sus-pended in the air is not because of the shutter speed used. The picture was taken by electronic flash synchronised with the camera, and giving illumina-tion for about 1/1000 sec. This sort of light source has an extraordinary ability to 'freeze' movement. The camera shutter was set to 1/30 sec because it was of focal plane design. (Read more about this problem of synchronisation on page 194.)

Exposure

Light Meter Readings

An exposure meter is really two units in one. The meter part itself gives a larger deflection of the needle the more light there is present. This is the only job it can do. The other half is a simple calculating machine to translate this deflection into practical exposure information. It is said that exposure meters can deal with 90% of the subjects tackled by the average amateur photographer. But why don't you get 100% success when you have bought a device for exposure measurement?

The 'Three Meter' Experiment

This is an experiment you can do yourself. You set up three pieces of cardboard so that they all receive the same amount of light. One card is white, one 'medium grey (see page 177), and one is black. If you measure the light reflected off each you will find that the meter readings vary considerably. For example, set for Kodachrome II the meter readings at $f8$ were: white cardboard 1/1000 sec; grey 1/125 sec; and black $\frac{1}{8}$ sec. The meters advice was followed and the group of cards photographed at all three exposure times. To show the effect of the different exposure levels on different colours, a Kodak chart with nine coloured squares was also included in each picture. So:

Measuring from the white card resulted in under-exposure (1). The other pieces of cardboard are so dark that they are hardly visible. Only the white, yellow and red squares are clearly recorded.

Measuring off the black card gave over-exposure (1) All coloured squares have almost bleached away, and colour rendering is badly affected.

Measuring from the grey card gave correct exposure (3). This reading also agreed with the exposure for normal subjects in sunshine, as recommended by the film manufacturers.

What happens when you vary the exposure by one stop? Half the correct exposure (250/8) gives a result in which brown has become almost black (4), violet and green are darkened considerably, and the other colours generally become more saturated. Double the correct exposure (60/8) still just records black as black (5), but all other colours are much paler than they should be. Red becomes orange. Up to about half a stop error in exposure however is unlikely to mean failure, even though it may be a deciding factor against the transparency when making final choice of a set of slides.

(1)

(2)

(3)

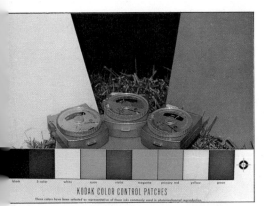

(4)

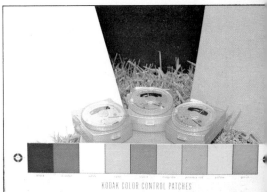

(5)

Skies in Landscapes

We saw that slight underexposure still allows light colours to reproduce well, while dark colours are more saturated. You can sometimes use this fact when shooting contrasting subjects.

Here is Donsö fishing village in the archipelago of Gothenburg, with its white houses under a heavy, thunder-grey sky. The sky was dark no doubt, but nowhere near as dark as the picture suggests. The effect in the picture was produced by the short exposure, which was sufficient for the white houses and their red tiled roofs, but too brief for the darker sky above.

When photographing landscapes, you usually let the ground detail determine what exposure to give. The sky often becomes over-exposed and pale when the ground detail is dark and necessitates a long exposure. On the other hand a blue sky might be under-exposed and dark, just because the ground was covered by snow. One solution is not to include the sky in your picture at all, especially when its blue tint does not blend well. Blue sky can be annoying when it produces distracting patches of coloured light between trees etc.

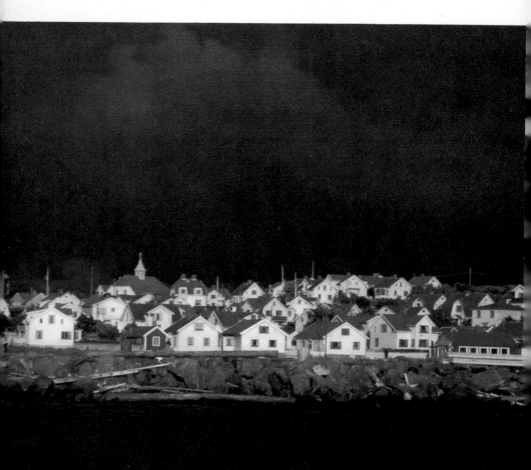

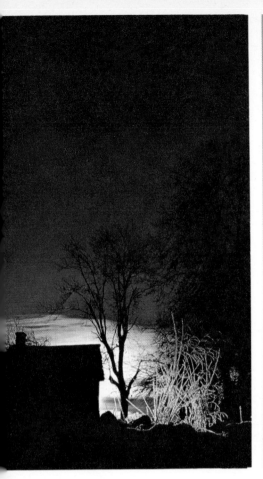
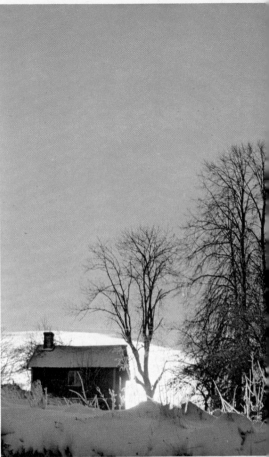

Sunrise Pictures

One of the two sunrise pictures above looks as though it was taken with stage lighting to create a ghost like silhouette. But in fact the picture is just a very under-exposed transparency of an ordinary sunrise on a winter morning. Hindås, Sweden.

To the eye the subject looked much more like the lighter picture, which was taken at 1/25 at f16. The back-lit cloud was shining brightly and became the only light part in the first picture, taken at a tenth of the 'correct' exposure, i.e. 1/250 sec at f16. This is an absurd exposure for a colour film as slow as 25ASA/15DIN.

So it pays to experiment. To be honest it must be admitted that exposures were made at 1/60 sec and 1/125 sec as well. But it was the shot at 1/250 sec which achieved the result I wanted. Of course it is impossible to predict exactly that the picture will come out just like this, or that, at the moment you press the shutter. But you can hope.

Reproducing Delicate Tones

The more delicate the lighter tones of the subject are, the more careful you must be to give the correct

31

exposure. Here the orange, yellow and grey tones of the granite rocks at Hållö, Sweden, must come out clearly and so should not be overexposed. 125/11, Kodachrome II.

This picture is, in fact, slightly under-exposed. You can see how green parts in some of the clefts in the rocks and most of the beach area are considerably darker than reality. This agrees with the results of our 'three meter experiment', namely that green becomes much darker when underexposed, whereas yellow tends to record quite accurately with slight over-exposure. Here the green parts were so small that they could be ignored. The deep blue sky is also the result of less than normal exposure. The same effect occurs when you photograph snow landscapes, see page 62.

On transparency film, with subjects like this, you ought to take several shots at slightly different exposures (exposure 'bracketing') so that you have a choice when the transparencies are returned from processing. After all, a few frames of film are among the lowest items of expenditure on a holiday trip.

Think About Your Exposures

'One thing must be clear from the very beginning—a meter cannot replace your own capacity for thinking.'

This is the opening statement in the instruction book for an exposure meter by a well known firm. Even the manufacturer admits that you cannot just aim and shoot. But many people do think along these lines, particularly in connection with cameras offering automatic exposure control. Such cameras, which have built in reflected light meters, have now become very common. Undoubtedly they have saved thousands of amateurs from making exposure errors, and encouraged others to start photography.

Recalling our 'three meter experiment' you might wonder why the amateur is able to produce so many successful pictures with an automatic light measuring system. The answer is simple. They mostly confine themselves to 'normal' subjects in normal lighting. In other words, all subjects are within the category represented by the grey cardboard in our experiment (page 28). As long as you do not choose odd subjects and unusual types of lights, everything comes out well.

Exposure and Lighting Contrast

If the lighting contrast on a subject is very great—as in the hall at Glimmingehus Castle, Skåne, Sweden—(page 34) you must decide what parts are most important in terms of correct reproduction. Here the light came through a rather small window in a seven-foot thick stone wall. The wall of the window recess on the left hand side of the picture, which is so much brighter than the rest, gave a meter reading of 1 sec at f8 on 25ASA film. (Actually the wall had a yellow-brown tone and was not quite as white as slight over exposure has produced here.)

The lighter part of the big pillar in the middle gave an exposure reading of 1 sec at f5·6 its shady part read 1 sec at f2·8. (Differences in subject brightness

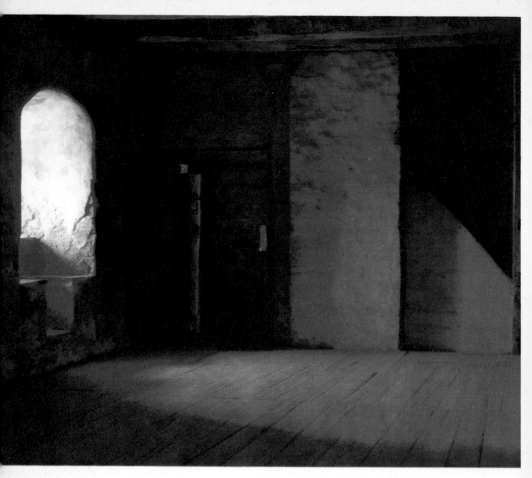

are thought of in terms of stops rather than actual *f* numbers.)

Here exposure had to be chosen to suit the main part of the hall. Therefore it had to be accepted that the window recess would be over-exposed and the window itself could not be in the picture. The next step was to find an average between the exposure measurements on the light and the shaded parts of the pillar—1 sec at *f5·6* and *f2·8*, a difference of two stops. The exposure was therefore taken at the average of *f4*, giving the result you see here. This picture also illustrates how lighting can create a strong interaction between lit and shaded elements in the pictures.

Highlight and Shadow Readings

Calculating averages needs to be done with imagination. The best technique is to measure the lightest and darkest parts of the subject *excluding* black and white. However, if an average scene contains, for example, one single bright yellow spot this should not normally be allowed to influence the exposure of an image which is mainly medium tones. You have to decide just what is important in your picture.

The usual reflected light meter reads the sum of light

reflected from *everything* the meter 'sees'. Close-up measurement will be necessary to get information about local areas of the scene. Also the meter should only measure what you want to photograph. For example, if you point the meter too high out of doors a bright sky will greatly influence the reading, giving the wrong exposure if you are mostly interested in darker ground detail. The result might also turn out wrong if you try to photograph someone in dark clothing in front of a white wall, or someone dressed in white against a black wall, to mention some extreme examples. Close-up measurement of the important elements in a subject is often the safest way, but remember the three meter experiment on page 00.

You can find out the measuring angle of the meter by approaching a surface of given size—for instance a white towel against a dark background. The closer you go to the towel, the bigger the reading you should get, until after a certain point it remains constant. This is the point where only the towel is being measured, which gives you an idea of how wide the meter's measuring angle is.

Experience shows that it is always easier to find the right exposure for low contrast subjects. This is why front lit images most often receive correct exposure.

'Spot' Readings

In some cameras light measurement is made through the lens itself. This avoids the risk that subjects outside your picture area will influence results. Sometimes meters of this kind only measure a small part of the image—usually denoted by a small circle or rectangle in the viewfinder. It is then up to the photographer to ensure that the part being measured is representative of the whole image. With such a camera you can of course make several light measurements using various parts of the image, and calculate an average.

Automatic Cameras Make Mistakes Too

The picture of the little girl on the next page was taken with a simple automatic camera which does not allow the meter to be over-ridden. The subject was back-lit and the meter, of course, chose exposure settings appropriate to the amount of light reaching its 'eye'. But because the light here came direct from a bright sky, and various intense reflections, the automatic camera greatly reduced the exposure 'believing' that this was a very bright subject. Actually, in this case the picture came out acceptably because the silhouette gave an interesting effect. However, if the subject had been, say, a group of children playing on grass near water with the lighting the same as before, the resulting silhouettes just would not have been an acceptable group photograph.

When photographing back lit situations, you should avoid using a fully automatic camera, and not trust the reflected light meter. (But see page 52 for methods of shading lens and meter in such situations.) Despite

35

this, an automatic camera is a very useful tool when you are in a hurry; for example taking reportage-type pictures in which the subject itself demands all your attention.

Making Corrections

Today many automatic cameras allow plus-or-minus exposure corrections to be made. These are used whenever conditions make you suspect that the meter will make a wrong choice (see page 174). The camera instructions offer hints on when this will be necessary. A camera with automatic-exposure over-riding facilities has settings for snow-scapes, back lighting and similar 'problem' subjects. Of course, as soon as you have finished shooting such pictures, the setting must be returned to 'average subjects', or all your following pictures will be incorrectly exposed.

If an automatic camera is not provided with any correction mechanism, but has a knob for setting the film speed, this can be used to 'cheat' the meter. When a backlit subject really requires twice what the meter would normally set, adjust the film speed to one half. (Half the ASA number or a decrease of 3 in the case of DIN speeds—see the table about different ways of calculating on page 166.) The meter is thus pro-grammed for a film of half the sensitivity of the film actually in use, and gives it twice normal exposure. Once again, *don't forget to reset the film speed correctly* after taking the picture.

Checking your Meter

If you consistently get under- or over-exposed pictures when you use your meter, you should try to discover the reason. If the meter is battery operated, start by checking the state of the battery against the zero point on the meter dial. If following the meter still gives incorrect exposures, it is wise to have it checked by a photo dealer. At any event, you might ask him if you may compare your own meter with a brand new one, preferably of the same type as your own. If your meter is consistently inaccurate, you may be able to allow for this by altering the film speed set. To avoid over exposure, you have to 'convince' the meter that the film in the camera has a higher speed than in reality. The meter then chooses a smaller exposure. Remember that you get half a stop lens exposure for every $1\frac{1}{2}$ DIN or 50% extra ASA number. Conversely, the meter gives half a stop increase in exposure if you 'convince' it this time that the film speed is $1\frac{1}{2}$ DIN lower (or ASA number less 25%) than the films rating.

If you are systematic you can make a series of documented test pictures with a variation of half a stop between each exposure, and draw your own conclusions from the results. Include labels carrying exposure time and aperture with the subject each time, so there is no risk of mixing up the frames. This may easily occur, particularly if you happen to run off two exposures at the same setting.

Your records then tell you the film speed to which

the meter must be set when using a particular film in your camera. Evaluation of test results really ought to be done with your own viewing equipment—projector, lamp, lens, screen type and projection distance. Everyone needs to judge exposure under his own normal viewing conditions.

In this exposure chapter we have talked mostly about reflected light meters, which are the most common. Professionals tend to use incident light meters, see page 178. Exposure of negative films is discussed on pages 8 and 177.

Colour Temperature

The wall of this half-timbered house lit by the setting sun has a warm tone, but the picture below has a much colder tone (Knäbäck village, Skåne). Both pictures were taken within ten minutes, and the differences in tone are caused by a cloud which covered the sun while the second shot was taken. Blue sky light then dominated the lighting. Comparing this with the one taken in sunshine makes the effect of the 'yellow' addition very apparent.

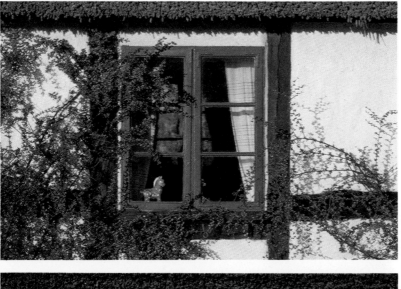

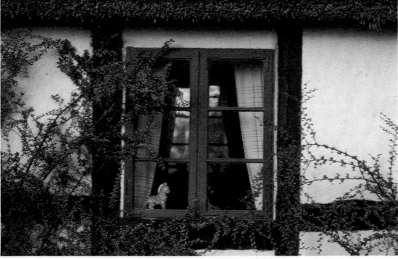

Before you start photographing in colour you tend to think that 'daylight' is all one kind of light. But in practice you encounter at least two different types of daylight—'yellow' sunlight and 'blue' skylight.

When the sun shines from a cloud-free sky we are illuminated by both yellow sunlight and blue skylight. The yellow light is about six times as bright as the blue. But immediately a dark cloud masks the sun, the balance between yellow and blue changes. The amount of blue remains the same but the yellow diminishes because it is screened. The balance therefore changes towards blue, and all colours in our subject become bluish.

Sun Plus Cloud

If, on the other hand the sun shines down through a slightly overcast sky or there are many white clouds present the amount of blue light diminishes. This is because the white clouds reduce the area of blue sky; they also diffuse the sunshine and give a soft, even type of illumination. You usually find that the best transparencies of subjects in daylight are produced under such lighting conditions.

When photographing subjects under side or back-lighting conditions you often find that the shadows come out a bluish colour. This is because the shaded areas received most of their light from the blue sky (see the snow scene on page 59).

Technically the colour of lighting is described in terms of colour temperature. This expresses the colour from red, through yellow and white to blue on an increasing scale of kelvins. More about this on page 118, where we shall be looking at colour temperatures of daylight and artificial light. Don't take information from tables about colour temperature of daylight too much to heart. They are approximate values only, because variations occur day to day as well as at different seasons of the year. Colour temperature can also be influenced by the degree of pollution in the air and by any large areas of colour in the surroundings.

Sunset

The reason that songs are more often composed about sunsets than sunrises is not just because more people are awake in the evenings! After a hot day the air has an appreciable moisture content, giving much redder sunlight. The unbelievably red picture opposite was taken one evening in May a few minutes before sunset at Lilla Frö on the West coast of Öland. The field glowing red is freshly sown. Its colour is partly due to Ölands reddish limestone—although this is not quite so red in reality—and partly because it is lit by the red disc of the setting sun. The unlit undersides of the clouds above have a heavy green-blue tone. The long shadows cast on the field by the photographer and his car show that the sun is very low. 125/4 Kodachrome II.

You are sometimes advised not to shoot colour photographs during the first and last hours of the day.

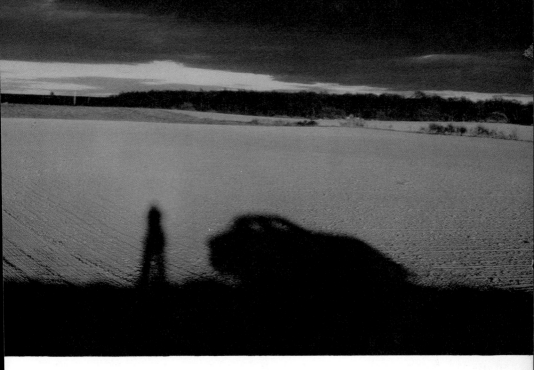

During early morning and late evening light from the sun slants through the earth's atmosphere and therefore has a longer path through air than when the sun is high. Because of this, much of the blue light in the sun's rays does not reach us, and the lighting appears predominantly red. People's faces look ruddy and foliage becomes heavier in tone. However, there is no need to avoid photography entirely under such lighting. Many things come out very well. An island off the coast does not necessarily look worse because the yellow rocks have a touch of red. But remember also that morning or evening light is weaker than normal daylight.

The Height of the Sun

The curves alongside show how high the sun rises above the horizon during different times of the year in Northern latitudes. Furthermore they tell you how long the sun is out per day.

By 4 a.m. in mid-summer the sun is already as high as at mid-day on Christmas Day. And the mid-day sun of the Spring and Autumnal Equinoxes only reaches the same height as at 7 a.m. or 5 p.m. in mid-summer. The diagram has been drawn for sun height in a Northern latitude of 60° (e.g. Northern Europe, Southern Canada) and the time information is correct for Sweden. The 'red' hours are denoted by heavier lines at the bottom ends of each curve. It is obvious that in winter the sun is almost all day in the 'red' zone, whereas at the height of summer you can shoot from 5.30 a.m.–6.30 p.m. without getting much red cast. Finally take a look at the colour temperature table on page 120.

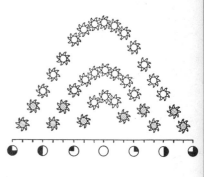

41

Morning and Evening

Conversely, if you want to introduce warm tones into your daylight pictures, you will have to get up early or stay late (depending upon what direction of the sunlight will best suit the subject).

This red wall was first photographed at about 5 a.m. in low morning sunlight. The height of the sun can be judged from the length of the shadows. All colours in the picture have a warm cast.

In the other picture the shadows are longer, showing that the sun was higher in the sky. It was taken at 11 a.m. The light is colder, making the cork floats appear 'chalky' and the wall take on a bluish tone.

Interiors

Do not be surprised if you get predominantly blue colours if you photograph an interior by daylight. This often happens because most of the illumination coming in through the windows is blue light from the sky—something which you don't notice at the time.

This picture of an old kitchen in Lyngby, north of Copenhagen should be compared with the pictures in Brahe church on page 126. Some sunshine reached the parts of the window frame just outside the picture area, but we decided to avoid sunshine altogether and create a still life in blue. This illustrates how the photographer can manipulate his picture simply by excluding unwanted parts.

Filters

In coastal regions and high mountains the ultra-violet content of sunlight can become very strong around mid-day (as most sun-bathers appreciate). Depending upon the type of film and colour of the lens, the picture may then come out with a more blue or 'colder' cast than the subject appeared to the eye. Such casts can be reduced by the use of an ultra violet rejecting or pale pink filter over the lens, as shown below. The right-hand picture was exposed with a 1·5R (R = Red) over the lens to remove the blue and other cold tones from the rocks etc. Both pictures were taken on a day in early summer when the sun was shining in a cloud-free sky.

As we have already noticed, the shadows of objects under a cloud-free sky tend to photograph blue. Sometimes this can be filtered away or toned down, but don't expect to be able to produce the same results that actual sunshine reaching these shadows would give. Difficulties occur when the subject contains both sunny and shaded parts, because, of course, the effect of a filter cannot be limited to the shaded areas only.

Do not buy a filter until you are sure that you need it. When you do buy one choose the type with a thread or bayonet mount, so that it cannot fall off. U-V absorbing filters and the palest pink filters do not affect exposure, but stronger colours will call for some compensation.

Leaving on the Filter

Don't forget to take the filter off the camera once you

44

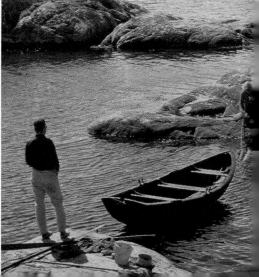

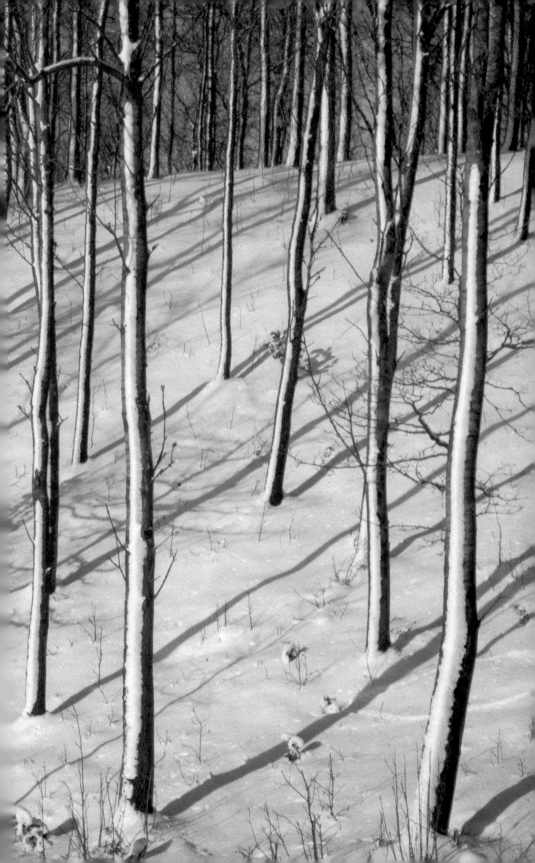

have used it. Indeed you sometimes produce very odd effects if you use the filter under different lighting conditions, and the results are usually disappointing. Your forgetfulness just results in an entire roll of film being spoilt by, say a pink cast.

In the picture on the previous page the snow has reproduced red, but the picture still has a strong graphic appeal because of the shadows on the ground and the dark sides of the tree trunks where they were protected from the snowstorm. The pink filtering has also darkened sky where it shows between the trees.

Lighting

Lighting Quality

The sort of light which produces hard-edged shadows is called harsh, irrespective of whether the light source is the sun, an electric lamp or a candle. The important fact is that the more point-like the source, the sharper the shadow edge. As a rule the harsher the lighting the heavier the shadows and therefore the greater the contrast between a lit and shaded part of the subject.

Soft lighting gives neither high contrast nor sharp

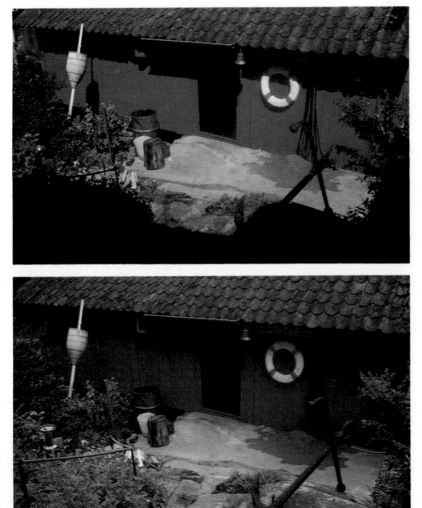

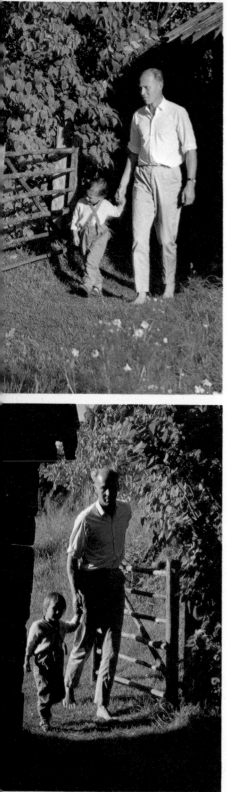

shadows. This is the sort of lighting produced when the sky is completely overcast, or when diffused sunlight finds its way through a thin cloud layer. Indoors you can produce similar quality lighting either by diffusing flash or floodlight with tracing paper, or by reflecting it off light toned walls or ceiling. Soft lighting is more even in its effect and unlike a 'point source' does not have an obvious direction. Meter readings taken out-doors under diffused daylight are often similar no matter from where you point the meter at the subject.

The reason the two pictures (on the previous page) of the boathouse at Tjörnekalv in Bohuslän are so different is because they were taken during an overcast day with brief sunny interludes. (If the sky had been clearer, the additional blue would have produced an even greater difference in colour temperature, see page 39.) The sunnier picture has high contrast; with heavy shadows because exposure was chosen to suit the sunlit parts, causing the shady areas to be underexposed. (125/8-11) The picture shot when thin cloud diffused the sunlight has hardly any shadows, except under the eaves. Notice how broadly and evenly everything is lit. (125/4–5·6)

Don't confuse *lighting contrast* with *colour contrast*. Colour contrast is present in the subject irrespective of the type of lighting—for instance in the contrast between the white life buoy and the red wall.

Buildings in particular look quite different in hard sunlight and in diffused light. Shadows may give a subject more life and shape, particularly if sunshine slants across the textures of walls etc. Diffused lighting can make them look flat and uninteresting, especially if it comes from behind the camera.

Direction of Lighting

When you shoot in flat lighting, i.e. with the light source somewhere behind the camera, the colours, lines and surfaces of the subject itself form the substance of your picture. But as soon as illumination comes from one side or even behind the subject, shadows also become an important part of your image and need to be handled carefully.

Here are some pictures of the same people, corner of the house etc. In the first shot the house is in shadow—creating a strongly contrasting background to the light clothes.

In the back-lit shot taken from within the farm, the corner of the house and foreground is in such heavy shadow that a black 'frame' is formed. Actually this is much heavier than it appeared to the eye, but because exposure was chosen to suit sunlit areas, the film could not resolve detail in these dark areas too. In other words we are utilising the exposure limitations of colour film to our advantage (page 28).

Of course, shaded parts of the figures themselves also reproduce dark—almost silhouetted—but sufficient light exists at least to outline their right-hand sides. Both pictures were given the same exposure

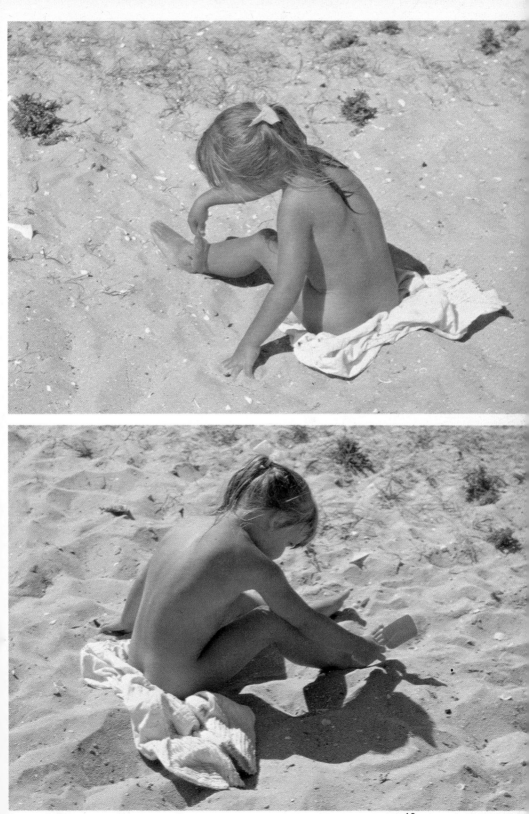

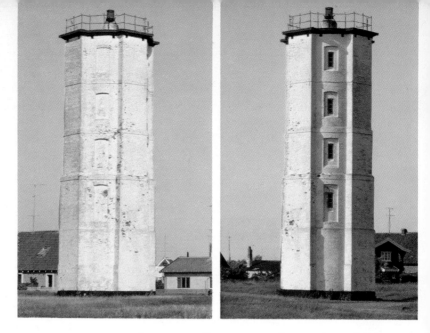

for comparative purposes (you can see this because the sunlit foliage has reproduced almost identically in both pictures).

Backlit Footprints
The little girl on the previous page was so busy playing that I could take photographs from all around her without being noticed. In the frontlit shot, the footsteps in the sand are hardly visible and the sand itself looks uninteresting. The backlighting in the other picture however gives the girl's back a nice sculptural effect. The body is more three-dimensional and the plastic spade becomes a stronger red due to light passing through it from behind. Footmarks in the sand are emphasized by the shadows thrown forward by the back lighting. Both pictures which were taken at Kungsö, Gothenburg, received the same exposure. You can use the same techniques with snow pictures.

Lighting Direction
A flat, frontally lit picture of the old lighthouse in Skagen, Denmark does not say much about the way it was constructed. But the picture shot with 90° side-lighting emphasizes the different thicknesses of the walls, and the tower now has 'body' instead of looking just like a flat surface.

This subject does not contain what we call *subject contrast*—in other words it has no strong contrasts of colour of its own. Suitably lit, however, the direction of illumination gives the subject *lighting contrast*. Often lighting contrast can be very helpful in livening up otherwise dull surfaces. For example, a plaster wall lit from the front usually reproduces flat white. Try instead to take advantage of times when the lighting comes from one side, almost parallel to the wall. Every pebble, every wrinkle in the plaster forms its own little shadow and the whole wall comes to life.

Monochrome Subjects

The picture of detail on the carved oak door of a church in Denmark owes a great deal to the use of strong side-lighting. Notice how well the shape of the relief and the grain in the oak record. In front lighting, this almost monochrome subject would have been much less interesting. Remember that textures of every kind—even on skin and other delicate tissues—are emphasised in light directed obliquely at the surface.

Coloured Shadows

Anyone who really notices colours will see in this picture that the shadows formed in the sand are blue in tone. The picture must therefore have been taken on a clear day with sun-shine and a cloud-free sky.

Had this subject been exposed according to an overall reflected light meter reading taken at the camera position (i.e., against the light) a very short exposure would have been given. The figures would have recorded as silhouettes. This is a good example of where an automatic camera without over-riding facilities (page 35) can create underexposure unless you can anticipate this by down-rating the film speed set, and so increasing the exposure.

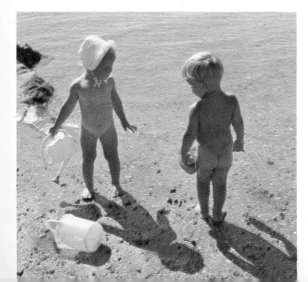

Coloured Reflected Light

Reflected light can often be coloured—for example in this picture by using light reflected off a red bathing wrap. If you shoot portraits of people standing close to someone dressed, say, in one of our modern highly reflective plastic materials, unexpected colours will appear in the subject. We accept the introduction of colour, in this way, much more readily if the picture also shows its source. The colour itself is also influential—we are more able to tolerate yellow or red casts than blue or green. (Green faces are just not acceptable!)

Light reflected from white surfaces is very useful in colour photography. Snow, sand, white buildings, sails or white cardboard all act as useful reflectors at times. The latter has the advantages of being movable —you can put the reflector just where you want it. Generally however, only the more ambitious portrait photographers go to the trouble of using reflector screens out of doors. Now and again, crumpled in aluminium foil is used, glued onto cardboard (smooth surfaced foil gives speckled lighting). When using flash or floods, a white reflector screen can be used in exactly the same way as when shooting in sunshine.

Often the use of reflectors is the key to successful backlit pictures. Notice how much the reflected light varies when, say, a person walks from a white beach to a lawn. Snow is a particularly effective reflector when shooting sun-lit portraits. Your subject can face away from the sun, thus avoiding 'screwed up' eyes, and the back lit snow surface itself comes to life.

Light Flare

Be careful, particularly when shooting back-lit pictures, not to allow the sun to shine directly on the front of the lens (or at least not on the open part of the diaphragm). If the sun does shine onto the lens, the light becomes scattered within the lens, resulting in a flat image in which colours are diluted as if by slight fog (top picture).

The bottom picture was taken at the same time, but with the lens shaded. Of course whatever you use to shade must not itself intrude into the picture area. This is most easily checked when using a single-lens reflex camera. When the sun is higher, the shader can be manipulated with less risk of appearing in the picture. You can control flare even with a simple direct vision camera, an assistant just has to use the shadow of his hand to shade the front lens surface. If you are alone you may be able to mount the camera on a tripod and then manage the shading yourself.

Professional film makers use a type of camera bellows, mounted in front of the lens, called a bellows lens-shade. This can be extended to cut out light from everywhere except just within the picture area. Many lenses have an accessory lens-hood or are so deeply mounted that the lens is protected when shooting most backlit scenes without any extra equipment. There are, of course, times when even a good lens hood will not help. This is when the sun

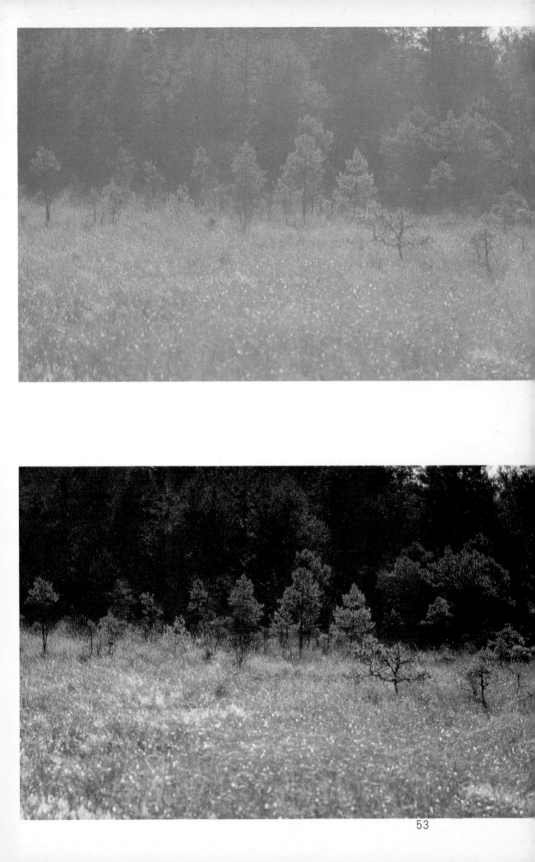

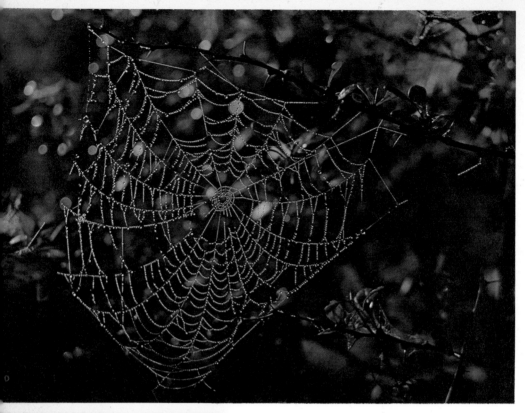

shines into the lens and is included within the picture.

Automatic exposure cameras use an 'eye' which is misled if allowed to receive direct sun light from back lit scenes. The 'eye' therefore also needs shading in the same way as the lens. Don't forget that sunlight can be also reflected upwards by water and other shining surfaces, and thus introduces lens flare.

Morning Dew Close ups

Dewy spiders' webs, such as the one in the picture above, are excellent subjects for back-lighting. The background must be dark if the web is to be visible, and the web itself strongly lit to emphasise the dew drops. You must shoot the picture before the sun has time to evaporate the dew. This picture also illustrates the 'circles of confusion'. described on page 19.

Halos

The halo portrayed in this picture was created by the many small back-lit hairs on the stalks, leaves and flowers. A multitude of small back lit objects (like the strands of our spider's web) look extremely bright when seen against a darker background. The same effect occurs when people are photographed in back-lighting whether their hair is fair or dark. Some years ago, the popular way to shoot portraits was to use this type of lighting combined with a soft focus attachment over the lens. The blur effects this pro-

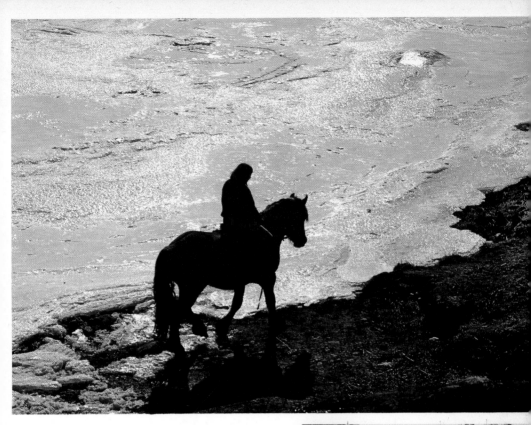

duced spread the hair light into an even broader halo. See page 87.

Silhouettes

Silhouettes occur when you photograph subjects which are basically dark or very underlit, against a bright background. In all cases the brightness difference between subject and background must be considerable. Photography usually records this contrast rather more strongly than it appears to the eye at the time, especially if you judge your exposure to suit the bright background. A good silhouette must have an easily recognisable shape. It must not be a photographic riddle.

The girl on horse-back is riding along by the ice covered waters of Nordre älv. Spring sunlight is all coming from behind her, reflecting off the ice surface so that the lighting could hardly be more contrasty (500/8). Kodachrome II.

Water Curtain

A curtain of water such as a fountain can create an interesting background for silhouettes. This picture would have been nothing without the broad fountain jet, because when the water is switched off you discover that the statue stands before a background of rather dull foliage. It was shot on Kodacolor-X negative colour film—disproving the statement, often heard when negative colour film was new, that it

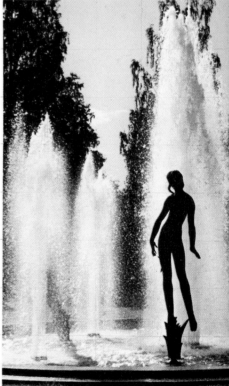

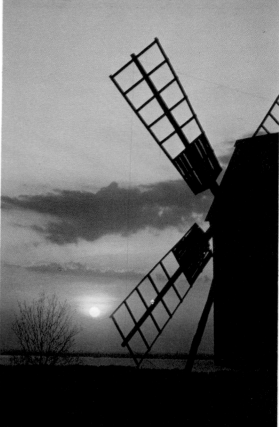

should only be used with frontal lighting. Subjects for prints from colour negatives need contrast, because the process itself tends to be rather soft in character. See page 8. The sculpture, by Carl Milles, is in Rottnenos Park, Värmland.

Old Fashioned Silhouettes

It is hardly possible to reproduce the wrought iron gates of this smithy at The Frogner Park, Oslo, in any way other than a silhouette. The only other variation the colour photographer can introduce is to wait until different clouds appear in the sky background. The picture of the mill is in good old picture postcard style, taken against a hazy sunset one summer evening Öland, Sweden.

No Reflected Light

Even an open meadow slope can make an interesting silhouette background—at least for a semi-silhouette shot like this. The two women have just walked along the path through the gap in the trees. As the trees provide very little reflected light for the back of the figures a silhouette effect is produced. The exposure chosen here was typical for 'average' subjects frontlit in summer.

Snow Scenes

Sunshine and Snow

When these two street snow scenes are projected, one after the other (the cloudy one first) the audience always asks to see the first transparency again. They suspect that the lecturer has duped them, although it is in fact the same street with the same covering of snow. The only difference is that one shot was taken in sunshine and the other next day when the weather was very overcast. If you want to check whether the same amount of snow is present compare the depth of the layer on top of the lamp or the roofs.

I doubt if there is any subject more dependent than snow on the character of the light. Sunshine creates sparkle and gives shadows to even the smallest three-dimensional objects; grey skies make everything look even and flat.

Pictures Depend on the Quality of Lighting

The character of a winter landscape does not therefore depend wholly on the subject itself. The type of lighting which exists at the moment you make the exposure is equally influential. Cloudy or sunshine . . . clear blue sky or small white clouds . . . frontlight or backlight . . . all contribute enormously to the appearance of that subject. Photographing snow scenes certainly sharpens up your awareness of lighting.

Front-lit Snow Pictures

Don't assume from these two pictures taken at Saalbach that you should always take snow scenes in backlighting to portray the surface of the snow. This can be achieved with front lighting too, provided the snow clad ground is not flat. Sunlit snow acts as a mirror, or rather as many mirrors. If the photographer has the sun behind him and photographs a rather perpendicular snow surface, it will reflect a great deal of light into the lens and so this becomes the lightest area in the image. Other snow surfaces in the picture at different angles to the sun and camera will reproduce darker, because they reflect most light in directions other than towards the lens. This is why the picture at the top of the next page has so many different tone values, even though it was taken in flat lighting. The shot was taken after a day-long snow fall which had flattened out and hidden the bank made by the snow plough the day before. Because the picture was taken from close to the ground, we are given the impression of an enormous quantity of snow. Perhaps the ideal sky for photographing snow scenes is blue with faint, hazy cloud. The cloud screens the blue light at the same time as it spreads the yellow sunshine. These two effects give soft shadows and good colour.

Blue Shadows

On page 40 we said that 'daylight' is often composed of yellowish 'direct' sunshine, plus bluish light from the sky. On clear days without clouds, shadows in the snow will therefore be lit mostly by the blue sky. The more you under-expose, the bluer the shadows become. For example, the background of the picture below—with the fence pole and wire—is simply a railway embankment, shaded from the sun. The embankment derives all its colour from the blue sky. Unlike the trained artist, the photographer may not at first recognise these colour subtleties.

Snow looks particularly granular when light strikes the surface very obliquely. Every little grain then forms its own shadow and the snow texture appears quite pronounced. The same principle is applied when photographing a textured wall. (Kodachrome.)

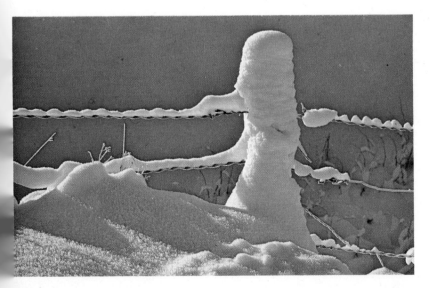

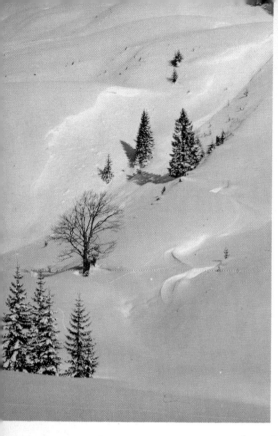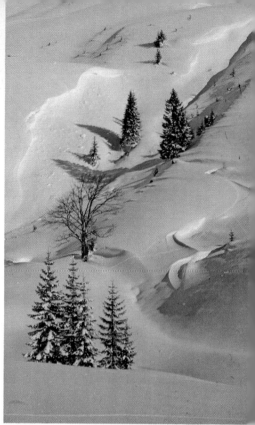

Low Lighting

As the sun sets and shadows grow long, the appearance of the snow changes radically. Even quite small undulations show up. Areas which seemed quite flat in top lighting are revealed almost as hills. Look at these pictures of a snow slope photographed with an interval of a couple of hours. The photograph taken when the sun was low has much more dramatic modelling. The shadows formed by the trees show you both the direction and height of the sun.

Notice the small break in the snow surface just to the left of the tree shadows. This broken edge has equal brightness in both pictures but comes out more clearly in the shot taken with the sun low, thanks to the extra contrast. Both pictures 250/5·6—8. Kodachrome II.

Thin spruces and leafless trees look quite good against a snow background. They take a graphic character. In sunshine you also get shadows plus a range of tones in the snow depending upon the contours of the land. In cloudy weather you may only record the outlines of the trees against a blank white surface. Much the same applies to close-ups of plants and shrubs. Saalbach, Austria.

Sun Reflected from Snow

We know how strongly sun-lit snow surfaces reflect light (one reason why sun glasses are essential when skiing). This shows up strikingly in back lit photo-

graphs. This spruce wood in Saalbach was photographed in backlighting; you can see the direct sunlight forming a strong halo around the trees. Apart from this, all the lighting is reflected illumination from snow on the ground or on the trees themselves. Contrast is therefore much lower than usual. Incidentally the blue background is a steep alpine slope in shadow. The two figures are deliberately recorded as silhouettes. I decided not to photograph them as they walked along the snowy part of the road, because there would be too much reflected light present from the snow banks and trees. The picture was taken when the two women reached the darker shadows to avoid unwanted detail.

Cloudy Weather
Cloudy winter days without glittering snow are excellent for taking pictures of people doing things out of doors. The child below stands against a background of grey shadowless snow. This emphasises the bright clothes and the sleigh, the boy standing out clearly from the background. Exposure 125/5·6.

Snow and Hoar-frost
The pictures overleaf show a scene photographed within a couple of hours one morning. At the time of the first exposure a cold, raw mist hung over the lake, and no background was visible. The birch tree looks

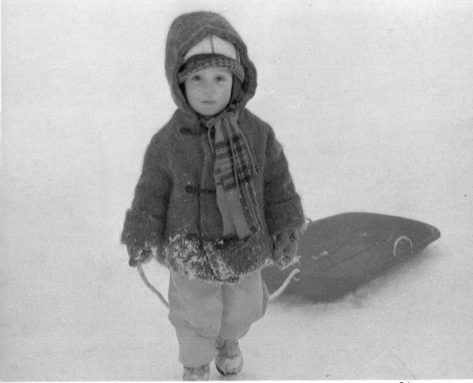

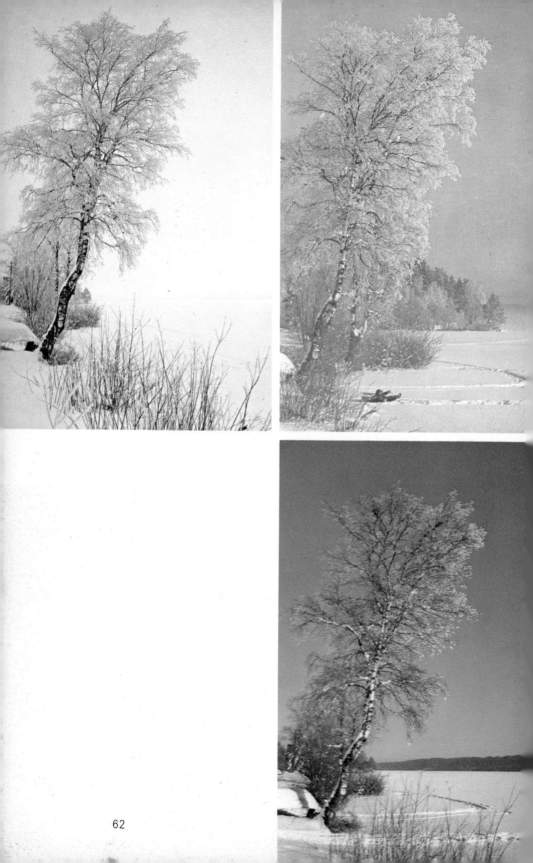

relatively dark against the light grey curtain of fog 125/5·6.

Quite soon most of the mist evaporated and the sun was shining. The sky grew blue, and in the next picture the hoar frost stands out white against the sky and the scenery has quite soft tones. 250/5·6.

A little later all the mist had disappeared, the sky appeared a cold blue and the scene had lost most of its charm. I think that the picture has rather a raw tone. This last picture is a good example of how the sky comes out very dark if you set your exposure (250/5·6) to suit a much lighter subject on the ground; in this case snow: see page 32. Furthermore the sky always appears a darker blue when you photograph it with the sun behind the camera. The closer you point the camera to the sun, the paler the sky becomes, which may be a disadvantage in backlit photographs. You may to some extent be able to overcome this by pointing the camera upwards, as a blue sky becomes darker towards the zenith. Hoar frost subjects in general require plenty of lighting contrast. This avoids the frosted bushes etc only just showing against a snowy background of more-or-less the same white tone.

Melting Snow

Close up photography often has to be done quickly before subjects containing snow crystals have then melted away in the winter sunshine. It is wise to focus and set the camera just before the sun reaches the subject. This is what was done here. Melting has started and some of the leaves have become moist, making them more shiny. However there are just about enough crystals left.

63

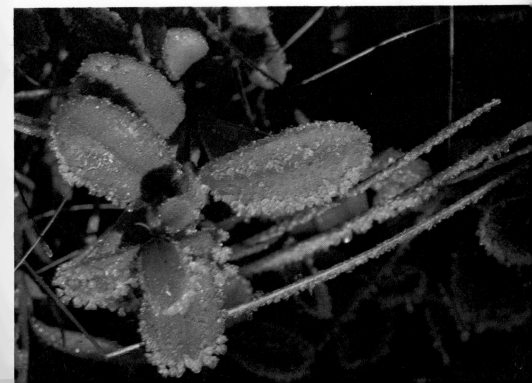

Water

Rolling Waves

You have to learn to press the button on the camera just a moment before the foam on top of a wave fizzes into the air, or the green water rolls up over a shallow beach. Our reaction time is usually longer than we think. During the fraction of a second as eye, brain and finger co-ordinate, the fleeting effect you wanted to record may all be over. So start off by studying the behaviour of the big waves just before they break and photograph waves of that size. In the same way you must decide exactly how to photograph smaller waves: will you shoot the wave as it comes in, or as it runs back into the sea?

This picture was taken at 500/4 on Kodachrome II using a 1A haze filter to reproduce the blue-green sea water with a slightly warm tone. The camera was mounted on a short tripod wedged into a sheltered cleft. (Never pull out the legs of a tripod longer than is necessary for the shot; tall tripods tend to be unstable.)

Only when the camera is firmly mounted and all ready to shoot, should you concentrate on the actions

of the subject. This care may seem rather excessive, but on a windy day a hand-held camera can give you an unsharp image at quite short exposures, possibly even at 1/500 sec. Be prepared to waste some film when shooting unpredictable subjects like waves.

A 135 mm lens was used for this picture. It could have been taken with a normal 50 mm lens, but then the breaking waves would have come out much smaller.

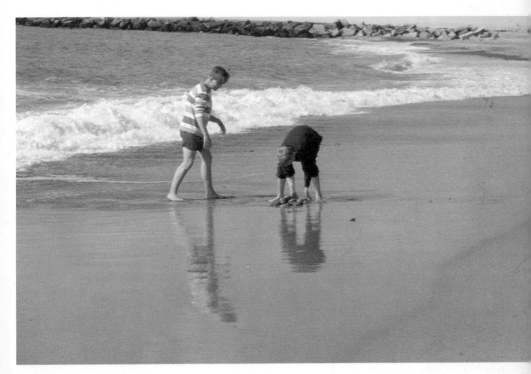

Wet Sand
The borderline between sea and land always offers great opportunities for photography. A shallow beach is a popular place for children to play. The sea continually washes the sand and rolls back again, creating a perpetually wet strip of beach. Wet sand acts like a mirror and here reflects the children as they build sand castles or walls to see how the sea breaks them down. Photographed at Thyborön at the western outlet of Limfjorden, Denmark.

It is always tempting to wade out further into the water to photograph the waves as they break there. However, on beaches with loose fine sand under the water you can easily lose your balance and so ruin your camera.

Reflections
You have to be rather careful when photographing calm water in which the sun is reflected. If intense reflected light reaches the lens it may well spoil the picture. Sometimes you may be lucky enough to find a tuft of vegetation or something similar breaking the water surface and 'hide' the suns reflection in it.

In this shot a little girl has made a sailing boat out of a large cork and some seagulls' feathers. The little vessel edged slowly forward and it was easy to wait for the moment when the cork nearly obscured the sun's reflection, so producing maximum contrast between the bright back-lit feathers and the background water rendered dark owing to the small exposure.

Water Patterns
Reflections in still water are popular subjects for photography. The reflection shows an upside down and slightly darker image of the actual scene. You don't see any coherent reflected image at all in choppy water, but some of the most interesting effects occur when subjects are reflected in slowly moving water. Straight masts become rippled, windows and roofs become crooked, and you get recognisable but transformed images of well known things.

At other times, the rippling reflections may give you

photographs of purely abstract patterns. Often pictures of this kind can be turned or trimmed in any direction, as the spectator is not influenced by any memory-picture. For example, the object forming the wavy white lines was just the planking of a rowing boat at a bridge which contained some green and brown colours.

Underwater

When you photograph almost vertically into deep water the water as a rule reproduces completely black, as in this shot of an old jelly fish. Vertical aerial photographs also show water very black. But on a shallow, light bottomed beach with very clear water you can not only record the bluish jellyfish but also see some of the seaweed on the sea floor beneath.

If you photograph on the beach between the high and low tide marks it is possible to get some interesting close-ups in rock pools and water holes where

shells, barnacles and other small animals abound.
This is a very rewarding area for anyone interested in
biology. Dunhure in Scotland.

Boat Races

To get good shots of a sailing race you really need a
fast motor-boat, so that you can choose the most
favourable position in terms of lighting conditions and
action. If you are unfamiliar with racing rules such as
the rounding of buoys etc you should have an expert
on board who can follow the official programme and
navigate while you concentrate on the photography.

Here are three IF-boats rounding a buoy during a
regatta in Gothenburg. Marks are usually the places
where the most interesting action occurs. (Agfa CT18.
Hasselblad 1000F with 250 mm lens.) Long lenses are
best for photographing boats in the open sea. It is
usually difficult to come close enough to sailing boats
to fill the frame with a normal lens alone. Racing

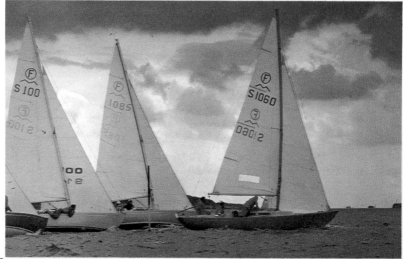

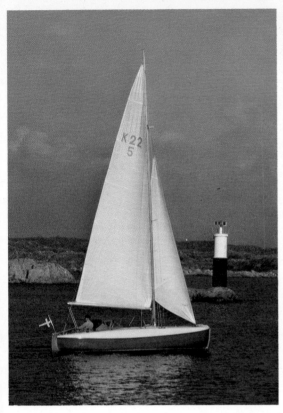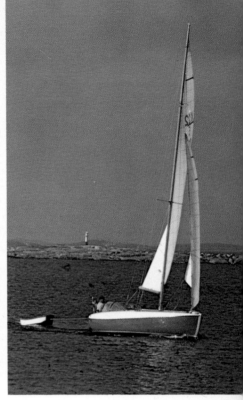

yachtsmen naturally hate to have photographers in boats coming in too close. Small boats near the shore can sometimes be taken from bridges or cliffs, if possible having pre-arranged the boat's exact course with the person sailing her.

Sails

Perhaps the most attractive feature of sailing boats is the magnificent curves of their sails and the way light changes their appearance. The yacht picture in which the two sails are evenly lit is much less interesting than the one in which mainsail and foresail are both front and backlit, giving better tone values. The play of the lines too are visually more interesting. Exposure here was kept deliberately short to make the sky darker. Photographed from land near the 'Mother's cap' lighthouse in the archipelago of Gothenburg.

Rain, Haze and Mist

Autumn mist on the stream

This stream runs near my family's winter home in Hindås. It took three years of autumn weekends before the right mixture of mist and sunshine occurred. We waited patiently for an effect we knew would eventually happen.

Scenes which include mist have an extraordinary 'depth', particularly if there is a dark foreground object such as the trees on the left.

Hiding the Background

Mist and haze are very effective in hiding the background in a scene. The well opposite, photographed on a misty winters day, stands out free from surrounding detail. A summer shot of the same subject records all the detail in foreground as well as background—which in this case is hardly an advantage. Furthermore the winter picture is a good example of the use of quite a limited range of colours.

A reflected light meter recommended an exposure setting of 50/8–11 for the winter shot. But from experience, this way of measuring snow scenes tends to lead to underexposure. The shot was therefore at 50/5·6 (see measuring white surfaces, page 28). A

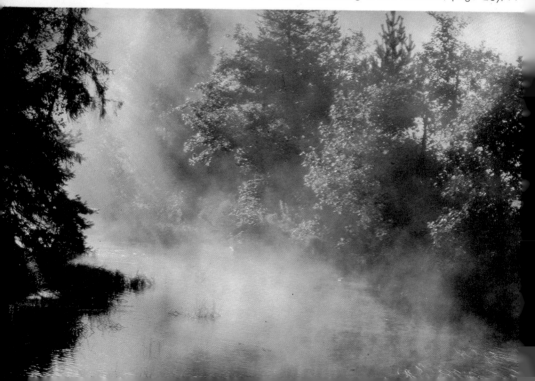

pale pink filter was probably used to give a warmer tone to the green.

Low Mist

The mill in the picture below (at Fleninge) was standing in fields covered by a low mist. From one point on the road sunshine reflected brilliantly from the mill's window. The photographer therefore set up his tripod on this spot and waited in the hope that a car

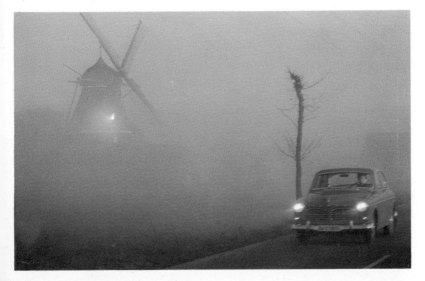

would pass with its headlamps on. Eventually one came, helping to produce this picture by emphasizing the mist. It often pays to wait for an additional element or different lighting before shooting landscapes or other static subjects.

Haze and Distance

Haze can indicate 'depth' and distance. This picture shows a back-lit morning haze over Sierra de Alhama, east of Malaga. It hangs in the air like a veil in front of the distant mountain. The furthest part of the scene is therefore the lightest. The less the haze between the camera and a ridge, the darker that ridge will appear. This explains why the tones fade away from ridge to ridge.

The Almond trees in blossom near the camera should have reproduced white, but because it was taken shortly after sunrise the light is rich in yellow and red, which has given colour to the blossom. (See page 39.)

If you photograph hazy landscapes with a long focal length lens you soon realise how the haze softens the image and lowers its contrast. To compensate for this, wait until there is as much side-lighting on the subject as possible. The shadows thus created give tonal contrast and with this an impression of improved sharpness. (Viewers often confuse sharpness with contrast.)

The warmer the air the more moisture it can carry, also on sunny days, hot air rising from heated roads, stones and so on may cause a blurring of the image. Therefore you get clearer pictures with a long focus lens in cold weather—what we call September sharpness. You can also reduce haze by going closer to your subject, if circumstances allow, and then using shorter focal length lens. In this way you put 'less air' between camera and subject. This may seem obvious, but it is often forgotten.

Shooting in the Rain

When you shoot rainy scenes, make sure the subject itself shows the effect of water, as in the case of the girl's wet hair. Asphalted streets and pavements are effective too, even though they sometimes give a bluish reflection.

Obviously you need to protect your camera. If you keep a filter (such as a UV filter) over the lens, it is much easier to remove rain droplets from this than from the lens surface itself. Often too, you can find shelter for yourself and the camera. Professionals are able to use assistants to hold a large umbrella over camera and operator; sometimes a relative can be persuaded to do the same for an amateur, but don't try their patience for too long.

Rain does not make colour look as blue as many people expect. If the sky is totally cloudy, very little blue light will reach the ground and often colour reproduction is good. A pale pink filter helps remove any blue cast that may be present (Kodachrome II 50/2·8).

The Effect of Exposure

During brief rain showers you can get sky effects like the ones in this picture of Kalmarsund, Öland. But be careful about exposure. In this instance exposure was measured from the light parts of the subject, in order to emphasize the contrast between the dark rainy area to the left and the sun-lit 'altar-piece' to the right. This slight underexposure of the clouds made them appear heavier. For the opposite effect you can 'over-expose away' unwanted cloud. (Kodachrome II 250/5·6—8.)

The Colour
of Subjects

Colour itself is one of the major pitfalls of colour photographers. The temptation to include every possible tone and hue in a picture is very great, especially for the beginner. Later on you become discriminating about the splashes of colour used, and begins to locate them in the right places. Really expert colour photographers, however, are rare. You keep on learning all your life—when you find yourself satisfied with all your pictures this probably means you are getting less critical not that you have nothing more to learn.

This chapter will not lay down rules on colour composition—or how to choose subject colours. The intention is simply to remind you that every picture is capable of improvement. The first impression of a scene does not necessarily produce the best picture. Give yourself time to assess its possibilities from various viewpoints, different lighting and so on. Anyone lucky enough to have a good colour sense is seldom in doubt about the 'right' juxtaposition of colours. Such people are to be envied, and have much to teach others. (But perhaps they cannot also tell how a good picture should look!) Always listen to the advice and criticism of visually discerning friends. Criticism is often hard to take at the time—anyone who has put pictures in for club competitions knows that. Nevertheless, constructive comment can teach you a great deal.

Too Much of Everything
This is a random shot taken at a well on Stora Kornö in

Bohuslän. Plastic buckets in three colours, a shaded spot on the ground at the bottom right and the rest of the right hand part filled with pieces of blue sky, dark water, and some barrels. Near the top of the gable a white window frame also competes for our attention. But as all this clutter was around the perimeter of the scene it would have been possible to avoid including it. I have marked lines across the picture to show how it could have been more orderly simply by restricting its borders.

Admittedly the shot was taken to be a bad example, but you would find plenty of pictures of this sort if you worked in a colour processing lab. The reason for this is the inexperienced photographers concentrate too much on the main subject in the picture and forget about all the surroundings. But the camera cannot discriminate in this way. It records everything, and when you receive the final picture you often find out with surprise just how much unwanted matter has been included.

Almost Colourless

You don't need a bright coloured or multi-coloured subject to make a colour picture. This picture of the tin crucifix, white artificial flowers, a couple of dark blue jars and a plastered wall is as close to a black and white picture you could find. And yet it makes an interesting colour photograph. Incidentally the small shadow in the niche contributed much to the effectiveness of this shot. Without it the niche itself would hardly have been noticed. Photographed in a Spanish cemetery at Arroyo de la Miel.

Yellow and Red
Remember you can take effective pictures with very few colours. Here is a picture, almost entirely red and yellow, of dried rose hips cut in halves and piled on a black baking dish. My close-up picture was taken with the same bellows equipment used for the grass head on page 86. Of course it could also have been taken with a supplementary lens.

Small against Big
Sometimes contrast in size provides the main theme for the picture. Here the little lamb is dwarfed by the large field. A similar example might be a little child climbing an enormous flight of stairs; or a little puppy with its huge Alsatian mother.

In this picture the contrast is further heightened by the colour contrast of the white lamb standing against an even green background. The dark transverse lines

are shadows formed by the terracing of the fields, typical of the Faroe Islands where this picture was taken.

Refraction Patterns in a Single Colour
Above we have a layer of shallow water over ridged sand giving strong shaded diagonals to the picture. The pale lines running across the shadows are formed by light refracted within the waves above onto the sand below. In deep or dark-toned pools you are unlikely to find such patterns. The presence nearby of red limestone gives the sand in this picture its warm tones.

Incidentally old or uneven window panes often contain 'waves' which can project striped light patterns onto an indoor subject when sunlight is shining directly through them.

Natures Colours
Nature is not the even green that town dwellers might imagine, but often presents magnificent combinations of colours. It's not surprising that artists living in the country are so often inspired by the vegetation growing around them. This grassy slope is not the even green that town dwellers might imagine, it contains many pale yellow and yellow-brown hues. The great variety of colours are there because the picture was taken during high summer, and the grass growing on the shallower earth had dried and faded. This contrasts with grass on the deeper and therefore more moist earth which is still a brilliant green. The lichen-clad grey cliffs and the blue sea make a fine setting for the grassy bank. Taken on Buskär, in the Gothenburg archipelago, Sweden.

Emphasis by Colour and Sharpness

During a regatta in Marstrand, dozens of fibre glass sailing boats were grouped at the quay. All the hulls were light and the sails white, but in the nearest boat there sat a yachtsman dressed in interesting colours. I wanted to take an unposed picture of him as he went ashore. Using a 90 mm lens on the camera so that I could stand well back from the boat, I put the camera on a tripod, focused on the bow stay, and waited. After about fifteen minutes he came by and I got my spot of colour in the middle of all that white, just as he passed the bow stay.

Lighting was good but in order to allow an exposure of 1/500 sec—to freeze his movement—I had to select a large aperture. This gave an out-of-focus background. Thanks to this contrast in sharpness, the figure stands out well. In fact we have contrast both in sharpness and in colour. The picture also proves that it pays to wait for a situation to develop.

Sky Background

This picture of a girl standing at the top of a mountain was taken from below to make her red bathing robe stand out against a blue sky. The sky is often a good background for portraits—but just how blue it reproduces depends upon what part of the sky you record, see page 63.

The subject is not a mature teenager, but a ten year old child. One strange feature about children's faces is the way they sometimes look quite grown up. This even happens with very small children. It can be just a brief smile, gesture or pose. The camera records this transient facial appearance, and in the resulting picture you discover family traits you would not otherwise have noticed. Sometimes pictures like this give pleasure to the family—and sometimes decidedly not!

Food and Flowers

We just did not have the heart to eat this Danish egg cake without first photographing it. As we were on Öland where they are plentiful, chives were used to spice and to decorate the cake, instead of the leek rings specified in the recipe. This explains the violet showing among red slices of tomatoes and brown fried strips of pork, on the yellow pancake. We thought that this made up an enjoyable combination of colours, particularly when framed in daisies. A still life of food and flowers (opposite).

Tackling Pictures of Food

Nowadays almost all food photography is shot in colour. Professionals specialising in this work have their own test kitchens, where expert cooks ensure that dishes look fresh and appetizing. If your shots of steaks and meat balls don't have as much shine as in the professionals' pictures, this is because he 'varnishes' the meat with cooking oil, and that lettuce looking dew-fresh has probably just been sprayed.

You should always try to take your pictures the moment the dish has been arranged, so that surfaces

have not had time to become dry and lack lustre. The camera should be focused ready on the working surface where the dish is to be put. Your wife will probably also appreciate it if you also take some shots of the entire table laid out for the meal. An example appears on page 143.

Too often amateurs attempt to photograph food dishes when guests have already started eating. But once a prepared dish is touched, it no longer appears appetizing. For this reason, if you must take a picture of the food being served take it as the very first guest is served. There is nothing worse than a photograph of a sideboard from which ten people have helped themselves—it looks like a looted butcher's shop.

Close-Ups

Broad views and fine detail complement each other and give variety. Film-makers know this, and add unusual variety by mixing long shots and close-ups in with average subjects. By applying the same principles we can make our slide shows more entertaining and our photo albums more interesting.

This charcoal stack photographed some years ago in Lappland, made an interesting picture. However, there was another picture in the tiny blue/black pieces

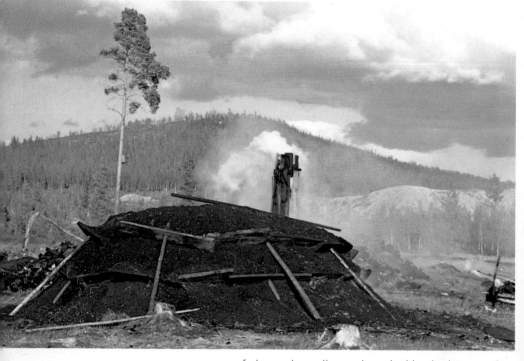

of charcoal, swollen and cracked by the heat, as they reflected the sunlight. It is shown opposite.

Extreme Detail

To a photographer of extreme close-ups a bunch of red currants is a 'large' subject. This photograph was taken just inside an open window—the currants lying on a grey-white board. The idea was to shoot a transparency from which a five feet high bunch of currants could be projected on a screen.

The advantage of close up work is not therefore just limited to making a large scale image on the film itself. This is further enlarged in the making of a print

or projecting onto a screen. Just how good this 'second stage' enlarging will be depends on the quality of the enlarger or projector. Remember that if you have a good camera, you should also have a good enlarger or projector, if you are going to do full justice to the pictures you take.

Detail Attracts

These two photographs show sea-shore plants photographed from above just using the normal camera lens, and then using a close-up attachment. I take pictures like these to convince people that if you remain standing, you cannot look properly at small objects on the ground. You really need to lie on your stomach in the sand with a magnifying glass to your eye. You may then see the wonderful shape of the leaves, the blown grains of sand, and the tiny repeated five pointed patterns of the flower.

At the same time don't completely ignore the more general view, showing in this case the plant in splendid isolation, hunched up close to a stone. (Bathing beach at Vrångö, Gothenburg's southern archipelago.)

How near you can go (and how great an enlargement you get) depends upon your equipment. The working limit for an ordinary lens on a 35 mm camera is about $\frac{1}{2}$ to 1 metre. To reduce this you can use supplementary lenses, the common ones give a distance of between 20 and 30 cm. They can be used with fixed lenses or with a system camera's interchangeable lenses.

Owners of most cameras with interchangeable lenses can put in one or more extension tubes, or a set of bellows, between the camera body and the lens, lengthening the lens to film distance so that it can work closer to the subject. An extension tube works almost at a fixed distance and you have to put in another one (either in place of or together with the

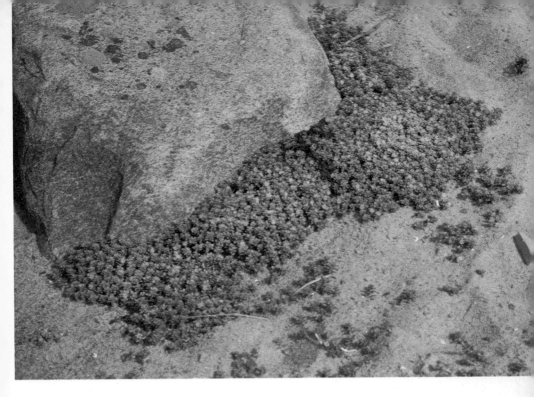

first) when you need a different focusing distance. This can mean a lot of fiddly changing and the specialist does not like focusing step by step, and so uses bellows for continuous adjustment in his close-up work.

When you get very close to the subject—for instance by help of bellows—you can record it on the film 2, 3 or 4 times its natural size. This is the photographic field called 'macrophoto' which is near the borderline of photomicrography, where you need a microscope, and then you are very far from amateur photography.

This discussion has been mainly on the closeness with which you can approach your subject, but for many purposes it is more important to know the area of subject which will fill the whole film area. There is more about this, and other things concerning close-ups, in the technical section on page 189.

Outdoor Subjects Photographed indoors

Close-up photography of plants such as flowering grasses is made very difficult outdoors because they are blown about by the wind. Using extension tubes or bellows (page 191) will probably necessitate more exposure than normal. Since you will want to use a small lens aperture to give you a reasonable depth of field, quite long exposure times will be needed even in bright sunlight, and air movement may make the shot quite impossible. It is often easier to bring your subject indoors. The grass-head on the next page was taken at 1/10 sec at f22 on Kodachrome II, using a 90 mm lens with extension bellows. The spray was pushed into sand in a tin, and placed inside a sunlit

85

window. While the shot was being composed through the camera, the tin was very easy to move about to set exactly the right position. Of course it is much simpler to move a tin of sand than try to push grass into just the right position in the sand.

The distance between spray and lens in this case was only 25 cm. At such short distances depth of field is very shallow even at a small lens aperture. This is why the background outside the window, a grassy mountain slope, looks such a jumble of colours. (Depth of field was in fact only about 1 cm) and the grass head had to be arranged exactly at right angles to the direction of the camera so that it all came out sharp.

The room itself had only one window, so there was a risk that the spray would become a silhouette. To avoid this, reflected light was directed into the shaded side of the grass with a mirror adjusted by hand. The exposure meter reading was taken as close to the subject as possible. The flower shown on page 54 was taken with the same equipment.

Camera Position

One of the most important decisions to make when taking photographs is where to place the camera—especially when the components of the picture cannot themselves be moved. Indoors you can usually alter things around, re-position a group of furniture, put together items to form a still life, or make up a flower arrangement. You seldom have such flexibility in nature. Subjects which have grown—or been built—stand in one spot, and you have to do the best you can with them.

Irrespective of subject matter, searching for the best camera position soon teaches you that horizontal surfaces can be enlarged or diminished according to how high you place your camera. Objects which appear well separated from a birds eye viewpoint look cramped up together from a lower camera angle. A coloured item you want to suppress can be decreased in size and importance this way. Sometimes it can be excluded completely by moving the camera still more.

Remember, all this choice or rejection has to be made *before* the shot is taken, if you are shooting transparencies. Once your finger has pressed that button the decision has been made. Here are some examples of how subjects can be looked at and photographed in original ways.

Worm's Eye to Bird's Eye

This small plant was photographed with the camera resting directly on the rocky ground. The low viewpoint shows the plant standing isolated against the sky, its four inch stalks looking unexpectedly tall. The result is dramatic because you seldom look at plants from root level. Here it appears to grow out of the stone itself. This picture was shot using a supplementary lens and a rather large lens aperture, the latter to allow a short exposure time because of a slight breeze. The large aperture caused the shallow depth of field around the tuft.

Here the same group of flowers shot from a bird's eye viewpoint gives a picture filled with very different colour. The cool blue of the sky has gone. Now the background consists of a carpet of yellow, grey and black lichens on rock. Interesting shadows from the flowers can now be seen and these help to give an impression of a bouquet of flowers. This viewpoint also reveals that the plant grows from a crack in the rock. Notice that the camera was orientated so that the crack does not run parallel to any of the picture edges, which might give a rather static composition.

The Main Subject

When you come across an old wreck on the water-front, your first impulse is to take a snapshot regardless of the background. This can result in the surrounding trees obscuring the interesting outlines.

You can get a much more interesting picture if you choose your viewpoint with greater care. Here the second picture was taken from another angle to show up the wreck as a stark skeleton against the sky. A low viewpoint further lifts the main subject in relation to the background—this picture was taken from a kneeling position. Öland, Sweden.

Wooded . . . or Bare?

The impression of the environment can be considerably distorted by photographing a smaller or larger part of the scene, or framing it in an out of focus fore-ground. This picture of the motor-boat and rocks seems to show a bare coast. But the same boat photo-graphed from further up the slope, its surroundings

become clad in the trees and bushes. The only difference is that the photographer moved 30 yards up and to the left. Shot at the Nötesund bridge Bohuslän.

Vertical or Horizontal

Quite a lot of cameras are designed so that they fit most easily into the hands when you take horizontal format pictures. But don't let this tempt you in to shooting everything this way, because there are many occasions when a vertical format would be better. Here are two pictures of a bridge over Pite River. Sitting in a car with a limited view upwards you tend to see the bridge as shown left. But if you get out and search around for a more interesting camera position you find that the high arch needs the sort of format offered by a vertical picture.

I must admit that the arch and wires of the bridge did tempt me to think of it in terms of a harp. On the whole I produced a tighter composition with more exciting interplay of straight lines and curves by shooting the picture vertically.

Walk Around Your Subject

Statues and other sculpture in built up areas usually have surroundings which make them difficult to photograph. This makes it imperative to walk round and take a good look at it from all sorts of directions before picking the best camera angle. Poseidon in Gothenburg in my left hand picture is shown against windows and the roof line of the town's theatre. The result is irritating, and the water spray plays little part in the picture.

The picture on the right was taken from another

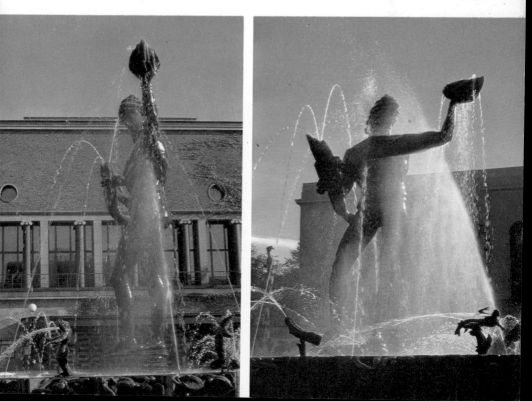

viewpoint, and with the subject now back lit. The back lighting shows up the water and gives the figure much more interesting surroundings. The shaded wall provides an unobtrusive background, we therefore get brilliant contrast and an improved image. One stop smaller was used for the second shot to make the figure and wall slightly darker, and to cope with the brilliance of the backlit fountain.

Oblique Lighting

This rowing boat is on the same stretch of water and photographed from the same bridge in each picture, and yet the water surface looks so entirely different. The direction of the light makes all the difference. The semi-silhouetted picture was shot in backlighting which makes the calm water appear very pale, particularly if the camera viewpoint is almost horizontal and near the water surface. See page 65.

The other picture, which shows so many colours in the water, was taken in oblique front lighting and

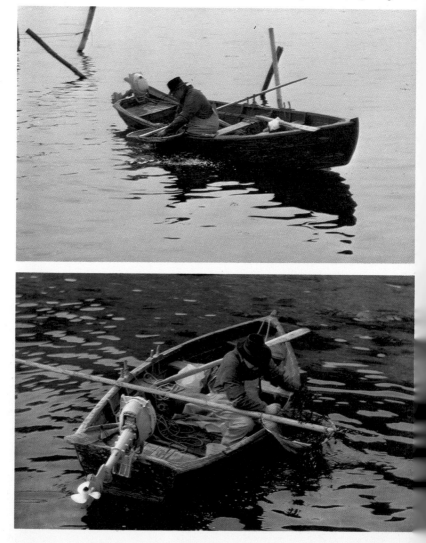

with the camera angle more vertical. The rowing boat is near a shallow beach which runs up towards a dark steep mountain. This explains why the lower part of the picture has alternating blue and black specks—reflections of mountain and sky. In the top part of the shot you have the sand and mud of the beach showing through the reflected mountain. (A light colour always 'kills' a darker one.) Had the water behind the boat been deeper, the mountain reflection would have extended right up to the top of the picture. These two photographs illustrate how the same place can provide you with two very different subjects for colour, simply by making different use of the lighting.

Different Lighting at Different Hours
The appearance of a subject changes very considerably throughout the hours of a sunny day. You will notice this in particular when trying to decide the best time to photograph a house. One of these two shots of boathouses was taken at 6.30 a.m. in June, with low

light coming from the East. The other was shot at noon on the same day, when the sun was high and the lighting came from the South. The lighting on everything is now very different. A gable illuminated in the morning is in shadow at mid-day, and vice versa. Morning shadows are long; mid-day shadows short. There are also differences in the overall colour of the two pictures. This is because of the change in height and colour temperature of the sunlight between morning and noon. (Discussed further on page 39.)

When you are taking pictures of a building, remember that there is usually one particular hour during which the lighting will give the best rendering of its structure. In the morning picture you can see how the sun has began to light the nearest wall. This oblique light emphasizes the rough textures of the limestone building. Finally you can see how the buildings appear to form a closer group in the morning —the shadows seem to hold them together.

'Photography' without a Camera

There are at least two aspects to every subject. That is what the last nine pages have been all about. Learn by seeing. You do not even need a camera for that. Make a habit of seeing your surroundings under varying lighting conditions. Look out for good foregrounds; find out where you can best position yourself to avoid disturbing detail; choose between high and low viewpoints. In short you can 'photograph' just by using your own eyes—and in that way develop what is called a photographic eye. You have then won something that cannot be bought—a built in viewfinder.

Landscapes

Open Curves
The top picture was taken from a hillock to make the most of the softly curving sandy beach—allowing it to cross the frame without a break. The composition is helped by the small green strip where the curve comes just inside the frame. 100/11 Kodachrome II.

Compressed Curves
In the lower shot the curve and the area of water sur-

face have shrunk. This is because the picture was taken right down on the beach itself. The nearer you place the camera to water level, or the surface of beach, street etc, the smaller space this surface occupies on the image. This is one of the main ways a photographer can manipulate the distribution of various parts of his picture. The first picture has no foreground because of its high viewpoint. But here a group of children at play can be used to fill the nearest part of the beach and add an extra touch of summer to the surroundings.

Notice, incidentally, how the children seem to be unaware of the camera. Natural-looking pictures of children, and adults, are easier to achieve when the subjects are absorbed in their own occupations. Notice also the nice even way the children are lit by light reflected from the pale sand. 100/8 Kodachrome II.

It is always a good idea to pay special attention to the lines and textures of a landscape before taking a photograph. Try to find features which offer cohesion and unity, giving stability to the picture. These may be lines formed by streams, roads, beaches, rows of trees, furrows, or the borderlines of fields. They may be the textures and surfaces formed by crops of various colours, or limited by groups of trees or the outlines of hills.

Using Roads

An unwanted road can often be suppressed if you are only interested in portraying the landscape. In the picture below, the shape of the land and the tree form the main elements, with the sea and sky forming a background. The road plays only an insignificant part in the composition.

On the other hand the picture with the white chervils growing gives the road a dominant position. In this case the camera was tilted downwards so that the road fills the picture almost up to the top. The tilt also helps to widen the road in the lower half of the shot, and give it a strong perspective. The opposite effect was used in the first picture where the camera was tilted upward. Weathered limestone in the surface of the road caused its generally reddish tone.

98

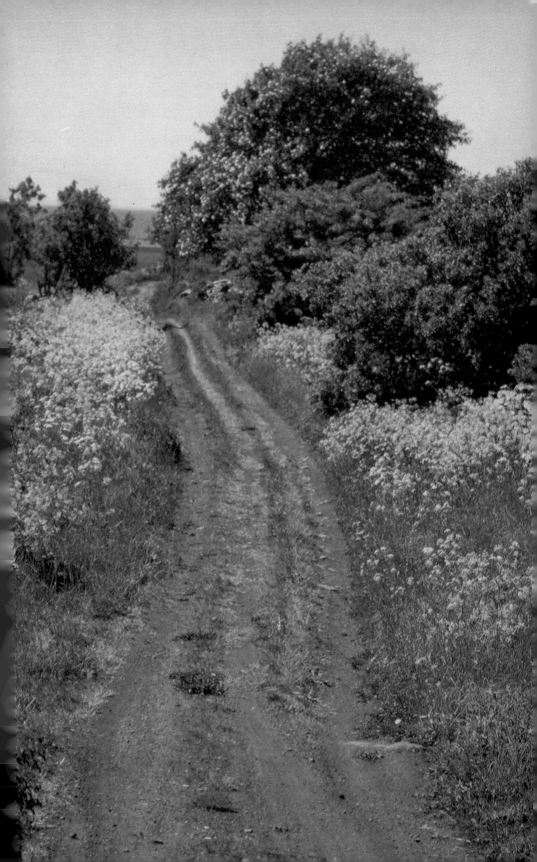

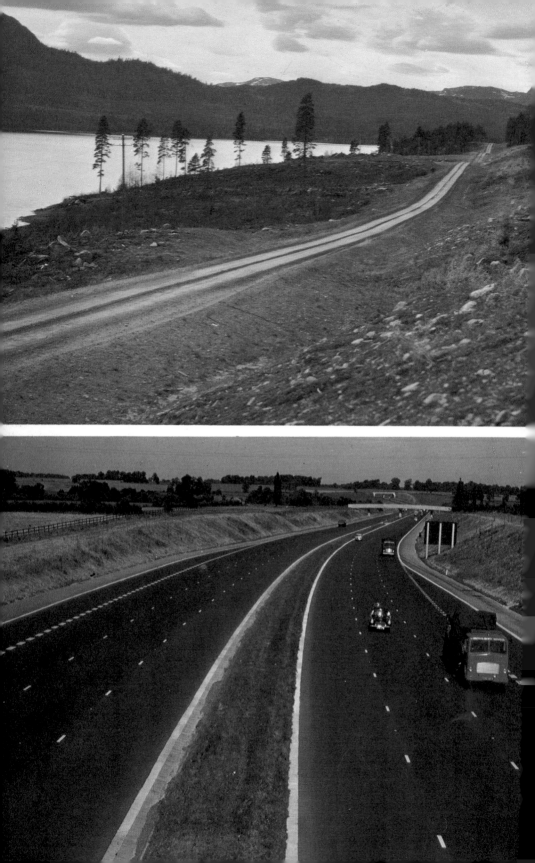

Controlling Road Width

If you don't want to make the road look so wide all you have to do is move slightly to one side. Of course, this also makes the road run diagonally through the picture. If, as in this picture taken in Lapland, you want to show a long lonely road, the best camera position will be somewhere from which you can see far over the landscape

For the opposite effect—emphasizing the width of a road—it is a good idea to shoot from high above the road. For example, this motorway picture (M1, England) was taken from a bridge. Tilting the camera downwards has filled the bottom of the picture with road, and using a short focal length lens has further emphasized the foreground and rapid convergence into the distance.

Making Mountains look Steep

This is an example of the sort of subject that cannot be adequately portrayed in one picture alone. The shot at the bottom was taken almost vertically and clearly shows the impressive zig-zagging road near Åndalsnes, Norway. In spite of the perspective it does not give the feeling of the steep hill up which the track is climbing. This is shown more clearly in the picture on the right, taken from the hair-pin bend shown at the top of the previous picture. The two views can be related by the position of the bridge over the foaming stream.

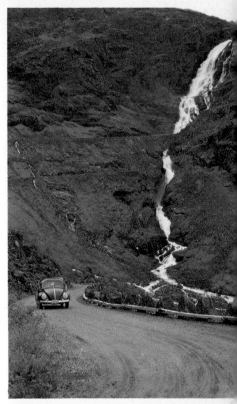

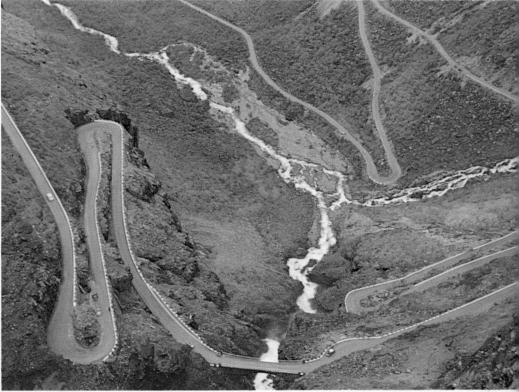

Lines in Nature
Nature itself sometimes gives us an unexpected inter-play of lines. Here is a zigzag line in the Camargue Delta, Southern France, marked out by the red plants along the shore. The general colour balance is rather more ruddy than usual because the picture was taken at sunset.

Endless Rows
Furrows and lines of plants are an everyday sight in cultivated fields. The converging lines in a beet field

102

one early summer produced this picture in which the field seems to extend forever. The picture was taken to exclude a farm at the far end as it would destroy the 'endless' appearance. Perspective is much more strongly marked if the photograph is taken along the centre line of the field. (Jylland, Denmark.)

Foregrounds

The two pictures here were taken on Öland, Sweden, where the limestone meets the water. Only Juniper trees grow in the shallow soil of the barren flat beach. A picture of Junipers forming the foreground to limestone boathouses gives an accurate record of the landscape. However, shooting from just beyond the trees, and so having only sandy ground in the foreground, creates a picture much more evocative of this beautiful wasteland.

Vegetation, such as bushes and trees, used in foregrounds can greatly help a landscape which would otherwise be empty and boring. Think of the number of dull hotels which look so much better when portrayed in tourist brochures behind an idyllic foreground of hanging branches (some held there by the photographer's assistant). Sadly, landscape falsifica-

tion in tourist literature is now almost taken for granted.

The road picture on the left is a good example of a framing type of foreground. It was shot through a canopy of foliage which has come out very dark, because exposure was chosen to suit the lighter road. The lighting was low morning sunshine in summer.

Pictures can be 'framed' by a doorway, a gate, a rustic trellis and so on. One way of putting a natural frame around a landscape is to shoot it through a window. You can include a potted plant on the window sill if you think the frame looks too plain. Fine net curtains may also help to soften the edges. Remember, however, to stop well down—the nearer the foreground the smaller the lens aperture must be. Otherwise your depth of field will not be sufficient to give you sharp focus throughout your picture. This is particularly important when shooting from a window or balcony, as these sorts of foregrounds really need to appear sharp.

There is an example of using the foreground on page 97 where a group of children help to liven up the picture of motor-boats. A lot of pictures of hotels in brochures feature the swimming pool as a fore-ground—an attraction which may sometimes eclipse the hotel itself as the main subject.

Almost every photographer has at some time shot pictures of landscapes through the car window—to prove that 'he was there'. In fact this and the use of friends as foreground 'actors' is a convenient way of creating frames, as long as you don't make them all too alike.

Depth from Scale and Colour

The right hand picture of Thingvallir in Iceland, in-cludes a boy about to take photographs from the top of a ravine. Compared to him all the people down there in the road look very small, and you get a con-vincing impression of great depth. The boy in effect provides a scale. But with colour photography we can use more than foreground content—colours them-selves can help to imply depth. Red and yellow hues tend to be 'near' colours and bluish colours more 'distant'. This is probably due to our experience of distant hill and mountains being predominantly cold in tone. Warm coloured foregrounds are therefore another weapon in our visual armoury, to be used when we want to create an impression of distance.

Morning Haze

The tremendous difference in character between the two pictures of the same islands which are reproduced on the next page is due to the hazy morning sunlight in one and cold, hard noon sunshine in the other. The morning shot is undoubtedly much more atmos-pheric, with its haze nicely separating the two islands. In the mid-day picture it is difficult to tell that the group of trees is not growing on the further island, which is in fact quite bare. Haze which gives 'aerial

perspective' has great importance as a means of implying distance and depth, see page 72.

Exposure for the hazy picture, taken at 5 a.m., was 500/4 on Kodachrome II. (Mention of this unearthly hour reminds me of an old Belgian landscape photographer, who used to say he could not imagine shooting later than nine o'clock in the morning!)

Using Cloud Shadows

The shadows cast by one or two isolated clouds are of great value when photographing landscapes from high vantage points. They can enliven an otherwise dull, evenly coloured surface.

In the picture opposite of Kollafjördur in the Faroe Islands, all I had to do was wait for the moment when the group of houses at the beach was free from cloud shadow. (Shot with 135 mm lens from a height of 1,150 ft and about 4,000 ft from the village.)

Sometimes cloud shadows may dominate a picture taken as shafts of sunlight break through stormy skies

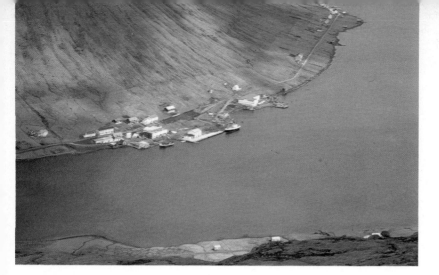

to illuminate just strips of landscape. Of course, you generally have a long wait before exactly the right part is illuminated and some times it just doesn't happen. But when it does occur and if you remember to expose for the sun-lit part only, you produce a very dramatic picture rather like an old master.

From Aircraft Windows

Flying over the Pyrenees one January, I took this picture through the cabin window. It was shot at 500/4·5 using a 135 mm lens on the Leica. The photograph has been used in geography lessons to show how the sloping terraces look like contour lines on a map.

Don't support the camera against the window frame, because vibrations within the airframe will give camera shake. This window was not completely clean, but because the surface itself was not lit and was only an inch or so from the lens, the resulting definition is not too bad.

Anyone who drives a car knows how difficult it is to see (and therefore photograph) through a dirty windscreen, particularly when sunlit. A halo of light forms around each grain of dirt, reducing visibility and contrast. If you go on a flight intending to take photographs try to pick a seat on the side of the plane most likely to be in shadow.

Summing up

A landscape may be worth photographing for its colour, or the direction and strength of the available light, quite apart from its physical content. The more you stroll around the environment the more you realize the important contribution made by lighting.

Perhaps we should finish this chapter with a couple of warnings. You often see examples of tourists' holiday snaps by photographers who were very impressed by the actual locality but failed to put this over in the picture they framed up in the viewfinder. It is so easy to be seduced by, say, a distant island surrounded by glittering water—forgetting completely how few millimetres that island will occupy in the image. Maybe it will fill one tenth of the frame, so that at some future slide show the audience will be lucky if they see the island as more than a tiny line near the middle of the screen. It doesn't help much either to be told by the photographer how wonderful the place looked at the time.

Try not to limit yourself to the main highways when you travel in a foreign country. Main roads—and particularly motorways—are unlikely to show you the real character of a country. You may not even be able to stop at the side of the road. I remember cycling in Britain the first summer after World War II. The warden at the Canterbury Youth Hostel asked me which way I had planned to go and I pointed on my map to the main road route along the channel coast. 'No,' he said 'don't cycle on the main roads, or you will never see Britain.'

People

Go in Close

The subject here is a tarpaulin, a pair of boots drying on the lawn and an inquisitive boy The first picture shows the scene as it was shot unnoticed from a distance away. Then I moved closer, and talked about grandfather's boots, and what might be in them. This is the resulting picture.

Photographing children usually calls for quick decisions and the ability to work without too much fussing over camera settings etc. In other words you need to work casually. One technique—if the child is one of the family—look through the camera so often that it becomes part of everyday life. The child no longer regards it with any interest, and the actions of taking pictures are ignored.

Try to stop people around just from making 'encouraging' comments to the subject, however well meant these may be. Shouts from various different directions confuse the child and drive the photographer to despair. On the other hand the subject's mother or father can be a real help if they will limit themselves to helping the child become absorbed in some activity which will offer natural situations for pictures. The photographer then becomes of secondary interest to the child.

Sometimes children cannot see a lens without staring into it and asking the photographer to 'take their picture'. But this is usually short-lived, and after one or two fake exposures the situation returns to normal.

Of course, proud parents usually want to show pictures which portray their child in the most flattering way, like the one with the clean cherubic face

dressed in a spotless beach robe. You can, however, take excellent pictures on other days; when, for example, he has been splashing in puddles, and his face shows his strong disapproval of parents ideas about washing. This is a picture which complements the other one rather nicely.

As a technical note, the lower shot was taken in clear sunshine, giving distinctive shadows. The dirty face picture was taken in sunlight diffused by thin clouds. Notice the softer shadow under the boy's chin.

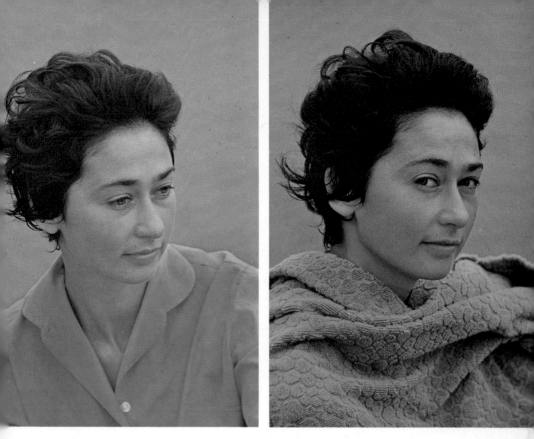

Complexion and Clothes

The colour of the clothes a person is wearing can determine the effect of a colour portrait. In the first picture, the pink blouse takes the emphasis away from the face. When portrayed in the blue beach-robe, however, the face with its olive toned complexion dominates the picture. The blue background is just out of focus water, far beyond the rock where the picture was taken. Soft, veiled sunlight provided illumination—the sort of light which is kind to people who screw up their eyes in anything stronger. A surprising number of people can really only have their portraits taken in this type of lighting or in shadow. Of course, soft even lighting makes photographing much easier because you don't have to worry about the distribution of shadows quite so much. But pale complexions do tend to come out flat and lifeless.

The Romance of Sail

Camera position for the next picture was decided by the surroundings. The bowsprit of the 'Christian Radich' in Gothenburg harbour fills the upper part of the picture, with a modern ship in the bottom left. (Kodachrome II, 60/11 using a Leica with 50 mm lens.) As you can see, the man strolling about is in focus, but the bowsprit is slightly unsharp. If we had wanted the man more separated from the background a much larger aperture (and shorter exposure time) could have been used. This is called contrast in sharpness,

and is most obvious when the main subject is much
nearer the camera than the background detail, and
there is only air in the middle distance.

Matching Tones

The main point about this picture is that dog and
mistress both have hair the same nice grey colour. As
the lady is a great dog lover, this matching colour is
rather appropriate in a double portrait.

Portraits can often be much more interesting if you
can combine a person with their hobby. Another
advantage is that a person who has a special interest
in something tends to have an easy and natural way
of handling his tools, boats, pets, or whatever it might
be. Given something to occupy themselves with, they
become less aware of the camera.

Dark Backgrounds

This girl's portrait was taken using an open doorway
as a background. The interior beyond the doorway
had only very weak illumination, but did not look as
black as it appears in the photograph. This is because
exposure was measured for the girl's sun-lit face.
Remember how this background underexposing
technique was used for the fishing village shot on
page 30. It shows that experience gained with one
type of photograph may often be applied to others.

The high angle of the lighting gives strong shadows
which emphasize the shape of the lips; helped

because the nose shadow does not quite reach the upper lip. Light illuminates the cheek obliquely, see pages 9 and 132 and the eyes are partly shaded. Often it is this kind of daylight you should try and imitate when shooting portraits in artificial lighting—be this flood or flash.

Situations

The top picture does not attempt to portray action, the girls are just waiting for the relay race to start. The picture below, shot just at the moment batons are passed, is much more interesting. For this sort of split-second situation, all the camera settings must of course be ready set, so that your entire attention can be concentrated on the subject.

In some sports it is possible to predict more-or-less exactly where something is going to happen. The starting shot . . . the leap over the hurdle . . . the high jump bar . . . and the finishing tape. You can be there

all ready to shoot. But you must also know how to recognize the decisive moment in various other kinds of sport. For example exactly when a particular high dive looks best, and from what angle you will get the best picture. The expert presses the button just a fraction of a second before the climax is reached. This allows the shutter to operate exactly when the action reaches its peak.

On this page you will see two situation pictures from Spain. In the first picture I was going to photograph the knotty tree, but then two donkey riders appeared far off along the road. There was plenty of time to set up the camera and arrange things so that a suitable space remained in one corner of the viewfinder. It was then just a matter of waiting for the right moment to shoot.

If the subject is in motion it is usual to leave some space in the composition for the movement to continue. Here the donkey has room for a few more steps before it 'hits' the right hand side of the frame.

By its very nature, this shot of the street-sweeper's siesta in Fuengerola hardly required quick camera work. It was as if the entire scene—with tree, broom, shadows and so on—were arranged specially. One just accepted gratefully, and took the photograph.

Notice how the film has a brownish tone. It was bought in the town, and although still within the expiry date on the box, the film had probably been stored in heat. (See page 167.)

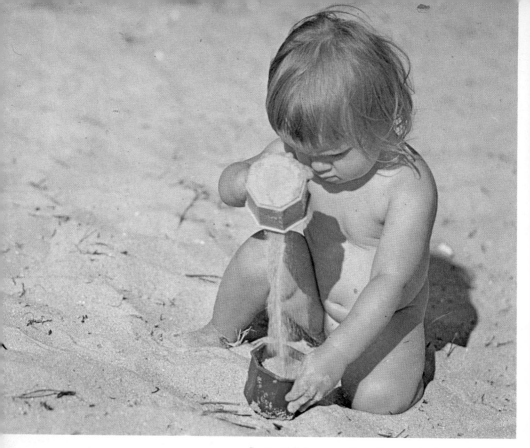

Busy children don't notice a photographer. This little girl was given two plastic containers with which to scoop sand. In fact sand is a very good environment for portraits of children. It does not steal any attention as a background, but it offers endless possibilities for the child to play. This photograph was shot at wide aperture, which is why the sand has merged into a structureless coloured tone. Always remember that, although in a situation picture the *situation* must have priority, where time permits give some thought to the composition as well.

Team Spirit

Winter ice at Brännö. Eager cod fishermen launch their boats from the ice. There is wonderfully co-ordinated action by all concerned. The men did not even know that they had been photographed. Colours are softened and diluted because of the haze present. The poles show us that the launching is taking place above summer moorings.

Invading People's Privacy

Sometimes the vexed question of possible invasion of people's privacy arises in connection with situation pictures. How candid can your candid camera shots be? It is true that no-one has the right to his own image when out in the crowd, but it is also a good rule never to photograph people to ridicule or hurt them in any way. Photographing into private property with

long focus lenses is, of course, an abomination.

However, such a nice couple cannot be hurt by this picture of modern Norwegian youth, photographed one Sunday near Oslo. Notice how careful the young lady is about the man's scarf being on properly.

Artificial Light

Artificial light' means all forms of illumination not coming from the sun. For example, ordinary electric lamps, floods, tungsten halogen lamps, fluorescent tubes, sodium and mercury light, flash bulbs, electronic flash-guns, even paraffin lamps, candles, open fires and fireworks are all regarded as artificial.

Just like natural lighting, they can have:

—*variable strength*. This can be read by a normal exposure meter or an electronic flash meter. (The latter is rather limited to professionals, because of its cost.)

—*variable character*. They may give sharp-edged shadows similar to direct sunshine, or produce broad shadow-free illumination like hazy daylight. Soft lighting may be created by fitting diffusers in front of the lamps (like 'clouds') or by letting the light be reflected from ceilings, walls etc.

—*variable colour temperature*. This varies from the daylight matching 'blue' of electronic flash to the very much 'redder' light from a paraffin lamp or candle.

The characteristics by which artificial light differs from daylight are:

—*Strength diminished with distance*. Artificial light quickly becomes weaker the further it is from its source. In fact, technically speaking, it diminishes in proportion to the square of the distance. So does sunshine—astronomically speaking—but as the sun is so far away we don't notice any differences here on earth.

—*The duration of the lighting can be extremely short.* Electronic flashes last only 1/500 or 1/1000 sec, flash bulbs about 1/80 sec. As a rule these light sources are intended to be used in conjunction with synchronized camera shutters.

—*The lighting can be directed*. Lighting units can be positioned to light the subject from any direction. In daylight the subject itself usually has to be moved, although reflectors and screens may sometimes be used to modify the lighting.

These and other differences make it necessary to deal with photographing by artificial light in a special chapter, even though the technique may in many ways follow the same lines as were discussed under daylight.

Colour Temperature

When you switch on a lamp in the evening it appears to give white light. Turn on the same lamp at noon and you notice that its light is more yellow than daylight. This is a simple demonstration that daylight and

artificial light have different *colour temperatures*.

The reason why we regard the yellow electric light as white in the evening is because our eyes soon become accustomed to different light sources, and use objects we know to be 'white' for compensations. Even the blue light from a TV screen seems white after a few minutes. You may also demonstrate the phenomenon when you project colour slides. If a brand of colour film has a slight characteristic cast of its own, or even if you project the slides onto a pastel-coloured wall, you will not find it disturbing after a couple of pictures. But as soon as you mix the pictures with different colour casts or with shots taken in different lighting, you will notice and be disturbed by the changes in colour. The eye can happily accept pictures shown in a projector with an old lamp of the 'wrong' colour. In fact the eye may not even accept 'true' colour if it has been looking at the 'wrong' one long enough.

'Gilding' with Electric Lamps

These pictures show the gilded wrought-iron gate of a square in Nancy, France, by day and by night. The daylight shot is technically the more accurate of the two, and as you can see from the colours of people's clothing and the foliage, it is normally exposed.

At night the gate is illuminated by floodlighting with red-rich electric lamps, giving orange cast to the whole subject. Notice how even the black iron work

119

Light, Films and Filters

	Colour Temperature (K)
Daylight: clear blue sky	13,000
Veiled sun	8,000
Sun and blue sky	6,500
Sun and white clouds	6,000
Morning or afternoon sun	5,600-6,000
Sunshine within two hours after sunrise or before sunset	3,800-5,200
	3,400
	3,200
	2,800

This table relates the colour temperatures of light sources to the various types of colour films. The blue squares on the left are symbols for different hours of the day and atmospheric conditions. The colour of the light is graded on the kelvin scale which gives highest numbers for blue-rich light and lowest for red-rich lighting. Electronic flash and (blue) flashbulbs, although artificial, are made to have a colour temperature suitable for daylight type film. This is why they appear on the line marked 6000 K. Lower down the Artificial Light column you find various types of lamps and the films matched to them—with the exception of the ordinary household lamp, which has no equivalent film.

The column on the far right contains a number of film/filter combinations. They are by no means the only ones, but have been included to show how to deal with deviations from the 6000 kelvin balance of daylight film. More information about this table appears on the following pages.

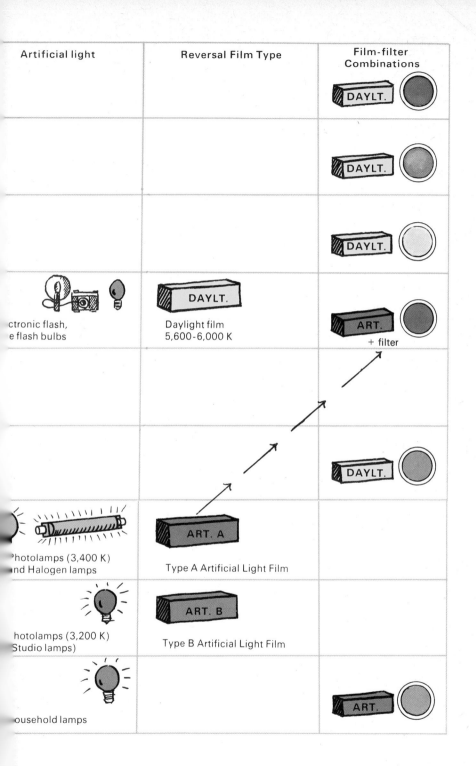

Artificial light	Reversal Film Type	Film-filter Combinations
		DAYLT.
		DAYLT.
		DAYLT.
ctronic flash, e flash bulbs	Daylight film 5,600-6,000 K [DAYLT.]	ART. + filter
		DAYLT.
Photolamps (3,400 K) and Halogen lamps	Type A Artificial Light Film [ART. A]	
hotolamps (3,200 K) Studio lamps)	Type B Artificial Light Film [ART. B]	
ousehold lamps		ART.

121

has acquired a warm brown tone. (The water in the fountain was lit by a green floodlight.)

A comparison of the pictures shows how differently the daylight type film reproduces the 'cold' daylight and the 'warm' electric lighting. Yet our eyes accept both daylight and artificial light (seen separately) as 'white'. This is a good example of how the human eye can adapt to the prevailing colour whereas the colour film cannot.

Both pictures were shot on Kodachrome II film. Exposure for the right hand picture was 8 secs at f5·6, based on an incident light meter reading taken at the fountain and directed towards the floodlight. Combined artificial lighting and daylight film technique is also discussed on page 124.

Light, Films and Filters

Closest matching of light source and colour balance of film occurs with artificial lighting and artificial light film. In the kelvins column at 3400 K you find a photolamp (3400 K)—the brilliant, short life lamps often used for amateur movies—together with their modern substitutes, tungsten halogen lamps. The film type balanced to give correct colour reproduction with these 3400 K sources is known as type A. artificial light type film.

Below this and opposite you find the longer lasting Tungsten lamp (3200 K). This sort of lamp was designed for professional studios, and is intended for use with type B film. Such films may also be sold in 120 rollfilm and 35 mm sizes.

What is Daylight?

Although light sources and film types marry up quite neatly for artificial light photography, you will not find the same correlation between daylight film and the daylight with which it should be used. The sun and sky deliver lighting which we know changes throughout the day and the year. In terms of colour temperature, 'daylight' varies from 13 000 K (for clear blue sky) to between 3800 and 5000 K for the orange sunlight at sunrise or sunset. See page 39.

As it is impractical for anyone to go around with different rolls of daylight film for different times of the day, manufacturers compromise by designing their daylight film to suit 5600 K–6500 K. This is shown bracketed together in our table.

Remember that, as a rule, daylight type film will give good results with electronic flash and blue flash bulbs. (A pink filter may be helpful with some types of electronic flash to avoid a bluish cast on certain films but only buy such a filter if tests show it to be necessary.)

The column dealing with filters starts at the top with a series of pink filters of various intensity. These are used to reduce the blue content of daylight between 6500 K and 13 000 K. These filters are further discussed on page 170. Notice how versatile type A film can be when a filter is also available. It can be used (1) without a filter with photo lamps (3400 K

tungsten halogen lamps; or (2) with an orange filter for shooting in daylight. This is a very practical arrangement for amateur movie makers, or still photography when a mixed lot of daylight and artificial light subjects may be shot on the same roll of film. (See page 128.)

The two blue filters in the table are used either to allow daylight film to be used in artificial light, or reduce the ruddy cast of daylight at sunrise or sunset.

Tungsten Halogen Lamps

In recent years photolamps (3400 K) have had to face competition from photographic halogen lamps, made to operate at 3400 K. (There are many other halogen lamps, such as modern car headlamps, which give different colour temperatures.)

Halogen lamps are particularly popular for filming home movies, because of their high light output. Large professional studios use banks of these lights. Groups of studio powerful electronic flash units are also used extensively for studio colour photography, on daylight type film.

While the light from most tungsten lamps gradually grows more red the older they become, tungsten halogen lamps maintain the same colour temperature throughout their working life.

There are no colour films balanced for ordinary household lamps, which function at around 2800 K. Either you must accept the warm colour cast the way it comes out (even on type B film) or correct it with a blue filter over the camera lens.

Paraffin lamps and candles have the very low colour temperature of 1800/1900 K, see the example on page 124.

Fluorescent Tubes

This is another range of light sources with colour temperatures quoted by their manufacturers within the range 3000–7000 K. However, beware. These tubes may not produce a complete spectrum as with natural lighting or tungsten lamps, and peculiar results may be produced even when using a colour film suited to its apparent colour temperature. A test made on a few spare frames of the type of film you intend to use is therefore advisable. Remember, however, that apparently similar types of tubes may give quite different photographic results. 'Warm' fluorescent tubes when present in conjunction with daylight (as in many offices) cause fewer problems than just tubes alone.

An Ordinary 60 watt Lamp

The light source in the top picture overleaf is an electric lamp which looks like a paraffin lantern. Everything has the orange cast characteristic of a 60 watt lamp (2800 K) shot on daylight film. Only the very over-exposed parts of the light itself appear white. The picture, however, conveys the atmosphere of this old cottage in Lilla Frö in Sweden rather better than a record on artificial light film would have done,

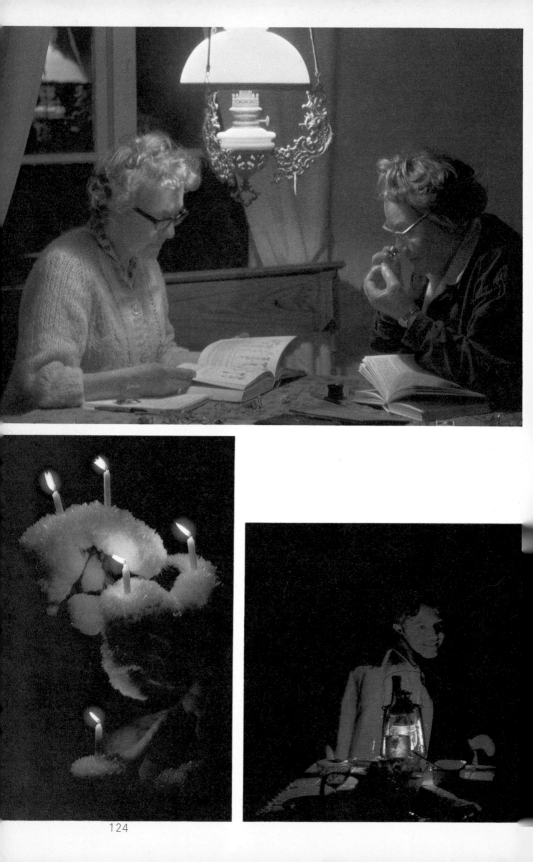

although it would have reproduced the white parts of the scene much more nearly white. Exposure was ½ sec at f2·8 on Kodachrome II.

A Paraffin Lantern Outdoors

Light from a paraffin lantern is always very red, particularly from the types which do not have a pressure system. The girl below wore a red plastic coat, but neither her face nor the tablecloth looked anything like the strong red colour shown here. The picture was shot outdoors at night, the flame from the lamp being carefully screened by the label of the wine bottle nearer the camera. Three seconds at f2·8. A long exposure like this is only possible with the camera on a tripod and a model who does not blink too often.

Photographing by Candlelight

Candlelight also has a very warm tone. The shot on the left was taken one winters evening when there was almost no wind, and the snow was so deep that candles could be supported even on the branches of a tree.

The top picture on this page is a still life shot in a draught-free room. Even the photographer had to move carefully to prevent the flame from flickering. Type A material was used, thus having a colour balance slightly closer to the 1800 K colour temperature of the candle than daylight film (5600–6000 K). Exposure chosen for the shot lit by the candle only was 1 sec at f2·8–4. The reflected light meter suggested f5·6, but since measurement was made from the yellow area this would have underexposed the darker decorations and painted beechnuts.

The bottom picture was lit also by 500 watt 3400 K lamp in a reflector which was 'bounced' off a low white ceiling. An incident light meter (page 178) was pointed towards the ceiling and gave a reading of ⅓ sec at f5·6–8 on Kodachrome II type A film. Reflected from such a wide area the photolamp lighting is even and shadow free; it also greatly helps to reduce the red cast produced by the candlelight. Which lighting effect do you prefer? Your choice really depends upon the purpose of the picture.

When Flash is Better than Daylight

The pictures overleaf showing a saint and a reddish limestone pillar were taken in the Brahe church on the island Visingsö. Weak daylight from a blue sky came through a window on the right. As you can see, one entire picture has a 'cold' cast, showing that the light was too blue even for daylight type film. Exposure, 1 sec at f2·8.

The other shot was taken using electronic flash connected by a long cord to the camera, see page 133. This flash was directed towards the front of the figure so that from the camera position the lighting clearly revealed the folds in the cloak. Had the flash been attached to the camera instead the figure would have looked shadowless and flat.

There are three main areas to this picture. On the

125

extreme left is the obliquely lit pillar, showing all the marks of the stonemason's chisel; in the middle, the front of the pillar and the madonna is strongly lit; and finally we have the strip of underexposed room which the flash could not reach. Suppressing room detai was, in fact, an advantage here.

Red and Green Snow
Everyone knows that snow is white, but in the left-hand picture it appears both red and green. This is because the lighting was a mixture of sodium and mercury vapour lamps. Colour films cannot accurately reproduce scenes lit by light sources such as these which do not deliver a full spectrum of colours. Sodium lamps produce little more than a narrow band of yellow light, which comes out red on daylight (and artificial light) colour films. The picture was taken under misty conditions which spread the sodium light into a red veil over the Älvsborg bridge in Gothenburg. At the same time the mercury vapour illumination from the street lamps looked blue-green (almost white close up) and reproduced a strong green on film. Mercury vapour lighting is particularly useless for portraiture unless you want to make horror pictures.

As for exposure, a reflected light meter reading was taken off the white (green!) snow and the indicated 1 sec at f2·8 hopefully set on the camera. Fortu nately it happened to be about right. (Kodachrome I daylight.)

The difference between the colours seen and those recorded on the film is similar to that obtained with fluorescent tubes as noted on page 123. Whenever you are to use an unknown type of light source, test shooting is the only safe way.

Camp Fires

A camp fire outdoors at night seems to produce a great deal of light—because your eyes are adapted for the darkness—but it is not really a practical source for photography unless you just want to see flames and glow. A little help from flash makes all the difference. Position the flash so that the lighting on the people seems to be coming from the fire itself, and use the lens aperture indicated by the normal guide number, page 194.

One way of making flash assisted camp fire shots is for one person to sit facing the fire with his back to the camera, holding the flash gun at ground level pointing

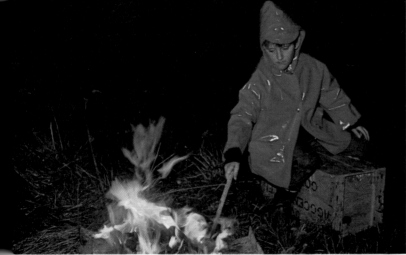

directly through the flames. This gives an illusion of 'fire light'; the person holding the flash, of course, appears as a silhouette.

Sometimes a large bonfire or camp fire has flames sufficiently high to allow an exposure of 1/500 sec— short enough to freeze flame movements the eye would not normally follow. Longer exposures of 1/10th or 1/25th sec show the movement of the flames and portray their roaring power.

One Film—Inside and Outside

A photographer shooting colour transparencies can still use his daylight film indoors by using flashbulbs. This is not possible when making colour movies, because there is no photolamp which gives the daylight colour temperature needed. A flashbulb is of course no use for filming because a long-burning light source is required. The film maker solves his problem by putting type A artificial light (3400 K) film in his camera, which suits the artificial lights. When he goes outside he continues with the same film but places an orange filter over the camera lens. This cuts down much of the blue present in daylight, making it equivalent to photoflood illumination.

For the first picture, an artificial light colour transparency film was used in daylight without a filter. The picture is very blue as you would expect. The second picture, using also the recommended orange filter shows how normal daylight pictures can be taken.

The movie maker therefore only needs one type of colour film too, providing he remembers to put on or take off a filter as required. (He might have it built into the camera.) You might wonder why he does not use daylight film all the time instead, and filter it blue when working in artificial light. The argument against this is the strong blue filter needed lowers the effective speed of the film by nearly two stops (e.g. 25 ASA to 8 ASA). An orange filter lowers the speed of artificial light film by under one stop (e.g. 40 ASA to 25 ASA) which is much more practical.

Light 'Peters-Out' in the Dark

When we look out over a landscape on a clear day we find that objects in the foreground and in the far distance have the same lighting. But if we walk out in the dark with our own little 'sun'—say a torch—we cannot light up the ground in front of us for more than a few yards. If we direct the torch beam out into the dark, the light seems to be swallowed up into nothing.

Such a comparison may seem rather drastic, but it does illustrate the essential difference between photographing under the light of the sun and by artificial light. With lamps or flash we carry the source around with us and can direct it as we please, but have to accept the fact that the strength of illumination falls off at an alarming rate.

On page 127 you saw a picture of a boy roasting sausages outdoors over an open fire. The picture confirms what we have just said—namely that artificial lighting diminishes rapidly with distance. The scenery behind him is lost in darkness, and even the use of a larger aperture would only have shown an extra yard or so of field.

For the picture of an open air dance floor on Brännö, Sweden, the lens aperture was set to correctly expose the nearest couple. As a result, dancers further away are only seen because of their light coloured clothing—their heads almost merge into the darkness. Other couples still further in the background are not recorded at all.

Rapid fall off in illumination is always most apparent out of doors at night. Indoors the situation is less critical because walls, ceiling etc all help to reflect some light back towards the subject. Guide numbers for flash are all calculated for 'normal subjects in normal rooms'. However, in bathrooms and other small light toned rooms reflecting surfaces are so close that the situation can no longer be called 'normal'. A smaller aperture is needed—but just how much will have to be based on experience.

At the top of this page we said that everything out of doors in daylight has about the same strength of lighting, independent of distance from the camera. Why then doesn't daylight follow the same fall-off, rule? Well it does of course, but since the sun is millions of miles from the earth, the fact that some parts of a scene may be a few hundred yards nearer to it than others has an insignificant effect.

Light Loss and Exposure

The further a subject is from a light source, the more evenly light reaches the subject. Variations in lighting intensity become very much more apparent when, for example you are shooting from only 2–3 yards away with flash on the camera.

Imagine that you are showing slides with a projector in a smoky room. You can therefore see the light beam—very intense near the projector lens but growing progressively broader on its way across the room (both vertically and horizontally). It looks rather like a square funnel. If you can imagine the projector lamp emitting a certain number of light particles every second, then in the narrow part of the 'funnel' particles are densely packed, spreading out to quite a sparse distribution on the screen. Strength of lighting per square foot rapidly becomes less.

If the slide projected on a screen $3\frac{1}{2}$ ft away is $3\frac{1}{2}$ ft \times $3\frac{1}{2}$ ft ($12\frac{1}{4}$ sq ft), then at 7 ft distance the picture area grows to 7 ft \times 7 ft or 49 sq ft. In this case the 'light particles' will have thinned so much that intensity per square foot is only 25% of the previous level. This is a practical example of the 'inverse square law' you may remember from school days. At 15 ft illumination is only 6% . . . and so on.

Let us imagine the luminous intensity at 3 ft to be 100 units, and then work out intensity per square foot at distances of, say, 5, 7, 10, 15, 20 and 28 ft. The table below shows these light intensities, and you can see how rapidly they decline with distance. The *f* number column shows how much wider the lens aperture must be set to give the same exposure level—in this case to suit a guide number of 56.

Dist.	Sq.-feet	Light pr. sq.-foot	Apert.	Feet × dist.
$3\frac{1}{2}$	$12\frac{1}{2}$	100	16	56
5	25	50	11	56
7	49 (50)	25	8	56
10	100	11	5, 6	56
15	225 (200)	6	4	60
20	400	4	2, 8	56
28	784 (800)	3	2	56

Luminous intensity reduces most rapidly during the first few feet. For example the table shows that a change of only $3\frac{1}{2}$ ft (i.e. from $3\frac{1}{2}$ ft to 7 ft) calls for two stops wider aperture (from *f*16 to *f*8). But when you reach 15 or 20 ft the loss each foot or so is very slight. There is only one stop difference between 15 and 20 ft, for example.

Minimising Light Loss

These pictures were taken at a maternity hospital in Gothenburg. New born babies are shown behind pane of glass, in front of which stand mothers and visiting relatives. In the shot of the smaller group, light intensity reduces so quickly with distance that the second nurse is hardly visible, despite being dressed in white like her colleague. But the larger group

photographed and lit from a greater distance, is more evenly illuminated—helped by the fact that everyone is about the same distance from the camera. Had we included a couple of people in the immediate foreground they would have been very overexposed and 'burnt out'. However the first few feet in front of the flash contained only air, which does not reflect light, if it is clean.

Both shots were taken with the camera slightly oblique to the glass screen. Flash directed at right angles to the glass would be reflected into the lens, giving an effect like the reflection in the window on page 71. It was also important to make the most of the VIPs—the newly born—and not have them hidden behind a wall of visitors, as they would be in a shot from eyelevel. The photographer therefore organized a couple of chairs to stand on before he took this picture.

Of course flash burns for such a short time that we cannot observe how illumination reduces with distance. (Candlelight is more obvious—we have all at sometime had to move closer to a candle in order to read a book etc.) Many beginners learn the hard way, after seeing the results of their first flash pictures.

Photographic dealers are constantly asked why the wallpaper in a room has come out so dark and changed colour, when the person standing some feet in front of it is correctly recorded. Of course black and white photography also gives a dark area behind flash shots of people, but somehow this does not seem to show so much as in a colour shot, which shows up background colour changes too.

Directing the Lighting

In an earlier chapter, we looked at the direction and influence of lighting on outdoor subject matter. What was said then in most cases applies to artificial lighting too. The main difference is that you can decide for yourself just where to place your lamp or flashgun. The responsibility is entirely your own, and you cannot say 'I'm sorry but lighting conditions were so bad that

Most modern cameras have flash units located very close to the lens, in order to provide a convenient compact unit. (In the days of magnesium powder—something young readers will only know from hearsay—photographers would regard a camera with built in flash as a utopian dream. Even the flashbulb had not then been invented.) Modern technology has made flash photography so simple and straight forward, that amateur photography at night is now relatively easy. This also has its dangers. One disadvantage, particularly noticeable in portraiture, is that the nearness of flash to the lens may illuminate the retinas of peoples eyes, making them record like red stop lights. Secondly the lighting is flat and characterless, without any shadows.

'Red eyes' can be avoided by changing the angle between flash direction and lens direction. Some cameras allow you to raise the flash on a 'stick' which

puts the flash several inches above the lens. More radically (if your camera allows the use of flash on an extension cord) you can separate flash and camera by several feet, and so solve the problem of shadowless lighting as well.

I'm not suggesting that conventional flash lighting is always wrong. Even the photographer with extension cord equipment uses flat lighting on some occasions. But there is no doubt that much more variety is possible with artificial lighting if you take the same time and trouble with flash as with lighting from the sun.

Flash from the Side

Above is an example of sidelighting from a flashgun on a long extension cord. The subject—a strange creature with an extremely long tongue—is the head of a club held by one of the figures in the naval museum in Karlskrona.

The right hand picture with the blue wall was shot with flash attached to the camera. You can still see the texture of his face, but this is not as apparent as in the first picture where the flash-head was six feet or so to the right of the camera. Side lighting gives stronger

133

shadows which help to convey form. The pupils of the eyes appear clearly and we can see deep into his throat. Also the nose has become thicker.

Side lighting has also prevented the near wall from receiving much light and so this has come out black. Part of a notice, other parts of the figure head and the entire skirting board have disappeared into the dark.

Skirting boards are a continual nuisance in indoor photography. If you let a child play close to the wall a skirting board often cuts the picture in half in an annoying way. One solution is to put all the toys into the middle of the room, so that skirting is far enough away not to intrude. If the room is rather small, you may have to shoot through the doorway from an adjoining room. Alternatively you can use a high camera angle, but be careful that the child's face is not then hidden by her hair.

Professionals manage to avoid showing skirting boards by using a wide roll of paper hanging down one wall of the studio from ceiling height. Enough paper is unrolled to cover the wall and a good deal of the floor right up to the camera. This gives a gentle concave bend where wall meets floor, and no join can be seen. With some subjects—still lifes for example—you can make similar arrangements at home, using a large sheet of gently curved cardboard.

'Red Eyes' in Portraits

If you use flash positioned very close to the camera lens, its effect is rather similar to a miners helmet lamp or the sort of lamp used by an optician when examining a patient's eye. Because light beam and camera lens axes are so close to parallel, the resulting photograph sometimes shows the pupils of a sitter's eyes as red instead of black. As we said earlier we are in fact recording the surface of the retina at the back of the

eye. This effect is worst in poorly lit rooms, because people (and animals) then have their pupils wide open.

The best way to approach the problem is to avoid illuminating the same inner part of the eye as is seen by the camera lens. This means removing the flash from the camera and fitting it with an extension lead to reach the shutter. Most electronic flash manufacturers and some camera firms sell cables of this kind, some several yards long. Make sure the cable you buy has connectors to suit your equipment. (An extension cable also opens up a lot of other possibilities, see pages 137–145.) However, make sure you don't accidentally shoot with the cable draped in front of the lens.

The right hand picture was shot with the flash raised above the lens. You can see from the shadows under the boy's hands that it was only raised slightly, but this was enough to prevent the 'red eyes' effect.

Successful Wrong Methods
Using the wrong technique can sometimes give interesting and successful results—even if they are not quite what we expected. The effectiveness of the picture of siamese cats curled up together in the chair

is largely due to their eyes, which are shining like lighthouses. You often see the same effect when your car headlamps reflect from the eyes of an animal standing in the road ahead. Another point about this picture is that having the two cats huddled up so close to each other makes them begin to look like one animal, with two heads and two tails.

Adam and Eve in Paradise
The avoidance of flat lighting (i.e. lighting from the front) is certainly valid in black and white photography. Shadows help to enliven many pictures which would otherwise be grey and uninteresting. In colour photography, however, you often come across subjects which have sufficient variety and contrasts in the colours alone to form interesting pictures, without modelling by lighting too. In some cases the existence of shadows is positively confusing.

In this picture of detail from an altar-piece in Rolfstorp Church, Halland in Sweden, the relief figures of Adam and Eve have a shadow edge to the right hand side of all their outlines. It reveals that the flash was positioned just to the left of the camera lens.

When convex and other curved surfaces are lit by flat lighting they often come out unevenly illuminated. The protruding parts facing the camera reflect most o

their light back towards the camera lens, but parts sloping in other directions send the illumination reflecting off away from the camera and so look dark. (You can see this effect on the guilded parts of the relief, for example.) Curved surfaces have to be considered as a mass of small mirrors set at different angles, like a reflective ball used in a dance hall. Unevenness is most apparent in correctly exposed transparencies— overexposure, for example, bleaches out such subtleties. Remember too what we said about reflections from snow surfaces on page 58.

'Torchlight' by Flash

One summer night this little girl awoke to hear the noise of a party out on the veranda. She got out of bed and came out to see the flaming torches which illuminated the house. Her amazement was a delight to see. A flash unit on a very long cable was positioned near the torch which particularly attracted the little girl's attention. Torch and flash were very low down and so lit the girl and her mother from below. Coming too from a position almost at right angles to the camera this lighting makes the roundness of their faces quite pronounced.

Without flash it would have been impractical to shoot this picture, because of the weak illumination provided by the torches. Their light was also very red,

137

similar to an open fire (page 127). The aperture chosen was of course based on the distance between the flash head and the subjects, divided into the guide number for the flash.

Use your Assistant

One of the secrets of successful flash photography is to have a helpful assistant. Part of his job is to direct the cable-connected flash while the photographer is actually framing up and shooting the picture. His other role is to gain the sitter's attention, especially when photographing children and animals. Adults tend to get self conscious and stiff in front of a camera, and find it more relaxing to talk to someone who is not staring at them through the viewfinder of a camera.

In this picture the assistant not only engaged the man's attention, but held the light so that those marvellous laughter wrinkles are emphasised. Of course it helps to have an assistant who knows something about photography, so that he and the camera-man don't have to discuss the lighting too much in front of the model.

When co-operating in this way the assistant should keep the flash head at an agreed distance from the subject all the time. The photographer can therefore move in or move back with the camera knowing the lens aperture remains the same. (Remember that flash-to-subject distance determines f number. See page 196.)

Fill-in Flash

If a room receives most of its lighting from a window
at one end, you will probably have to introduce some
flash or flood lighting into its darker end. This is one
such case. Boatbuilder Niklas of Torshavn has a long
narrow workshop which without supplementary
lighting would photograph with a very dark fore-
ground. A cable connected flash was therefore used
to help balance up the light from the windows. The
flash was directed from a position on the left of the
camera, pointing towards the nearest part of the boat.
Only the shadow of the stem on the wall gives away
the presence of flash (and the part of the picture
could easily be masked off). However, as shadow
shape typifies the shape of a Faroe-type boat such as
this, the shadow was left in as essential detail.

When you mix light sources—such as daylight and
flash—the main problem is to establish a balance
between the two. Usually in pictures which include
daylight, you want to try and preserve the daylight
effect. If you are a methodical photographer you may
evaluate the two sources as described on page 200.

You also have to consider the effect of the camera's
shutter—whether it is a focal plane or diaphragm
type. The calculation can be a bit long winded, but it
is interesting to have tried it once. Sometimes it is the
only way to provide a solution to a particular photo-
graphic problem.

Daylight and Flash

Even when shooting under daylight, flash can be useful to lighten shaded areas. This picture was taken at dusk, when there was a risk that the lighting was insufficient to record facial expressions in a fast moving situation. A flash unit was attached to the camera, because from any other position shadows would have

given away its use.

The picture shows a raconteur entertaining guests at a party. Fortunately the photographer knew the punch lines of his stories and was ready to shoot as these points were reached. Without this knowledge it would be easy to be caught calculating flash distance and *f* number just as the situation reached a climax. Balancing of daylight and flash is discussed on page 200.

Mirror and Flash

The flash lighting in this picture comes from the right. It reflects from mother's toilet mirror and lights up the girl's face. We want this to be correctly exposed. Therefore when calculating *f* number from the flash guide number (page 194) we must remember that the total distance the light travels is flash-to-mirror-to-girl.

However, her 'real' figure is somewhat nearer the flash—so that her neck must receive more exposure

than her image in the mirror. This anticipated over-exposure could be prevented by placing a dark shawl around her shoulders and neck.

When working out the depth of field needed for a picture of this kind a reflex camera will show you the furthest limit required when the girl's mirror image is sharp. The near limit will be her real figure. With other cameras you will have to estimate these two distances and set the lens focus accordingly—see page 187. If the flash unit is not powerful enough to allow a small enough stop for this depth of field, then it will be better to sacrifice the 'real' image of the girl in order to keep the reflection sharp.

Bounce Light

The top picture overleaf is lit by direct flash, shown by the shadow on the wall. But in shooting the picture below the same flash was directed towards the ceiling between the girl and the flash head. The light was therefore reflected or 'bounced' down towards her.

The important change here is that light now reached the girl from a large area of ceiling rather than from a small compact source. The illumination is soft and almost shadow-free, and of course directed from above. (Avoid bouncing light off the part of the ceiling directly above the model as vertically reflected illumination may then leave deep shadows around eyes and chin.)

Not surprisingly, the longer route taken by the flash lighting—flash/ceiling/model—and the reflecting and scattering of the illumination always results in less light reaching the subject than when used direct. In this picture the lens aperture had to be opened by two and a half stops compared to the direct lighting shot, i.e. from f8 to f2·8–f4. Flash bounced in light toned bathrooms and other small rooms will not call for quite so much change of aperture. Remember that flash can often be bounced from a wall, even the wall behind the photographer.

Shooting in colour you have to be careful not to
bounce light from ceilings and walls unless these are
absolutely white. Off-white surfaces give a yellowish
cast to transparencies, and dirty ceilings give weaker

reflection of light. It is therefore sensible to make a few test exposures on the last frames of a film. Make a note of exposure and flash distance. If you are using floods the differences between direct and reflected light can of course be measured with an exposure meter.

Camera Height and Lighting Direction

The lighting of still-life is also important. This Christmas table was photographed with a wide angle lens on a 35 mm camera. The shot taken from the higher viewpoint shows strong reduction of size with distance (see page 12). The nearest corner of the table is so 'pulled' that it seems to be falling towards the camera.

In the picture taken from a lower viewpoint the distortion is not so obvious. Actually a camera with a wide angle lens should be used horizontally if vertical lines are not to converge. This problem becomes most acute when you photograph interiors or exteriors of houses or other subjects with strong vertical lines. In nature, with its less formal shapes, you can often get away with some distortion.

Vertical lines distort most markedly near the edges of wide angle pictures. If possible you should therefore position important verticals near the middle of the picture—if necessary trimming some of the sides. This is what was done here. Both pictures were originally horizontal format 24 × 36 mm shots.

The lighting in the first picture was flash on the camera, making all the table contents shadow-free and flat. In the second shot a flash on an extension cable was positioned well to the left at an angle of about 90° to the direction of photography. Shadows therefore all fall towards the right. Thanks to this oblique lighting every item on the table forms a shadow, emphasizing shape far better than with the flat lighting.

143

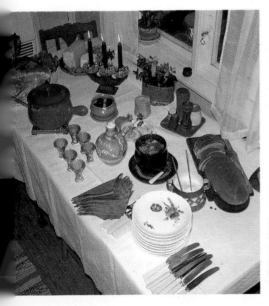

In comparing these two photographs you can also see what a difference camera height makes to a picture. Seen from above items seen all spread out; from a lower viewpoint they overlap and form a more unified composition.

Paper-bag 'Spotlight'

If you restrict the spread of illumination emitted by a light source you can produce an effect similar to a spotlight. This is what I did for the shot of the seated girl on the next page. It was all arranged as simply as possible.

An electronic flash head, connected by cable to the camera, was pushed through the bottom of an ordinary paper bag. This formed a 'light funnel' which could be directed at the sitter. The resulting transparency shows the girl well separated from the shaded wall by her light clothes. At the same time direct light coming through the mouth of the paper-bag 'spot' gives texture to her knitted sweater.

One of the problems of artificial light portraiture is positioning the sitter's shadow. The usual recommendation is to keep the model far enough forward of any background surface for her shadow to form somewhere on the floor if the lighting is sufficiently high, or outside the picture as with oblique lighting.

In this case sidelighting throws the model's shadow onto the wall, but fortunately this is so much to one side of her it could be easily masked off.

Shadowless Lighting

Shadowless 'multi-directed' lighting, can be produced by a piece of equipment known as a 'ring-flash'. This is an electronic flash tube bent into a ring which clips around the camera lens. A ring flash will give shadowless lighting when used for close-ups. At longer distances it works just like any other flash unit mounted on the camera.

The thistle in this shot was about 10 in from the lens and flash. As the ring flash diameter was only 4 in, light came from all directions around the lens, cancelling out any shadows. The background was a piece of cardboard, held behind the growing plant at the moment of shooting.

Exposure was 30/22 using a Minicam ring-flash. Using this flash for extreme close-ups calls for a neutral grey filter over the lens to prevent overexposure.

Another way of creating shadowless lighting is by hanging a clean white sheet of thin fine-meshed tissue between flash and subject. Don't place the flash too near the tissue—about 12 inches is a good distance. The diffuser spreads the illumination into a large patch of light, serving the same function as a cloud veiling the sun, and softening the shadows. This is a great asset when photographing middle aged or elderly people with wrinkled faces. Make tests to find out how much wider the aperture must be set when using your diffuser. Reflected light is also discussed on page 98.

Photography at Night

'Framing' at Night
One of the attractions of night pictures is the way that the lightest parts—in this case the three staircases—loom out of the darkness and form a frame. The exposure time was calculated from measuring the inside of the staircases. Lighting in the yard was too weak to register during the short exposure needed for the stairs.

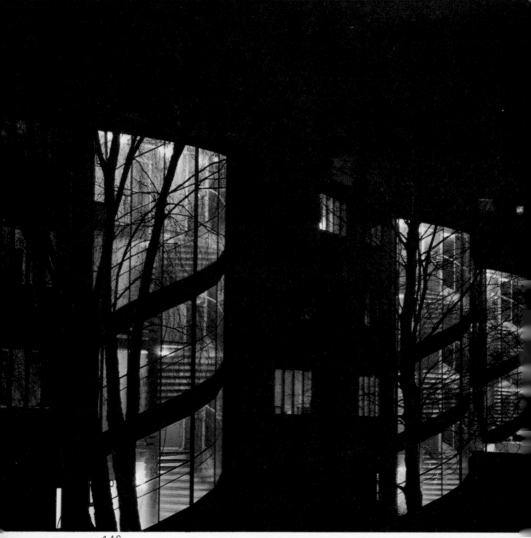

The yellow-green lighting was produced by fluorescent tubes on daylight type film; as explained on page 123, it is difficult to predict the exact colour which will be produced on the film. The striped reddish squares are the windows of rooms lit by ordinary household lamps. Biskopsgården, Gothenburg.

Which type of Film?
Choice of colour film for night photography is really a matter of taste. These two pictures of a window photographed from the street were taken on two different types of film. The 'red' or warmer picture was shot on daylight film; the other on type A film intended for photolamps. (See the table on page 120.)

Even the artificial light film will not reproduce the lamps as white unless they are over-exposed. Notice how snow is portrayed a cold blue on the artificial light film and orange on the daylight type.

Street Scenes

A news-stand is a good place for practising situation photography at night. Take a close-up reading with your meter (for this shot it read 1 sec at *f*8 for Kodachrome II). People often stand still briefly when shopping at the counter. Others in front and behind may continue moving and so become blurred, but this contributes to the feeling of reality. Lines of light in front of the stand are created by a passing tram during the one second exposure. Red lines come from a sign on the roof and at one side, and the white light from a headlamp. The brown stripe is again from the tram. Details of the stand, which have been exposed by its

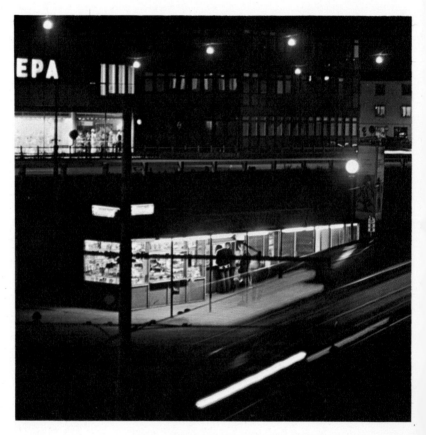

own light show through the red light from the tram.

Night pictures often produce light 'snakes' from passing cars, which collectively give an impression of busy traffic. Even when a street is almost empty these streaks can be 'collected' onto the film during several seconds exposure. Much the same applies to fireworks, page 151. Of all the street lighting, neon signs are usually the strongest and tend to dominate others. In misty conditions 'burnt out' halos form around them.

Experiment with pictures taken at night on odd frames of daylight type film and make a note of exposures and lighting so that you have data to follow in the future.

Abstract Light Shapes

This picture of Gothenburg container dock was taken to show the effect of reflections in water at night. It was windy at the time, and this probably shook the tripod. As a result we have these light 'hooks' which you can see most clearly on the aft superstructure. Some photographers deliberately move their camera when shooting night scenes containing light-sources, preferably following a pattern. But remember that if you overdo this technique the result may just be a confusing jumble.

Beginners in night photography tend to search around for as many lamps and neon signs as they can

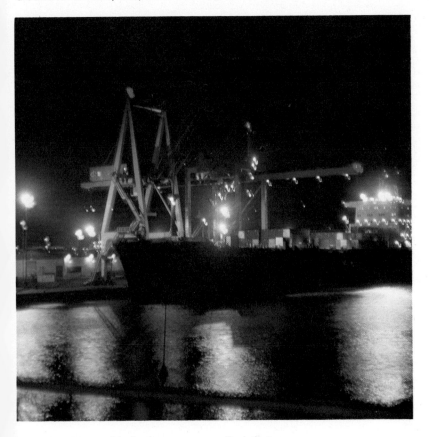

find. But the trouble is that you soon find that you have too many points and streaks which do not create interesting patterns. You have to learn to restrain yourself—to get lines and colours under some control. Of course if you are taking night shots in black and white you have the opportunity to 'spot in' superfluous white areas on the print with water colour or ink, but this is much more difficult on colour transparencies.

Some of the best night pictures are those of subjects which are outlined in points of light—in other words a helping hand has already formed a pattern for you. The picture of Älvsborg bridge in Gothenburg shows the suspension wires, illuminated by rows of

ordinary light bulbs, arching high above the sodium road lighting. The bridge has towers at the high points of the arches, but these are not lit strongly enough to show in the picture. (10/3·5 on Kodachrome daylight film.)

Fireworks

The most important requirement for good pictures is to ensure that you can see the firework through the viewfinder during the entire exposure period. A single lens reflex creates difficulties here because its viewfinder is sealed off immediately exposure begins. Try using a direct vision camera instead, or a camera with an open frame viewfinder.

You fasten the camera to a tripod—preferably one with a ball and socket joint. Don't lock the joint too hard because you may have to move the camera around slightly before you find the area of sky in which most of the rockets etc explode. Lens distance is set on infinity, the shutter on 'B', and the aperture kept fairly large. These pictures were shot on Kodachrome II daylight film (25 ASA) using f4·5. A faster film of course would allow you to use a smaller aperture.

When taking pictures of fireworks such as this flower-like piece, or some 'set pieces' you should remember to close the shutter before the spray of light spreads out too far and is lost beyond the picture area. Try to be far enough away to record the fully extended pattern of fire, bearing in mind that some fireworks, such as exploding rockets, spread over a very large area of the sky. If you have a choice, use a wide-angle lens to help you cover the area you need.

Slide shows are sometimes more interesting when

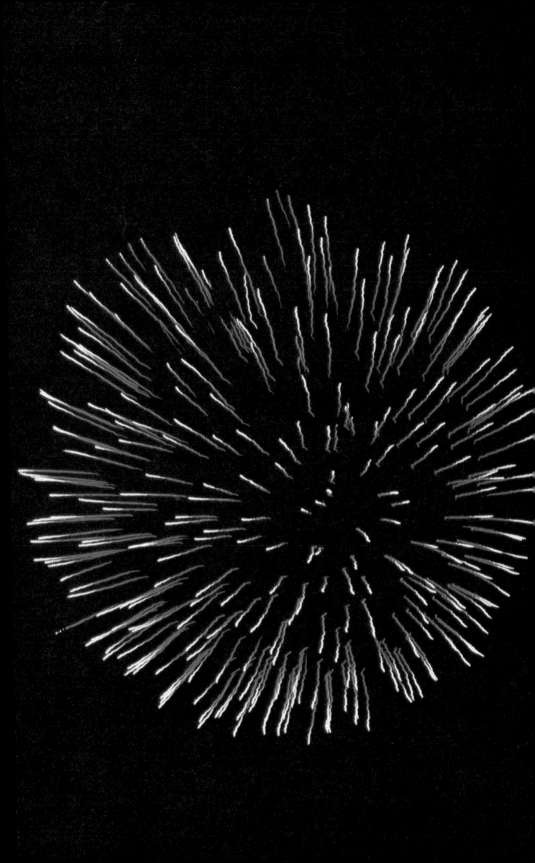

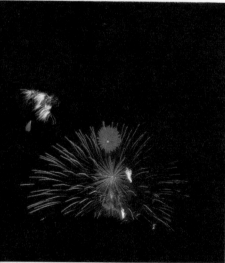

an 'off beat' image is slipped in to show a visual parallel. If we include this picture of angelica in with the fireworks the relationship between fireworks and opening flowers is emphasised. Making your real and pyrotechnic 'flowers' the same size also helps the comparison.

Multi-fireworks

You will have to use some restraint when several rockets are bursting in the sky at the same time. Stop the exposure before the criss-crossing lines become too confusing. Similarly, exposing several images of rocket bursts on top of each other fills the sky with more action than the eye saw at the time, but often the effects kill each other. The picture of the fireworks of different colours is the result of a two second exposure. During this time a number of fireworks exploded.

Whenever possible stand on the windward side of the firework display, otherwise smoke from the first fireworks may hide most of the performance. Also be prepared to shoot lots of pictures. Fire-work photography is largely hit-or-miss because you seldom know in what order the rockets etc are to be sent up, or exactly where they will explode. Wait for large static displays to build up to a climax and shoot them with a fairly short shutter speed.

Moonlight

A night sky containing the moon may need exposing for less than half a minute, but landscapes lit by the moon require very long exposures indeed. This shot was an attempt to record a moon-lit snow land-

scape. It was exposed on Kodachrome type A film, which is made for sources such as 3400 K photolamps. The reasoning here was that the film should capture what we romantically call the 'blue' of moonlight. In fact the moon-lit landscape came out looking violet, and only when you have stared at it for several seconds projected on the screen can your eye interpret the main tone as white and therefore perceive some of the 'moonlight blue'.

The atmosphere of night is emphasised by the warm light from the house included in the picture. If the house lights are rather strong you may be able to arrange for them to be switched on for only part of your exposure. In this shot only the lamps on the other side of the house (not the ones just inside the windows) were left on throughout the six minute exposure. This gave strong enough lighting for the snow surface outside the back window. By the way, you may, have noticed a blurred figure in the doorway. This was someone going out, quite unaware that the photograph was being taken.

Reflections in Water
The blue moonlight picture on the next page was taken at dusk. The right hand picture was shot at night. Lights from the houses show us that the dusk picture was taken when it was relatively dark, but exposing for 20 sec at f2·8 on Kodachrome II daylight film has reproduced the sky quite light. The night picture with clouds was exposed in the same way.

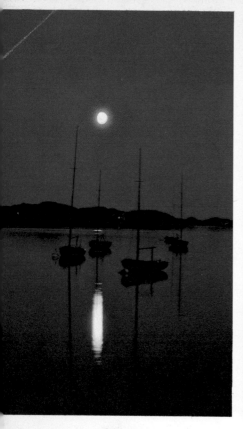

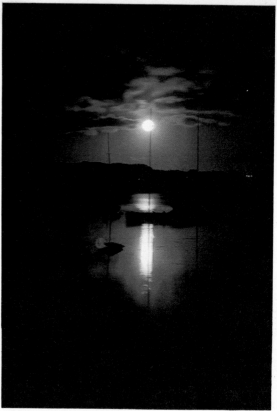

At moonrise and moonset in damp night air the moonlight becomes rather red. But at dusk this is masked by the blue skylight. Both pictures were shot with a 90 mm lens to make the moon's disc rather bigger than it would be with an ordinary 50 mm lens.

Moonlight shots of boats on water can really only be shot when it is absolutely calm—perhaps between evening and morning breezes. Probably the reason the moon has 'eaten' into the boat's mast is because the boat rolled slightly during exposure. The moon disc itself becomes sufficiently exposed in quite a short time.

Both pictures show a weak 'extra moon' created by reflections within the glasses of the lens itself. The same ghost images can appear when you take pictures of sunsets with a clear sun disc.

Moonlit Townscape

When you take pictures in the street at night, you can use the moon as an extra light source. In this picture of Biskopsgården in Gothenburg daylight film was used to make the moonlight appear a blue–white and the lights in the windows of the houses a warm colour.

Unfortunately the half-completed house on the right is leaning into the picture. This is because conditions required that the camera be tilted, and the photographer did not want it to miss the silhouette

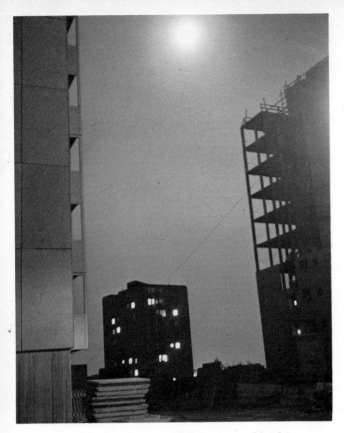

given by the house. 30 secs at *f*3·5 on Ansco 32 ASA.

Stars

The exposure for the picture overleaf of the Great Bear was 20 minutes at *f*2 on Kodachrome II daylight film. Equipment: a camera with B setting shutter, locking cable release, and a tripod. Each star with sufficient illumination draws its line on the film. The larger the aperture, the faster the film (and the brighter the stars) the more intensely the lines will record. Here the lines are broken up like the morse code because the occasional cloud wandered across the sky during the long exposure.

Star photography is most successful during moonless nights and as far as possible from street lights and haze or smoke. This picture was taken one October night in a meadow surrounded by woods and with no houses within sight.

The nearer any star is to the Pole Star (in the Northern Hemisphere) the shorter and more tightly curved its track will be. Exposures of an hour or longer show this very clearly, but the mass of star tracks may become confusing. The constellations of the Bear and Orion (left) were both taken on a 35 mm camera fitted with a standard 50 mm lens. Orion is probably the best constellation, because it contains a number of stars, of different colours which show more clearly on film than they do to the eye.

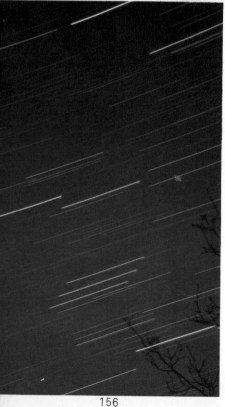

Up in the stars the photographer meets good old colour temperature again. Blue-white stars are as high as 22 000 K or more, the white 10 000 K, yellow white 7000 K and the yellow (including the Sun) around 6000 K which we call 'normal' colour temperature for sunlight. Orange stars are about 4000 K and the red ones 3000 K—in other words little warmer than our paraffin lamps. Orion contains all these types.

The whole sky and its stars appears to rotate clockwise around the Pole Star, so remember to allow for this when photographing one constellation. If it fills the frame too closely, you may find that it has wandered off out of the picture during the exposure !

Travelling

Amateur photographers have their busiest season of the year at holiday time—particularly if this involves touring. You want photographs to revive memories of your summer holiday for the gloomy days of winter, and at the same time the stimulus of strange sur- roundings to produce interesting pictures. It's easy to become 'blind' to your own local environment because everything is so familiar.

I enjoy travelling both privately and as a journalist, but to get the most out of my trips I always try to learn as much as possible about the place I am going to visit, well before I go. Picture books covering the place or country I intend to visit are usually available from the library, and these give a good idea of its photo- graphic potential. There are travel books which have the personal touch, and detailed guide books for routes and distances. If possible, mark on a map places you want to photograph then join up the marks and so plan your journey.

Every journey becomes more interesting if you know from the outset what you want to see on the

Plan your journey so that you don't miss interesting subjects.

way. Too many people don't even bother to read over the suggestions in the better road atlases—I have known photographers pass by a really interesting subject at a distance of half a mile without realising its existence. Even if you do not finally follow all your plans and notes, there are always other subjects you discover by chance, so that the set of photographs is essentially a record of *your* journey.

Another way of arranging your holiday is to have someone organize it for you, in the form of a conducted tour. The trouble is that guided tours are organized to tight schedules, with halts at set times for food and drink. As a photographer, you get the impression that the organizers of the tour did not consider its photographic possibilities. For example, I remember one morning on the road between Malaga and Granada (picture on page 72) we saw the snow on the distant Sierra Nevada beautifully lit by the sun. We pleaded to our guide to stop the coach for a minute or two. 'No,' he said, 'but if we hurry up to Granada you can take that picture when we pass this way again, *this afternoon.*'

Half an hour later we were frustrated again. We were programmed to stop for mid-morning coffee at a certain inn which was hopeless photographically because of its boring surroundings. But five minutes further up the road we saw the most wonderful little town with fantastic tiled roofs. There must have been plenty of places for coffee there too, but presumably the tour organizers had their contacts elsewhere. If only the holiday operators realized, amateur photographs can have almost as much advertising value for the country and firm as the average brochure. Moreover, you tend to believe more in the pictures taken by friends than in the ones put together by advertisers.

Don't always expect to get pictures as good as those by photographers who live in the place—they have more opportunities and can shoot under a wider range of conditions. In the Alps, for example the local man can get fine snow track pictures because he hurries out just after fresh snow has fallen, and may even arrange the most skilful ski instructors to create those tracks which look so seductive in side lighting. Similar organization produces the clouds of powdered snow that spurt into the air in successful ski jump pictures.

Bear in mind that it takes time to work yourself into a new environment. The first day surrounded by new subject matter you shoot indiscriminately, because everything is so strange to your eyes. But after second thoughts you realize that these subjects can be presented in either good or bad ways, and that what you have learnt about lighting and viewpoint can be applied everywhere. Look out for unusual angles. When you go up in a ski lift you can get nice sloping lines into an upright format picture. You also get dramatically steep looking views by including, say, a group of pines in the foreground, photographed from tree-top height.

When there are crowds about, you are less likely to

A collapsible table tripod, here with a long lens and ring flash, is a useful aid.

be noticed if you stand out of the way—close to a wall or a dark porch, or even indoors photographing through a window. If the daylight outside is very strong people seldom notice what is happening in the shadows. Also if you are standing still, you attract less attention than when fussing around with the camera. It may be better to wait for your 'victims' than hunt them down.

Brochures and leaflets from the places you visit are very useful either for movie film or slide show titles, or just to glue in an album along with prints. Collect them with this in mind. Another thing to remember is to bring enough film—plus a little more. Make it all the same brand and batch number too. If you buy odd films in small local shops you have no idea how the film has been stored. In Fuengerola, Spain, I bought a film which was in date according to the packet, but all the pictures had a brownish cast. The picture of the road sweeper on page 115 is an example from this film.

Some countries officially restrict the number of films you can import, but I have never heard of customs officials even enquiring about the number of films carried by a tourist. In fact every tourist-conscious country encourages visitors to take pictures. If you are uncertain, however, do enquire at the embassy of the country you intend visiting.

Take your flash unit if you have one, even if you go to the sunniest country. There are always dark corners and places where the exposure meter will not give you a reading, and you may want to use your camera after dark.

Camera Care
If you have a camera with several accessories, try to put everything into a specially compartmented case when travelling, to avoid having to sort through them

159

every time you use the camera. When you are travelling by car it is a good idea to wrap soft tissue or chamois leather around each item. A specially cut case liner of foam plastic is even better and eliminates the risk of metal scraping against metal when moving the camera case in and out of vehicles. Be especially careful with electronic flash units—protect the head, and put a rubber band around the power-pack to prevent the switch being knocked into the 'on' position. This will stop the flash discharging its accumulators accidentally.

For one trip to Norway I remember I carried my gear in a large diameter metal tube I had made up with threaded screw top and rubber lining. As much as anything this was to keep water out, because I was travelling all the time by canoe.

In boats, cars and trains, avoid travelling with the camera case on the seat. It can easily fall off on sharp turns or sudden stops. The shock of dropping to the floor may not appear to damage the camera, but can knock inner parts out of alignment. A damaged camera can make an otherwise good trip a disappointment. (Sometimes a metal lens hood will help to absorb shocks, which would otherwise damage the lens.)

Sand, salt water, and even damp salty winds are very dangerous for camera equipment. In fact, on windy beaches (particularly if the sand is dry) you should keep the camera in a plastic bag between each shot. (It is only when you look at fine sand through a microscope that you realize what good grinding material it is.) An ordinary camera bag is really no protector against sand. One good way of protecting the lens surface is to keep a UV filter over the lens all the time.

In cold weather, try to keep the camera warm under some thick garment. A very cold shutter sometimes works more slowly, and exposure times are longer than you expect. Some careful photographers include a bag of moisture-absorbing silica-gel crystals in their camera cases. If you use this chemical, include some with a marker dye which is blue when dry but pink when it has absorbed moisture. Once it goes pink it will not keep the air around your equipment dry, and needs to be warmed in an oven at 100° C for 10–20 min (until it is all coloured blue again).

Try to change films in the camera in surroundings which are as dark as possible, never in open sunlight. Remember too that exposed film is just as sensitive to light as a new roll. Sometimes you see people leave the exposed roll in sunshine while anxiously keeping the new roll in shadow.

If you are unlucky enough to break the film in a 35 mm camera while you are out (by trying to use the 37th frame) do not panic. Above all, don't open the camera because this will spoil the last half dozen or so pictures. Try to find a photographic dealer with a darkroom, or perhaps use a cold storage room in a shop—anywhere that is light tight. (Make sure of

Mark each camera or magazine clearly with its film type.

ourse that someone stands outside the door, both to
top other people coming in and to let you out
gain.)

Send exposed films off for processing as soon as
ossible, particularly if you are making a long tour in a
ot climate. On a short holiday, it may be better to
ring the films back with you and thus avoid the risk of
ong delays in postal services.

If you are taking two cameras—perhaps one for
olour and one for black and white—try to have two
f the same type. It is so easy to mix up setting details
n two cameras which differ, especially in fast action
vork. Best of all use two 'system' cameras, i.e.

161

cameras in which lens, body, accessories etc are all interchangeable one to another. Another possibility is to use one camera (such as a Hasselblad) with interchangeable magazines for colour and black and white.

If you have more than one camera, or use different types of films, make a point of clearly marking up what film is in the camera. Stick labels on each camera or magazine, and write in large letters (some cameras have provision for holding a film carton end). Don't assume that you will somehow remember what has been loaded, particularly when the camera has been left on the shelf for some weeks.

Be careful not to leave a loaded camera round in a hot place—in a car for instance. In winter-time, avoid having the camera out of doors one minute and indoors in moist heat the next. This causes condensation of moisture on the cold surfaces of the lens, and it may take ages to disappear. Condensation may also occur on the viewfinder or on the film. Even worse; if you go out into freezing conditions with condensation already on the camera, this can freeze over.

Be sure that all your equipment is marked with your name and address, and a local address as well if possible. Keep a record of all the serial numbers, and report any losses as soon as practical. Even if the police don't find your camera, your insurance company will want proof of reporting a loss.

Technical Digest

Lens and Shutter

Angle of View. Angle of view is quoted in compass degrees and indicates how much of a scene will be included in the image formed in the camera. A lens with a 'normal' angle of view usually has a focal length roughly equal to the diagonal across the picture format on the film. In practice a more useful criterion is the angle of view relative to the long side of the film format. Miniature cameras therefore may have information on angle of view in terms of both length and height of the format. Here are some figures from a Leica data sheet. These refer to 24 × 36 mm format pictures when the lens is focused for subjects at infinity.

Angle of view	Focal length	Length	Height
Extreme wide angle	28 mm	65°	46·5°
Wide angle	35 mm	54·5°	38°
Normal lens	50 mm	40°	27°
Long lenses (for shots without a tripod)	90 mm	23°	15°
	135 mm	15°	10°
Long lenses (for tripod mounting)	200 mm	10·5°	5·5°
Very long lenses	400 mm	7°	3·5°

Advertisements for interchangeable lenses usually include comparative shots all taken from the same place with lenses of different focal lengths. For example, the first picture is a general view of the town, and the last one just includes the clock on the church tower. These comparisons merely show you the differences between different angles of view.

Change of lens focal length has even more importance when we come to consider perspective. Perspective in an image depends upon distance between subject and camera—not the focal length of the lens. But if you turn the problem the other way round, you could say that interchangeable lenses give the photographer the opportunity to choose the place from where he can fill his frame with the picture.

Some photographers seem to have a blind faith in the magnifying ability of long focus lenses. It is more realistic to judge the possibilities of a lens by working out the scale of reproduction. This is done by dividing the camera-to-subject distance by the focal length.

Imagine that the lens focal length is 135 mm ($5\frac{1}{2}$ in), and the distance to the subject is 55 in. The ratio is therefore 1:10 and all subject details will be reproduced on the film at one-tenth original size. A bird 5 in long will record $\frac{1}{2}$ in long on the film. A simple calculation such as this shows the most optimistic photographer that long lenses are not really such magical tools.

Focal length is only one factor to consider when buying a lens. You are also paying for its optical performance—its ability to form a good negative or transparency which will in turn give a sharp image on the screen or paper enlargement.

Long focal length lenses have advantages in colour photography in that cropping and 'enlarging' of the subject can be made at the moment of shooting, similar to some of the modifications possible in the black and white darkroom. (Of course similar darkroom manipulations are carried out in colour printing too, but colour printing is not yet common among amateurs.) You can also use the 'telescope' effect of long lenses to photograph landscapes or animals, where geographical or other reasons make it impractical to come in closer.

Don't forget the effects of atmospheric haze when photographing landscape with a long focus lens. This can be annoying because it forms a blue cast over distant parts of the view. Under these conditions it may be better to move to the scene and use a lens of shorter focal length to include the same view. Haze will thereby decrease because you are putting less air between camera and subject. Landscapes shot from distant viewpoints can also become flat in tone, especially in flat even lighting. Town or natural history subjects appear more clearly defined and well separated spacially if photographed in oblique lighting. Houses, for example, then show different tones on different walls, gables etc. The contrasting side lighting also minimizes haze effects.

In the case of short focal length lenses, you have to be careful to hold the camera absolutely horizontal when shooting subjects with important vertical lines, e.g., Architecture. In natural landscapes absolutely vertical lines seldom form an important part of the picture. If the camera just has to be tilted to include the top of a building, then try to decide the most important vertical line and locate it in the middle of the picture. At least this line will then be undistorted. *Shutter—In Lens or Body?* The shutter can be in one of two positions: 1. Within, or just behind the lens, and consisting of moveable thin metal leaves. (These are most common in cameras with non-interchangeable lenses.) 2. Inside the camera body immediately in front of the film. This 'focal plane' shutter is made either of a rubberised fabric blind or of metal, and has a variable width slit which flies across the film plane to make the exposure.

Of course, a focal plane shutter does not illuminate the whole film frame at the same time unless the slit is as wide as the frame. (This happens at settings of

1/30 sec or slower on most cameras.) At faster settings you can imagine a 'light broom' sweeping image light across the film. You have to be rather careful about this in flash photography and use only the longer shutter speeds, as explained on page 194.

The focal plane shutter is most common on system cameras because the interchangeable lenses can then be simpler. There are however interchangeable lens cameras having a shutter in each lens, or immediately behind the lens. This is mainly to overcome problems in flash photography.

Aperture Scales

There are two series of lens aperture scales, either of which you may find on your camera. Each series is arranged so that the exposure doubles with each successively larger setting, and half with each smaller aperture (higher *f* number). The series immediately below is used on cameras which use exposure values (page 16) and virtually all modern cameras:

$$f1 \cdot 4; \ 2; \ 2 \cdot 8; \ 4; \ 5 \cdot 6; \ 11; \ 16; \ 22 \ etc.$$

The other series used to be in common use on continental European cameras up to about 12 years ago.

$$f1 \cdot 1; \ 1 \cdot 6; \ 2 \cdot 2; \ 3 \cdot 2; \ 4 \cdot 5; \ 6 \cdot 3; \ 9; \ 12 \cdot 5; \ 18; \ 25$$

'Half stops' are sometimes indicated in the form of *f*8–11, which means that the setting is half way between *f*8 or *f*11. Some cameras are made with 'click' stops, where intermediate aperture settings can be made. (You feel a little click at each setting position.) This is quite useful if you want to increase or decrease the aperture setting without taking the camera away from your eye. Lenses for enlargers, which are intended to be handled in the dark, are also equipped with these click stops.

Sometimes it is useful to know the value of these half stops. Here is a list for half settings in the most widely used aperture scale.

*f*2–2·8 = *f*2·5	*f*5·6–8 = *f*7
*f*2·8–4 = *f*3·5	*f*8–11 = *f*10
*f*4–5·6 = *f*5	*f*11–16 = *f*14
	*f*16–22 = *f*20

Adjustments of one-third or one quarter of an aperture may occasionally be needed, for example when using certain filters, page 170.

Film

Film Speed
The light sensitivity of films is commonly rated by numbers on the American and British (ASA/BS) and German (DIN) scale. Most film boxes quote both figures. As a service to photographers who use an automatic camera or exposure meter calibrated in only one system here is a conversion table:

ASA	DIN	ASA	DIN
10	11	250	25
12	12	320	26
16	13	400	27
20	14	500	28
25	15	640	29
32	16	800	30
40	17	1000	31
50	18	1280	32
64	19	1600	33
80	20	2000	34
100	21	2500	35
125	22	3200	36
160	23	4000	37
200	24	5000	38

An increase of three degrees DIN means a doubling of film speed. On the ASA scale doubling speed means doubling the number. Hence 50 ASA and 18 DIN films have twice the sensitivity to light of 25 ASA and 15 DIN.

Film speeds and expiry dates are printed on film cartons.

You have to know the speed of the film you are using in order to set the exposure meter or automatic camera controls correctly. If meters are set to the wrong speed they give wrong exposure information. (Of course you can use this to over-ride normal exposure settings on an automatic camera where over or under-exposure will help the picture, see page 32). A few automatic cameras can only be loaded with film having the speed the exposure metering system needs.

Dimensions of Photographic Materials

Films and papers are labelled so that dimensions are quoted in inches or metric units, depending upon the country of origin. If one or other of these sizes are missing the following table might be useful.

MM	INCHES	MM	INCHES
24×36	$1 \times 1\frac{1}{2}$	100×150	4×6
60×60	$2\frac{1}{4} \times 2\frac{1}{4}$	130×180	$5\frac{1}{8} \times 7\frac{1}{8}$
60×90	$2\frac{1}{4} \times 3\frac{1}{2}$	180×240	$7\frac{1}{8} \times 9\frac{1}{2}$
90×120	$3\frac{1}{2} \times 4\frac{3}{4}$	240×300	$9\frac{1}{2} \times 11\frac{3}{4}$
		300×400	$11\frac{3}{4} \times 15\frac{3}{4}$

These measurements are not exact, but taken to the nearest millimetre. A 60×60 (6×6) film for instance has a picture size of 56×56 mm.

Film Storage

A colour film has three stages of life. The first is in an unopened film packing, the second is its stay in the camera, and the final one its existence as a finished colour picture. The period in the camera can be the most risky one. Nearly every roll of colour film nowadays comes packed in a sealed plastic bag or a metal container with an airtight lid, both kinds being considered damp-proof. Dampness and heat are the enemies of the colour film, they change its colour rendering.

The storage temperature is most important: one film manufacturer states that his film keeps for a year below 50° F (10° C), six months when stored at temperatures up to 60° F (15° C), but only two months at 75° F (24° C). Another maker warns that four weeks of storage above 70° F (21° C) may change the colour rendering.

The best place for storing film is a refrigerator (for long storage—say a couple of years—a freezer set to between −10° C and −18° C the best. Use separate sealed plastic bags for small numbers of films). But a chilled film must be kept for some hours at room temperature before its sealed package is opened so that it can be loaded into the camera. Otherwise moisture will condense on it and ruin it.

The storage problems of the professional photographer are discussed in more detail on page 172.

Once the film is removed from its container and placed in the camera, and you have started taking pictures, it is in its most vulnerable state. It is no longer protected against damp, and people very often,

unfortunately, leave their cameras in damp and hot places. The most dangerous time of all is after the film has been exposed—the unprocessed picture can deteriorate faster than can unexposed film.

Just imagine how swelteringly hot it can be in an attic room, on a sea shore, or in a car.

Leaving a camera loaded with colour film in a car parked in the sun is worst of all—quite apart from the risk of theft. Be over-careful—treat the camera like a pound of butter, and put it in the coolest available place!

After processing keeping the colour pictures in a cool place is not so vital. But on the other hand, they should not be exposed to heat or too much daylight all the time.

Storage in light-proof boxes at normal room temperature appears to be sufficient. However, much you like to frame and display colour prints on your desk or on the walls, it is wiser not to expose them to strong light in summer.

Preferably remove them to the darkest room, or put them in a drawer, if you go away for any length of time.

Processing

If the cost of processing is included in the film price, you can send it off to the manufacturer's laboratory yourself or get your photo dealer to do this for you. Films which are not pre-paid in this way can be handled by the dealer himself. Reversal (transparency) and negative colour films are processed differently and used in a variety of ways. Single transparencies can be printed on paper to give colour prints or on film as new transparencies. They can also be put together in series—for example as filmstrip for teaching. (To make a film strip you have to make a strip negative first, so the first copy is quite expensive. Subsequent copies cost less.)

Colour prints on paper, from either negatives or transparencies, turned out in standard sizes in a semi-automatic printer are comparatively inexpensive. You can also have high quality enlargements made by hand, but of course these become more expensive, particularly when made from transparencies. From colour negatives you can also have colour slides black and white slides, and black and white paper prints prepared. In every case ask your photo dealer what he advises for the best or cheapest result.

Processing your Own

So far not many amateurs have begun developing and printing in colour, but equipment is available and have seen quite good results produced; for example in a High School in West Germany. Admittedly you need more equipment for exposing colour papers and processing also demands more accurate control than most work in a black and white darkroom Descriptions of processing methods are not within the scope of this book, which is more concerned with the taking of pictures. If you are interested in colou

printing, one source of information is the material's manufacturers. Keep your eye on the latest books and magazines for really up-to-date information. Materials and processing methods are still being improved so try to keep in touch with developments through these and other sources of data. Your photo dealer can help with the latest leaflets.

Of course, if you are intending to buy a new enlarger for black and white printing, it may be worth buying one which is also suitable for colour printing. A colour enlarger needs a drawer for filters and should be sufficiently light tight so that there is no risk of fogging colour paper. Light spill on to the person using the enlarger may be the worst kind, because it reflects from him. This is one reason why it is best not to wear a white dust coat, or a light coloured shirt for colour printing. Similarly, the darkroom should have the parts of the wall and ceiling closest to the enlarger painted black. Finally, the enlarger needs to have good optics — that is lens and lighting system — and it should give very even illumination over the entire paper surface: enlargers with diffuse lighting systems give better results with colour materials than do those with condenser systems.

Filters

Filters for Colour Photography

For most colour photography with daylight film, the amateur only needs orange filters of various densities and an ultra-violet one to reduce undesirable bluish casts in his pictures. There are examples of this on page 44. Professional photographers work with a lot more filters of various colours and densities. Part of their work—particularly in advertising photography —is to reproduce a subject with a 'right' colour or a 'wrong' colour. There are customers for both sorts of interpretation.

A professional uses filters for all sorts of reasons. One is because colour films vary slightly in manufacture. Professional films—particularly sheet films— therefore come with a packing note stating what special filter is needed for that particular batch in order to give optimum colour reproduction. Again, the photographic light source may not exactly suit the film slightly in colour. This is often the case with some types of electronic flash. Another reason for filtration may be slight colouration of the camera lens. Professional photographers buy large quantities of film of one batch, and make tests with their equipment to calculate the exact filters they need.

Filters are essential for colour printing. The machine-made prints which you get back from your photo dealer will have had filtration, selected by an electronic negative analyser and monitored by the photofinisher technician. Despite all the automatic equipment, the ability of the technician to know which is important in the picture is still fundamental to the quality of final results. Enlargements may be hand made or machine made. Hand made enlargements particularly from unusual subjects, should be more pleasing because of the skill applied in selecting filtration.

Amateurs may also use conversion filters, which allow both artificial light and daylight scenes to be shot on the same film, see page 128. This is a common practice in cine-photography.

Filter Factors

Filters need extra exposure, and the exposure increase when using the filter is usually given in the form of a filter factor. This indicates how many times the normal exposure is to be multiplied. For a filter factor of 2× you therefore either have to double the exposure time or use the next larger aperture. If the exposure without filter is, for instance, 1/50 sec at f8, the exposure with a 2× factor becomes either 1/25 sec at f8, or 1/50 sec at f5·6.

Things become a little more intricate when the filter factor is a decimal fraction. Few modern shutters give reliable intermediate settings, so it is better in practice to make small adjustments on the aperture setting. The table below sums up the amount, to the nearest $\frac{1}{4}$ or $\frac{1}{3}$ stop, by which the aperture must be increased for various filter factors.

With exposure values, the correction is easier still—you simply reduce the exposure value by the same number of steps as the increase in aperture stops given in the table. However, you have to round off the correction to the nearest $\frac{1}{2}$ stop, as exposure values settings cannot usually be made in less than $\frac{1}{2}$ stops. For example a $2 \cdot 7 \times$ filter, requiring an extra $1\frac{1}{2}$ aperture stop reduces an exposure value of, say, 12 to $10\frac{1}{2}$.

The filter itself, or an enclosed leaflet, usually indicates the correct factor. Should this information be missing, enquire from the manufacturer or importer.

You may take account of the filter factor by reducing the film speed setting on the exposure meter. (See page 166 for information on the relationship of exposure stops to film speed ratings.) In this case, you use the exposure settings recommended by the meter, and do not use the alternatives previously suggested.

Filter factor	Exposure increase in aperture stops	Filter factor	Exposure increase in aperture stops
1·1	+0	2·7–2·9	+$1\frac{1}{2}$
1·2	+$\frac{1}{4}$	3·0–3·2	+$1\frac{2}{3}$
1·3	+$\frac{1}{3}$	3·3–3·6	+$1\frac{3}{4}$
1·4–1·5	+$\frac{1}{2}$	3·7–4·3	+2
1·6	+$\frac{2}{3}$	4·4–4·8	+$2\frac{1}{4}$
1·7–1·8	+$\frac{3}{4}$	4·9–5·0	+$2\frac{1}{3}$
1·9–2·2	+1	6·0	+$2\frac{1}{2}$
2·3–2·4	+$1\frac{1}{4}$	7·0	+$2\frac{3}{4}$
2·5–2·6	+$1\frac{1}{3}$	8·0	+3

Mired Values

Instead of quoting colour temperature of light sources in kelvins, we can use Mired numbers instead. (You find the Mired number by dividing one million by the colour temperature in kelvins.)

Some technicians prefer the Mired scale because the size of a colour change for a particular shift on the kelvins scale depends on where you stand on the scale. For example a difference of 100 K does not mean such a large colour change at around 7000 K as it does around 3000 K. A filter cannot therefore be given a 'Kelvin change' number which would apply to any light source. A colour change quoted in Mireds, however, will be roughly the same at any colour temperature. This particular filter may be given a 'mixed value', which describes its effect when

used with light sources at any colour temperature. Mired numbers are therefore useful for making calculations when you begin doing advanced work, making use of professional filters.

Problems of the Professional Photographer

The pictures of a professional photographer must be of a high standard. His customer is his strictest critic, and usually insists on faithful colour rendering. The commonest colour faults are due to variations in the colour film itself, wrong storage, variations of the colour temperature of light sources, difficulty in deciding the correct exposure, and possibly variations in processing.

The manufacturer numbers every batch of colour film during production. This emulsion number is stamped on the outside of the film package. It should not be confused with the expiry date by which the film should be used. For consistent results, then, keep to a film of the same emulsion batch number as long as possible. At least stick to one type of film, buying Agfa film one week, Kodak the next and Ferrania the third, as some amateurs do, is the very worst kind of hit-and-miss photography.

When the stock of film is getting low and needs replenishing, the professional way is to test the new emulsion. That involves exposing a couple or more rolls under different light conditions and with different camera settings. No filter of any kind is used with these exposures. For examining the processed film, a viewer with a light of standard colour temperature is desirable. The same colour picture examined against the blue sky may look too blue, while against an ordinary electric lamp it might appear excessively red. In other words, a yardstick of colour viewing is important.

When a professional colour photographer is not satisfied with his first test of an emulsion, he can modify the appearance of the transparency, viewed against a standard light source, with various filters. This entails having a much wider range of filters than the amateur. Comprehensive filter sets for this purpose may consist of up to 40 filters of different colour and density intended for just the minute variations of colour liable to arise. These are colour-balance filters. Choosing the right filter or combination of filters is, of course, a matter of experience. Once the filter is found that makes the colours of the subject appear correct, a new test can be made with the same filter in front of the camera lens. Additional filter combinations may also be used for comparison. Re-examination of the processed results may then narrow down the correction required to a specific filter or filter set. Occasionally, it is useful to make further tests under different lighting conditions with a standard subject of different colour patches and differently toned grey cards.

This, then provides a filter combination for further use with the same emulsion batch. Based on such tests, the results are likely to be reliable and consistent

The tests show how the particular equipment, plus the tested film, will give good results. Detailed notes are, naturally, important to determine the speed of the film to daylight or lamplight, measured with a given meter, or the guide number for specific flash bulbs or electronic flash units.

Professional colour quality is thus based on detailed preliminary tests. And these are valid only if the actual working conditions remain the same. A different camera, new lighting units of another colour temperature, or unsuitable storage of the film may upset the results.

As indicated on page 167 heat and moisture affect colour films. Once bought and tested, the bulk of the film batch is best kept in air-tight packings in a refrigerator or deep freeze cabinet. This ensures that the last roll of film, several months later, is still in the same condition as the tested ones in the beginning.

Photolamps and other lamps must, of course, always work at the same voltage. Most well-equipped photographic studios, therefore, have accurate voltage control equipment.

Many professionals nowadays use electronic flash for taking colour pictures, not least because the colour temperature of electronic flash is constant—except possibly when the flash tube nears the end of its life. If electronic flash is used, only daylight film is needed in the studio and out-of-doors. Further, electronic flash can serve as fill-in lighting for daylight subjects without giving disturbing colour mixtures.

As many studios need several electronic flash outfits—either wired together or controlled by photo cells or similar 'slave' units—it is important that they match one another for colour temperature. The flash quality should also suit the balance of the daylight film in use. This, consequently, requires a great deal of careful checking before the equipment is purchased.

All these test procedures, needed for professional colour work, may seem to be superfluous in an amateur book. The average amateur has neither the scope nor the equipment for going to such extreme lengths to secure 'perfect' colour reproduction. And, in most cases, he is satisfied with the results he gets by reasonably careful working. High quality colour photography is almost a science in itself—it has to be, to yield a consistent and precisely pre-determined end product. The above summary—giving a glimpse of some of the requirements involved—is, however, perhaps a fitting reminder that in colour photography you can never be too meticulous.

Exposure Calculations

Instruction Leaflets

To help photographers without exposure meters, each box of colour film contains an instruction leaflet carrying suggested exposure settings for normal subjects in various common lighting conditions. For this to be useful you need to learn how to evaluate the different kinds of daylight quoted.

Clear sunshine with its sharp edged shadows is easy to recognize. When the sun gives soft edged shadows you have *hazy sunshine*, as in the case of sunshine diffused by thin clouds or slight mist. *Cloudy bright, Dull* or *Cloudy* all mean shadowless conditions. They are otherwise somewhat vague although they do not mean the heaviest low thunder clouds. *Cloudy* is often bracketed together with what is called *open shadow*, the sort of strength of lighting you find in the shadow on a day when the sky is blue. See page 59.

If you only take colour photographs of normal subjects in normal lighting the manufacturer's packing sheet instructions will probably give you successful results. It is, of course, in the film manufacturer's interest that your pictures come out well, otherwise you will buy some other make of film. Exposure recommendations are therefore calculated mathematically and thoroughly tested out all over the world by amateur photographers.

It is always up to the photographer himself to judge what are light coloured, dark coloured, or average coloured subjects. In each case it is the brightness of the colour which counts—you must not call a subject bright just because it is well lit. A brown cow does not become a light subject, even in the strongest noon sunlight!

Here are some examples to help assess the degree of brightness of a subject.

Light coloured subjects include light flowers, beaches, people in pale toned clothes, light buildings and snow.

Dark coloured subjects include dark greenery, dark toned animals, deep coloured flowers and heavy toned buildings.

Average coloured subjects are all those in-between the above mentioned groups, and anything which you cannot categorize under light or dark. In other words, in the terms of a public opinion poll, the 'don't know' group.

We know that light and dark coloured subjects may need different levels of exposure to reveal all their details under the same illumination—our coloured squares in the three-meter experiment on page 28

Put a label in each picture when making exposure tests.

showed us that. You remember how yellow is the lightest colour, and brown, violet and green are really quite dark.

Consequently you have to watch the brightness of the subject itself when calculating exposure. This is where it is helpful to have a 'normal grey' card (page 177) against which subjects can be compared to find whether they are darker or lighter.

Exposure and Sidelighting

Manufacturers instruction sheets usually deal with subjects lit from the front—in other words with the sun roughly behind the photographer. But as soon as a subject is lit from one side it will contain shadow areas. These will come out dark unless exposure is slightly increased. There is no firm rule to say how much increase is necessary, because this is governed by the amount of reflected light that the immediate surroundings may or may not deliver.

The proportions of lit and shaded areas also vary in size and importance. You may have to decide between correct exposure for a backlit portrait or for the sunlit landscape behind the subjects. Differences in illumination between highlight and shadow areas are always greatest when the sun is shining from a clear sky. Thin clouds act as diffusers (page 110) and reduce this lighting contrast.

The three-meter experiment, made on colour transparency film, showed that over exposure makes colours lighter and destroys their saturation. Pale weak areas in a transparency generally give an unpleasant 'bleached' impression. The maxim to apply in *colour transparency* shooting is therefore 'expose for the highlighting and let the shadows look after themselves'.

175

Exposure Tests

You cannot assume that all shutter speeds offered by a camera are exactly accurate. Even at the manufacturing stage there are various tolerances allowed. Some experienced photographers suggest that you vary the shutter speed as little as possible and instead control exposure level mostly with the lens diaphragm. Aperture settings are usually more consistent (but some reservations must be made with the smallest apertures in some 35 mm cameras).

Anyone unsure of the exact exposures he is getting, but wanting to be as accurate in his exposure estimation as possible, should do tests to see how meter and camera settings work together. For all rests always use your own equipment, including your own projector and screen in your own room for assessment of transparencies. Suggestions for making tests appeared on page 198. Remember to change only one factor at a time. To check whether the meter has the correct film speed setting to give correct exposure using your camera, make exposures with the meter set to ASA speeds slightly higher and slightly lower than those normally quoted for the film. Make your tests on a 'normal' subject or the sort of test objects used for the three-meter experiment on page 19.

Include a label in with the subject each time; this can carry the exposure data for that particular frame, and avoid confusion when the processed results are compared.

Reading through the Lens

There are two basic ways of measuring exposure with a meter. One way is to measure the incident illumination from a light source—sun, sky, floods, etc—and is thus called *incident light measurement*, page 178. The other way is to measure light actually reflected off the subject itself, and called *reflected light measurement*. We are concerned here only with reflected light meters.

Reflected light meters used to be rather bulky—practically filling your hand. When miniaturized meters began to be made these could be built into cameras, having a measuring 'eye' of their own close to the lens. The next step was to take the meter's separate eye away and use the actual camera lens instead—'through the lens' metering.

Manufacturers design through-the-lens metering in a variety of ways. For example, the meter may give a 'sum' of all the light passing through the picture-taking lens (an over-all reading). Or it can measure over only a limited part of the subject, within an area marked in the viewfinder. The photographer therefore has to be sure that this part is representative of the whole picture or of the parts he wishes to portray correctly.

A simple through-the-lens meter works just like any other reflected light meter and can be just as easily misled as a hand-held meter. Some other TTL meters however are more sophisticated. For example, they may compare one reading from the small local area

marked on the ground glass, and one from the overall picture. Together these provide more accurate exposure assessment in some conditions.

Reading through the taking lens has the great advantage that you do not have to calculate exposure increases required for filters or extension tubes. The meter takes these into account. It can even give you reading when photographing through a microscope.

Single-lens reflex cameras are usually designed to allow focusing at full lens aperture, which of course gives the brightest most critical image in the viewfinder. When you press the shutter release button, the internal mechanism may stop down the lens the moment of shooting. The aperture may have been preset, or may be determined by an automatically coupled exposure meter. Many lenses also have a special 'pre-selector' button which closes the diaphragm down to its working aperture allowing a preview of the depth of field you will achieve when the picture is taken. On many cameras, however, particularly when used with non-standard lenses, the lens has to be closed down manually to the required aperture before the shutter is released.

Focusing at full aperture is a real asset when taking flash pictures in a room with poor lighting. If you have ever tried focusing the lens stopped down to $f11$ or $f16$ will know how hard it is to see detail on the focusing screen.

Exposure Latitude

The three-meter experiment was made using colour transparency film. Variations in results are obvious (page 28) even when exposure changes were as little as half a stop. Exposure latitude is slightly more than this for colour negative film, which like black and white negatives, is processed and then printed. (A transparency film is processed and the same piece of film returned to you.)

Small exposure errors may be corrected when printing from colour negatives. The greatest correction is possible when the subject is low in contrast—in other words when variations from medium tones are not too great. These sorts of subjects allow you to make errors of $1\frac{1}{4}$ stops over or under exposure on negative film, or $\frac{1}{2}$ stop either way on transparency films.

Don't, however, use this as an excuse to be careless when exposing colour negative films—regard it as an extra safeguard which should not be abused. The extra latitude also explains why good colour prints can often be made from colour negatives taken with quite simple cameras.

Using a Grey Card

You may remember that we used a piece of grey cardboard in our three-meter experiment. In that case it was a 'Kodak Neutral Test Card' of the type used extensively by professionals (although the amateur will find it useful too). The card represents an 'average' subject. It reflects 18% of the light reaching its surface

—equivalent to what film manufacturers have discovered to be typical of the average amateur photographer's subject. The grey card therefore has a function for the photographer similar to that of a folding rule for a carpenter—a fixed unit for measuring.

The card can be used for exposure calculation like this: the card is placed beside the subject, facing the camera. Here of course it receives the same light as the subject itself. A reflected light meter reading is then made from the card and corrected—setting the camera $\frac{1}{2}$ to 1 stop *smaller* for lighter subjects and the same amount larger for darker subjects. (For some films used in artificial light, the meter is set to the normal speed rating and exposure given as suggested by a straight reading off the grey card.)

The other side of the Kodak Neutral Test Card is white. This of course reflects far more light, 90% in fact. You turn the cardboard and point your meter towards the white side on those occasions when lighting is too weak for a meter to record any reading from the grey side. This is then corrected by giving an exposure five times as long as the exposure suggested. For example, if the meter says 1/50 sec at a certain *f* number the corrected exposure must be 1/10 sec at this aperture. This agrees with what we said earlier about the error a reflected light meter may give with light toned subjects. You may have also realised that, by reading from the grey and white sides of the card, you are measuring the lighting rather than the subject.

A white card can be called the common denominator for reflected light and incident light measurement of exposure. Some reflected light meters are equipped with a small opalescent dome, serving the same function as a white card, but it is smaller and easier to use. It simply covers the measuring cell on the meter.

Incident Light Meters
Meters of this type are pointed towards the light source and therefore give information about the strength of the incident light. The readings are suitable for normal subjects, but lighter subjects must be given less exposure and darker subjects more. Some photographers think that this is safer than measuring the light after it is reflected from the subject, where different parts reflect different amounts of light.

Incident light meters have built in opal diffusing domes or discs. Some exposure meters work both as incident light and reflected light types, conversion being simply a matter of putting the plastic dome in place. Sometimes diffusers are even found on meters which are built into cameras (not the TTL types). Unfortunately, most owners of these cameras never bother to use the little piece of plastic. Probably they have never read through the meter manual. Anyone who is interested in experimenting ought to try both methods and compare results.

If a reflected light meter is used to measure a very light toned subject—for example a sunny beach—it

A grey card, like a normal subject reflects 18°. of the light falling on it.

A white card reflects 90°

Exposure meter cells receive reflected light.

For incident light readings, a diffuser is fitted over the cell.

may suggest a rather shorter exposure than an incident light meter. Remember how the reflected light meter measured light subjects (i.e. the white test card) in the three-meter experiment on page 28. In cases such as this, the best result will probably be the exposure indicated half way between incident light and reflected light readings.

Always remember that you will get a totally wrong reading if an ordinary reflected light meter is directed towards the light source. This meter will also give wrong information—by a stop or more—if you point it towards a water surface reflecting the sun.

Flash Meters

Exposure meters specially designed for use with flash are now available. They are mostly used by professionals, who need precise information when using several electronic flash sources at one time. If you have ever had trouble in knowing just where to direct an electronic flash unit, bear in mind that professionals have small (25 w) bulbs located close to each flash tube. With these they can predict how the lighting will spread and how the shadows will fall. May be this is something of interest to the do-it-yourself man.

Sharpness

Types of Blur

There are several different kinds of blur. The most common are:

Camera shake blur—when no part of the picture is sharp.

Distance setting blur—when some zones of the picture are sharp, but not the desired parts.

Movement blur—on moving subjects such as cars, people etc.

Camera damage blur—a misplaced focusing screen, faulty lens, distance scale etc. When the photographer has performed correctly, and the camera has failed.

Blur caused by camera shake is probably the most common of all photographic errors. Often it is caused by the photographer himself who has not learnt to hold the camera still at the vital moment he presses the button. You can train yourself to avoid this error, using a little mirror fixed in front of the lens with an elastic band. Point the camera towards the sun or other bright light source such as a projector light, so that the reflection is directed onto a distant shaded wall. Then practice pressing the button (the camera of course being empty), at the same time minimizing the jump made by the reflection on the wall. Because of the distance between camera and wall the reflection greatly magnifies any camera movement.

If you have a camera with a viewfinder designed for use at eye-level, press the camera body firmly against your face. Place a finger between your cheek and the camera, and press the camera body against your forehead and nose. The idea is to give the camera as many contact points with your body as possible. Using the camera for upright pictures demands more care. When you shoot you may have to put a finger between the camera and your forehead. The shutter pressing finger should not have any supporting function. Pressing should be very gentle—more of a squeeze.

The camera strap, too, can be put to good use when you shoot. Shorten it to a neck strap and you have another support. You can tighten it by putting the button pressing hand between your head and the strap. Another alternative is to make the strap long enough to act as a sling around your head. Tightening makes this even more effective.

You can also improve steadiness by leaning against a wall, tree etc. This avoids movement of the whole body which so easily occurs when you stand without any other support. Door and window openings also provide good supports, and like the others are especially valuable if you work with long lenses.

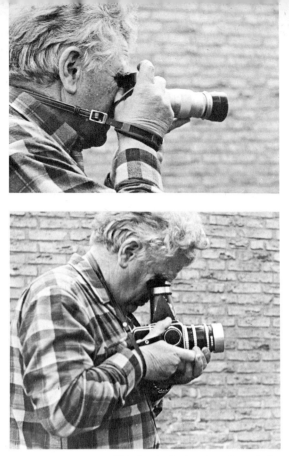

Use the neck-strap to reduce shake.

Of course, a firm tripod is the safest most flexible camera support, but many people consider them too troublesome to carry except in a car. For closeups, the tripod is almost a necessity, even if the lighting is good enough to take normal pictures without it. Close-ups usually demand the use of small apertures to create sufficient depth of field, and the resulting long exposure time increases the risk of camera shake. The first thing to check when buying a tripod is just how collapsible it is likely to be. A tall tripod with many joints easily becomes unsteady, a bad tripod is a treacherous support.

Inside buildings, even a tripod may not be enough. The floor may vibrate if people are walking nearby and you should ask them to stand still if exposures are longer than about 1/100 sec. Close-up work in conditions of vibration can be very difficult indeed.

Careful photographers also remember to carry a long cable release. This allows a much smoother pressure on the shutter release button, and is very helpful when shooting close-ups. Another useful weapon against camera shake is the self timer. This is often built into the camera shutter and once set off buzzes quietly to itself for 10–12 secs before firing the shutter. While this is happening the tripod-mounted camera has time to become quite stationary. A lock-

able cable release is helpful too when photographing in very low light conditions, such as moonlight. The shutter stays open as long as the locking screw remains screwed in, the screw is released to end the exposure.

Of course, if a subject shot at night has bright point of light, street lights for example, the least movement of the camera when opening or closing the shutter is made very obvious. Each highlight forms a 'track' like those on page 148. If you want to be careful about this hold a piece of black non-reflecting material just in front of the lens for a while when you open the shutter, and again just as you close it. This should ensure that there is no movement of the camera whilst the lens is actually recording the picture.

Some places are worse than others for vibration. On motor vessels for example you should try to stand in the most vibration-free part of the boat, as far as possible from engine or propeller vibrations. Also, stand with your legs slightly apart and heels slightly off the deck. This, combined with bent knees, gives your body a springy S form, reducing the vibrations transmitted up through it to the camera. Even if you take all this care, you should still use as short an exposure time as possible.

Camera-shake when shooting is the most common error of beginners in photography. Therefore if you put a modern lightweight plastic camera into the hands of a beginner, you need to give plenty of attention to the way he presses the button. A heavy camera is not so likely to shake during exposure as a lightweight one.

Children, in particular, are easily overwhelmed by excitement when taking a photograph. However, young photographers must be encouraged to remain calm and always remember to press the button smoothly.

Distance Setting Blur has been discussed already on page 19. Tables and explanatory text also appear on page 186

Subject Movement Blur depends upon how much the image of the subject moves across the film during exposure. This is determined by their actual speed, their distance from the camera, and their direction of movement relative to camera viewpoint. (See page 27 about this last point.) A fast train seems to move as slowly as a snail when it is far away in a landscape ; but even quite a slow train passing a few feet from our eyes, at a railway station, may come out blurred with an ordinary amateur camera.

The fact that image movement *on the film itself* causes blur must be remembered to when you use long lenses. These lenses not only magnify the image size, but also its *movement*.

'Panning,' or following with the camera was a necessity in the days when films had low speeds and it was impossible to freeze movement with a very brief exposure time. Today panning trotting horses, racing cars and athletic events of all kinds has become popular as a method of intensifying the impression of

Some cable releases can be locked down for long exposures.

speed. Notice how photographers consciously choose a broken background which will reproduce as broad blurred brush-like strokes, e.g. trees, railings or crowds of people. See page 27.

Camera Damage Blur cannot be cured by the photographer himself. All you can do is establish that there is a fault and ask a camera technician for help. The most common cause of focusing error in single-lens reflex cameras is lack of alignment between ground glass screen and film. Adjustments usually have to be handled in the service repair shop of the manufacturers or their accredited agents. In a few cases the camera may have to be sent back to the factory. If possible when sending a camera for repair, enclose a few frames of film which clearly show the error—this will make diagnosis easier.

Simple Cameras

There are cameras designed with fixed focus lenses and fixed apertures. They rely on depth of fields to give a usefully sharp image. The cameras are often fitted with a short focus lens, about 40 mm if they use 35 mm film—working at about f11. The makers locate the lens at such a distance from the film that depth of field extends from about $4\frac{1}{2}$ ft to infinity. You therefore need to advise beginners using these cameras that they cannot expect to produce a sharp image of say, a face closer than $4\frac{1}{2}$ ft. It is impossible to make a sharp image of face which fills the viewfinder, but as the finder is usually the cheapest possible, it will not show you whether the camera is producing a sharp image or not. The viewfinder merely acts to show you the extent of the picture you will get.

If on the other hand, you possess a camera with a lens that focuses and stops down, but are lending it to someone who does not understand such settings you can 'simplify' your camera as follows. Choose a film and an exposure time that gives a fairly small aperture in the expected conditions—say 1/125 sec at f11. Look through the depth of field table for a suitable focusing distance setting. According to the table, a 50 mm lens at f11 produces a depth of field extending from 10 ft to infinity when set for a subject distance of 25 ft. The only thing the person who handles the camera then has to remember is not to go closer than 10 ft. (The figures quoted in depth of field tables are for pictures with high standards of sharpness—the beginner can usually go a foot or so closer and still get acceptable results.) Of course, if he prefers to, our beginner can have the lens focused for 7 ft and be told to limit himself to close-ups, working between five and ten feet from his subject.

Long Lenses

If I were asked for advice from the owner of a 35 mm camera system, I would suggest buying a 90 or 100 mm lens as the first extra piece of equipment. In colour photography it is usually an advantage to avoid including too much foreground—the sort of uninteresting material you would omit at the enlarging

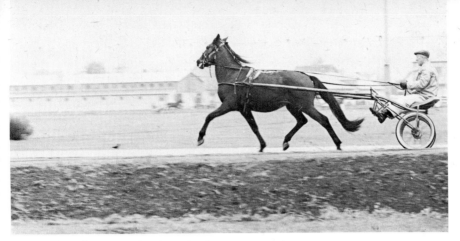

Short shutter speed and panning freeze movement.

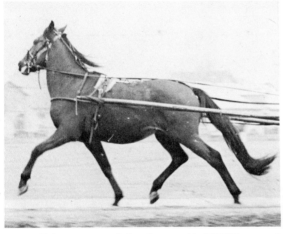

If the movement is just frozen with 1/500th second.

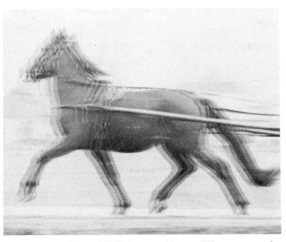

you get "four 1/500th second horses" if you expose for 1/125 second.

185

stage in black-and-white photography. I think it is easier to fill the entire frame with subject matter if you use a lens of longer than normal focal length. However, a very long focus lens can be difficult to handle properly without a tripod, as the longer the focal length, the more the slightest unsteadiness is magnified on the film.

There are one or two delusions which persist about depth of field. Some photographers say that long focus lenses have a more limited depth of field than normal lenses, and because of this 'give a flattening perspective'. This is not quite true. If a subject is photographed at the same time with both a long and a normal lens, the depth of field will be about the same, provided that both lenses have the same relative aperture (*f* number) and the scale of reproduction remains the same. If you don't believe this try it out for yourself by making test exposures, using a subject which fills the frame (from different distances) with each lens.

Take a practical example. Suppose that we shoot the same subject with four lenses, all set to *f*11, and having focal lengths of 24 mm, 50 mm, 200 mm and 400 mm. These are used from distances of $\frac{1}{2}$ m, 1 m, 4 m and 8 m from the subject respectively. Under these conditions the subject reproduces the same size in all four shots because scale of reproduction depends upon focal length and subject distance, see page 13.

Checking over a Nikon table for four lenses of these focal lengths tells us the following.

Focal length	Distance setting	Depth of field from—to	Extent of depth of field
24 mm	$\frac{1}{2}$ m	0·428–0·606 m	18 cm
50 mm	1 m	0·92 –1·09 m	17 cm
200 mm	4 m	3·91 –4·09 m	18 cm
400 mm	8 m	7·91 –8·09 m	18 cm

Smallest Aperture

We said on page 17 that the smallest aperture offered by a lens gives largest depth of field, so it is therefore tempting to use it as often as possible. However, exposure times may then become impractically long, especially when shooting on relatively slow film. Another problem is due to mechanical reasons—the actual shape of the smallest aperture in 35 mm cameras may not be geometrically exact. So that if you give an exposure of $\frac{1}{4}$ sec at *f*22 on one frame and 1/125 sec at *f*4 on another, two pictures may not receive quite the same level of exposure. Theory and practice do not always agree.

Another factor concerns resolving power, which is the ability of a lens to produce an image containing very fine detail. (The difference between good and poor resolving power is really only apparent when you project transparencies or enlarge negatives.) The

aperture at which a lens gives its best resolution is usually neither the largest nor the smallest f number. For a good 35 mm camera lens with a maximum aperture of f2 optimum resolving power may be expected at about f5·6 or f8. (In most cases achieving sufficient depth of field is of more practical importance than optimum resolving power, and so a smaller f number may be chosen.)

Contrast in Sharpness

Depth of field tables quote the limits of sharpness very precisely—right down to fractions of an inch in the case of close-ups. This does not, however, mean that an unsharp image suddenly occurs outside these limits. The changeover is gradual and experience tells you how the degree of unsharpness builds up.

Of course the most noticeable differences in sharpness occur when you have a sharply defined subject in the foreground, no middle ground, and a distant out of focus background. Contrast in sharpness is greatest when there is considerable difference in distance between foreground and background, when the foreground is very close to the camera, and when the picture is shot using a large lens aperture. Page 110.

Depth of Field Indicators

Most modern cameras carry depth of field indicators in addition to the shutter and distance figures.

This is what it may look like on the camera:

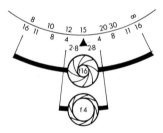

The distance setting in this case is 15 ft.

At f16, the depth of field extends from 8 ft to infinity. Infinity is usually marked by what looks like a figure eight on its side.

If you keep the same distance setting, but use a much larger aperture like f4, the zone of sharpness only extends from 12 ft to about 20 ft.

With an intermediate aperture you get a medium zone of sharpness. For instance at f8 it covers everything between about 10 and 30 ft. Note how the depth grows faster behind the focused point.

In the small space around the lens, there is usually little room for many distance figures, and you may have to estimate intermediate values. But you get a good idea of the zone of sharpness, especially at near distances where it is really important.

The depth of field indicator of the camera is a very handy kind of calculator. For instance, you may be taking an indoor shot with the far wall of the room 12 ft away. You want to know the largest aperture

and the right distance setting to get everything sharp from 6 ft to 12 ft away.

So turn the focusing adjustment of the camera so that the 6 and 12 ft marks are equally spaced at either side of the arrow marking the distance setting.

Like this:

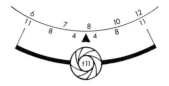

Here *f*11 is the largest suitable aperture, and the depth of field covers the zone between 6 and 12 ft. The actual distance setting will be about 8 ft.

On some modern cameras, the depth of field indicator is still more ingenious. There you may have a pair of pointers which are coupled to the aperture control.

As you stop down the lens, the pointers move apart; as you open up, they come together. They directly indicate the near and far limits of sharpness, automatically as the lens aperture is set.

You can also get this information from a depth of field table (e.g. on page 190).

Close up Photography

Close up photography requires some special techniques and equipment:

1. Supplementary lenses, or extension tubes, extension focusing mounts or bellows to focus close subjects.

2. Some means of viewfinding which is accurate at close distances. If you don't have a single lens reflex camera you may have to aim with a ruler to find the centre of your subject area. Alternatively mount the camera looking vertically downwards and drop a plumb line from the centre of the lens.

3. Extra exposure must be given when you use any form of extension focusing device (tubes, bellows etc) because the f number engraved on the lens mount no longer holds good.

Close photography starts where the closest distance setting on the lens ends. A 35 mm camera with a 50 mm lens can usually just include a subject area $19\frac{1}{2} \times 29$ in at its closest setting. To reproduce still smaller subjects, we turn to supplementary lenses or other close up equipment. Supplementary lenses number 1, 2 and 3 ($+1, +2, +3$ dioptres) allow us to reproduce the following size subjects areas:

(1) From $17 + 25\frac{1}{2}$ to $8\frac{1}{2} \times 13$ in

(2) From $8\frac{1}{2} \times 13$ to $5\frac{3}{4} \times 8\frac{1}{2}$ in

(3) From $5\frac{1}{4} \times 7\frac{1}{4}$ to $4\frac{1}{2} \times 6\frac{1}{2}$ in

These figures have been moved over progressively to the right to show that overall the three lenses cover subject areas ranging from 17×25 ins to $4\frac{1}{2} \times 6\frac{1}{2}$ ins. In some systems of supplementary lenses you only have two actual lenses which are then used together to provide the third 'lens'.

The above information is valid for 35 mm film camera with a standard 50 mm lens. If you use a 6×6 format camera with its (standard) 75 mm lens, supplementary lens No 1 covers a square of subject with its side 31 in long, down to 15 in long. No 2 offers between $14\frac{1}{2}$ in and $9\frac{1}{4}$ in, and No 3 from 10 in down to $7\frac{1}{2}$ in length of side.

The larger area of subject in each range is covered when the camera lens is set for infinity and the smaller when set to 3 ft (i.e. when the lens is at its maximum extension). The shooting distance when using supplementary lenses is therefore dependent upon the distance setting on the camera lens itself. Below there appears a table with distance settings for supplementary lenses. In each case distances apply from the front of the lens to the subject. (Some manufacturers give the distance from the actual film surface in the

camera to the subject. In this case a symbol engraved on the side of the camera tells you the position of the film plane.)

Supplementary Lenses
Setting table for +1, +2 and +3 dioptre supplementary lenses.

Distance setting of camera lens	Distance to subject from front of supplementary lens		
	+1 dioptre lens	+2 dioptre lens	+3 dioptre lens
3 ft	$19\frac{3}{4}$	$14\frac{1}{8}$	12
5 ft	$24\frac{3}{4}$	$16\frac{1}{8}$	$12\frac{7}{8}$
8 ft	$28\frac{3}{8}$	$17\frac{1}{4}$	$13\frac{1}{2}$
10 ft	30	$17\frac{5}{8}$	$13\frac{3}{4}$
12 ft	$31\frac{1}{8}$	18	14
25 ft	$34\frac{1}{4}$	19	$14\frac{3}{8}$
50 ft	$35\frac{3}{4}$	$19\frac{1}{2}$	$14\frac{5}{8}$
infinity	$38\frac{1}{4}$	20	$14\frac{7}{8}$

Example: If you are using a +2 supplementary lens and want to photograph at a distance of $17\frac{5}{8}$ in from the front of the supplementary, then the setting on the camera lens needs to be 10 ft.

Supplementary lenses are normally packed together with a setting table and depth of field table. Check that these are supplied with any lenses you buy. Here is a sample of the sort of information that tables of this kind can give to the practical photographer. The table below is calculated for a +2 supplementary on one of Kodak's 35 mm cameras with a 50 mm lens. The first two columns gives the film-plane to subject distance, and area of subject that will be covered. The third column gives the distance setting of the camera lens needed for sharp focus in each case. The depth of field columns give the zone of sharp focus in front of and behind the chosen distances for apertures of f5·6, f11 and f22. The numbers to left of each column show the distance (in inches) that sharp focus extends towards the camera and the figures on the right the distance behind the subject.

2 Dioptre Close-up Lens on Cameras with 50 mm Focal Length Lens

Approx field size (inches)	Object distance (inches)	Camera setting (feet)	Sharp zone (inches) in front (f) and behind the focused distance at indicated aperture				
			f5·6 f	b	f11 f	b	f22 f
$8\frac{1}{2}\times12\frac{3}{4}$	20	∞	$\frac{7}{8}$	1	$1\frac{5}{8}$	$2\frac{1}{8}$	3
$8\frac{1}{4}\times12\frac{3}{8}$	$19\frac{1}{2}$	50	$\frac{3}{4}$	1	$1\frac{1}{2}$	2	$2\frac{7}{8}$
8×12	19	25	$\frac{3}{4}$	1	$1\frac{1}{2}$	$1\frac{7}{8}$	$2\frac{5}{8}$
$7\frac{5}{8}\times11\frac{1}{2}$	$18\frac{3}{8}$	15	$\frac{3}{4}$	$\frac{7}{8}$	$1\frac{3}{8}$	$1\frac{3}{4}$	$2\frac{3}{8}$
$7\frac{1}{4}\times11$	$17\frac{5}{8}$	10	$\frac{5}{8}$	$\frac{7}{8}$	$1\frac{1}{4}$	$1\frac{3}{8}$	$1\frac{7}{8}$
$6\frac{3}{8}\times9\frac{1}{2}$	$16\frac{1}{8}$	5	$\frac{5}{8}$	$\frac{3}{4}$	$1\frac{1}{8}$	$1\frac{1}{8}$	$1\frac{3}{4}$
$4\frac{7}{8}\times7\frac{1}{4}$	$13\frac{3}{8}$	$2\frac{1}{2}$	$\frac{1}{8}$	$\frac{3}{8}$	$\frac{1}{2}$	$\frac{7}{8}$	$\frac{7}{8}$

Total depth of field then when shooting at a distance of 20 in and an aperture of $f11$ is the sum of $1\frac{5}{8}$ in and $2\frac{1}{8}$ in ($= 3\frac{3}{4}$ in). You can also express this by saying that depth of field is between $18\frac{3}{8}$ in and $22\frac{1}{8}$ in measured from the film plane in the camera. As you might expect, smaller apertures give larger depths of field. This is apparent when you compare figures in the last three columns. (All distances quoted are in inches unless stated otherwise.)

Aids for Calculating Distance and Area

If you have a single lens reflex with interchangeable lenses it is easy to see the subject area and zone of sharp focus when using supplementary lenses), extension tubes etc. Also if the camera has through-the-lens metering, you do not have to calculate the exposure increase entailed in using these accessories.

Some range-finder cameras can be fitted with viewfinder adapters to allow them to be used close-up.

Some cameras with separate viewfinders can have special viewfinder lenses attached so that the range-finder and viewfinder are still accurate right down to short distances when using close focusing accessories. In other words the viewfinder accessory compensates for parallax error—difference in viewpoint between viewing and taking lenses because of their physical separation on the camera. Parallax error is always greatest when working close up.

Another ingenious aid for close up work with simple fixed focus lens cameras is a supplementary lens with a built on marker frame to measure subject distances and area included (see picture). The metal frame attached to the lens is placed against the surface you want to photograph (or it acts as a support for the camera pointed vertically downwards). The camera is thus at the right distance for a sharp image, and the limits of the subject area included are clearly shown by the metal frame itself.

Extension Tubes

If the camera lens is interchangeable you can fit threaded or bayonet mounted metal tubes (extension tubes) between camera body and lens. This allows the lens to focus subjects very close up, giving a large —even larger than life—reproduction on the film.

Bellows

If you want to do much close-up photography, you will find that extension bellows are more convenient than extension tubes. Once again they fit between the lens and the camera body, but allow continuous adjustment of lens extension rather than the fixed amounts provided by tubes.

Bellows cost more than tubes, but they are worth buying for their speed and ease of use if you use them often. Among other features the entire unit of camera, bellows and lens can be mounted on a tripod and slide on a rail towards or away from the subject.

Even just using your ordinary camera lens, equipment such as this may allow you to reproduce subjects on film up to 5–6 times their original size. When

Focus distance and picture area can be simply defined by a rigid frame attached to close-up lens mount.

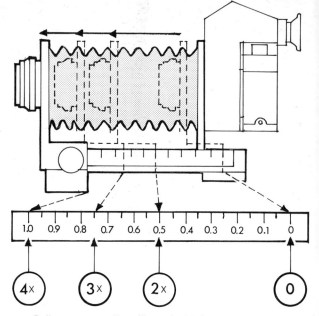

Bellows are usually calibrated with lens extension distance, which can be used to calculate magnification and exposure factor.

you add to this the magnification offered by projecting the final transparency onto a screen, results approach the performance of a microscope. At lesser magnifications, bellows equipment is useful for copying drawings and duplicating existing transparencies.

A word of warning. It is usually wrong to buy special equipment and then start trying to find something to shoot with it. I started with a fixed lens camera and then went over to a system camera. Such a versatile camera opens unlimited possibilities to the owner to ruin himself financially unless he considers each purchase on its merits. The reason I own a bellows unit today is that during some years working as a biology teacher I had to compile a library of transparencies of mosses, algae, lichens and other small specimens.

Aperture Corrections

When you work very close to your subject, using any means to extend the lens to film distance, you meet new exposure problems. The *f* numbers on the lens are no longer accurate. On page 15 we said that the *f* number denotes how many times you can divide the diameter of the aperture into the lens focal length. If you make the lens 'throw' longer by means of extension tubes etc, the light has a longer distance to travel and the image becomes dimmer.

Engraved *f* numbers on the lens mount show the value of the 'mathematical aperture' but you have to calculate the 'effective' aperture when taking extreme close ups. (Keeping to the engraved aperture as in general photography will result in under exposure.)

The increase in exposure necessary is often engraved on extension tubes or bellows, different figures being given for various combinations of lens focal length and its distance from the film. Extension tubes are normally sold with printed tables of 'exposure factors'.

Here is a table giving the exposure increases needed when using tubes, or bellows, or extended focusing mounts. It shows that, when the subject is reproduced on film at one tenth original size, exposure time must be multiplied by $1 \cdot 2 \times$, and so on. (On page 170 we discuss whether to prolong exposure by increasing exposure time or aperture opening If you have a through-the-lens meter you have no problems, as the meter takes account of all lens factors.)

Scale	Multiplying factor	Scale	Multiplying factor
1 :10	1·2	1 :2·5	2·0
1 :8	1·25	1 :2	2·3
1 :7	1·3	1 :1·5	2·8
1 :5	1·5	1 :1·2	3·5
1 :4	1·6	1 :1	4
1 :3	1·8		

Close up work using a supplementary lens over the normal camera lens (no extension devices) will not call for adjustment in exposure.

Flash

Almost all cameras today are flash synchronised—designed so that the shutter is fully open at the same time as the flash burns. The most common synchronization setting is denoted as X. On this setting, the shutter is fully open when the flash fires. On some cameras the shutter speed dial is also marked 'X', at this setting the shutter speed is about 1/25 sec. This is long enough for an ordinary flash bulb (which has a burning time of 1/80–1/100 sec) to become lit and burn out while the shutter remains open. The burning time for electronic flashes tends to be between 1/500 and 1/1000 sec and so can be synchronized at much shorter shutter speeds on cameras *with diaphragm shutters*.

A *focal plane shutter* runs like a curtain with a slit just in front of the film. If a flash fires just as this slit is moving across the film only a small strip on each frame will be exposed. Flash-exposures with focal plane shutters must therefore be taken at a shutter setting which makes the blind slit so wide that the entire frame is exposed to the image at one point. As a rule this means a setting of 1/30 or longer. If you own a camera with a focal plane shutter you therefore need to check the instruction booklet rather carefully on flash synchronization. Incidentally, if you use unnecessarily long exposure times with a focal plane shutter for flash synchronization reasons, you may have problems when combining flash and existing daylight, see page 200.

Some cameras have two synchronization settings—one for X, and one marked 'M'. The 'M' setting fires the flash just before the shutter opens, and may be used when you want to use short exposure times (say 1/125 sec–1/250 sec) with flashbulbs. Under these conditions you do not utilize the entire light output of the flash, because the flash burns for a longer period. You therefore need a powerful flashbulb and/or a wide aperture lens. (Guide numbers printed on the flashbulb carton are smaller the shorter the shutter speed chosen for the shot.) M synchronization is never used for electronic flash, because the flash will be over before the shutter opens.

If your camera carries no information about the sort of synchronization it offers, this will usually be found to be X type.

Guide Number Tables

Really, the only function the shutter has when photographing with flash is to stay open *a little longer* than the flash takes to burn. A flashbulb burns out in about 1/80 sec and an electronic flash takes about 1/500–1/100 sec. But the shutter opening

Aperture Table for Type 1b Bulb
(1/25–1/30 sec shutter setting)

	15–16	17–18	19–20	21–22	23–24	25–26
DIN	15–16	17–18	19–20	21–22	23–24	25–26
ASA	25–32	40–50	64–80	100–125	160–200	250–320
Guide no.	65	75	100	120	145	195

Aperture	Approximate distance (ft)					
f4	15	19	24			
f5·6	12	13	19	21		
f8	8	10	12	15	19	24
f11	6	7	9	10	13	19
f16	4	5	6	8	9	12

must *coincide* with the burning period—a coincidence ensured by internal synchronization.

A flash of light is too short to measure with a conventional exposure meter, nor can we choose from the full range of shutter speeds and *f* numbers as in daylight photography. On page 15 we said that the action of making the exposure gave the film a *certain quantity of light*. When photographing with flash this amount of light is mainly controlled by varying only the size of the lens aperture. The *f* number chosen will depend upon the strength of the flash, the speed of the film, and distance from flash to subject. This sounds a little complicated but flash bulb manufacturers have simplified the problem by giving numbers for most combinations of flash bulbs and film speeds. These numbers are called Guide Numbers, and appear on all flash bulb containers. Here is one such table.

The top lines show various film speeds, in DIN and ASA figures. You notice how guide numbers underneath increase with increasing film speed. The table shows that using a 19–20 DIN (64–80 ASA) film the guide number is 100—assuming that you are using a type 1b flashbulb (class M) in the equipment specified by the bulb manufacturer. This guide will now enable you to find the right aperture for normal subjects in normal room conditions. To find the number needed you divide the guide number by the distance between the flash and the most important part of the subject, like this:

$$\frac{\text{Guide number (i.e. 100)}}{\text{Flash distance (say 9 ft)}} = \text{Aperture (approx. } f11)$$

In the table above the manufacturers have even taken out this simple piece of maths and supplied a list of aperture/distance combinations. To use this you just find the speed group of your film, look down that column until you coincide with the flash to subject distance for your shot, and then look along to the

left to find the aperture. E.g., on 125 ASA film and a flash distance of 21 ft an aperture of f5·6 is needed.

Of course if you mainly use one type of film you can just draw a line around the appropriate speed column to localize the information you need.

Guide numbers are not so exact that you must measure distances right down to inches. A discrepancy of a foot or so will hardly matter—at least when the total distance is more than 6 ft. (Remember that the table printed here is mainly intended to explain how such tables work. Always follow the figures printed on the carton of the bulb you are actually going to use.)

Flash guide numbers (on bulb packages) do not often mention colour films by name, but just quote ASA or DIN ratings. You have to remember that these are only *guide* numbers. Some modifications are often needed in practice, and a few test shots will help you decide exactly what guide number gives you the best results.

Aperture Table for Flash Cubes

	Film speed		
DIN	15–17	18–20	21–23
ASA	25–40	50–80	100–160
Guide no.	55	80	110
Distance	*Aperture (f no.)*		
5	11	16	22
7	8	11	16
10	5·6	8	11
13	4	5·6	8

Here is a corresponding table for flash-cubes, which are now in common use, particularly for simpler cameras. Such cameras seldom have information about the *f* number of the lens, but this is usually around f11. Try to find this out before starting to shoot pictures with flash.

Notice from the table that a film with a speed of 50–80 ASA—typical of the sort of film used in simple cameras—would allow this cube to be used at a distance of about 7 ft. (Once again the table printed here is intended only for training—use the figure packed with the cube you actually use, or the distances given in the camera instruction book.)

Flash Lighting Distance

The distances in feet (or metres) quoted on flash packages always mean the distance between the flash and the main subject. Let us call this the lighting distance. When the flash is mounted on the camera itself the lighting distance is the same as the photographing distance (the latter being of course the camera-to-subject distance.) If you have a long connecting cord between camera and flash, the two distances can be made independent of each other

As we saw on page 133 some interesting lighting effects are possible when flash is used off the camera. However, remember that the guide number always refers to the lighting distance.

If you follow the correct guide number, the main subject will receive correct exposure, and so will all other objects at the same distance from the flash. Things further away will be underexposed, and nearer ones overexposed, see page 131.

Remember too that dark subjects will need a larger lens aperture than the guide number suggests, while light toned subjects will need less exposure. This is because the number operates for 'normal subjects in normal rooms'.

Distance Linked Aperture Systems

Some cameras—even quite simple ones—are designed so that when they are set for flash, the correct aperture is chosen automatically as the subject distance is set. This assumes that the flash is attached to the camera and (in some cases) that only film of a certain ASA speed is used.

On simple cameras, the aperture setting ring may be calibrated with flash distances as well as weather symbols.

If your camera has a coupled range-finder and you take plenty of flash pictures, you can save yourself time by means of a system similar to the above. Simply mark the lens *f* numbers on the distance scale of the lens with a mapping pen. Then once the subject has been focused you just read off the *f* number required. If there is very little space to write on the lens mount itself, attach a piece of paper carrying the *f* numbers along the edge of the scale. This sort of time-saver is a great aid in candid and action shots—it leaves you free to concentrate on the subject itself.

Calculating Discs

Most electronic flash units carry a calculating disc relating film speed, distance and *f* number. The disc illustrated here is set for a film of 25 ASA (opposite the triangular arrow). Now you can read off the *f* numbers to use when the flash is used at various lighting distances between 3 ft and 60 ft. In this case we would use *f*16 for shots at 3 ft, *f*8 for 6 ft, *f*4 for 12 ft and 20 ft. A calculating disc like this removes the need for any mental calculations.

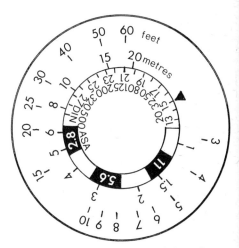

Most flashguns carry calculating discs to aid exposure calculation.

Self-quenching Electronic Flash

Some of the more expensive portable electronic flashes automatically decide the exposure at a given aperture. They act as though they contain an electronic 'door-keeper' who measures the amount of illumination reflected off the subject, and bounces the light when just the right length of flash has been given. To do this the flash unit contains an electronic 'eye' directed towards the subject. If you are bouncing the light off a wall or ceiling, it is important to arrange that the eye still looks towards the subject, not the bounce surface. Not all self-quenching units allow this. Like any other type, automatic flash units can be used off the camera on a long synchronizing lead.

Guide Number Quotations

We have seen that the guide number of a flash unit varies with the speed of the film in use. Sometimes advertisements and technical leaflets quote a particular flash as having (for example) 'a guide number of 25'. Such a quotation usually means that this is the correct guide number *when used* with a film of 50 *ASA* (18 *DIN*), the agreed 'norm' for comparing individual flash units.

Exposure Tests

Although guide numbers are quoted for electronic flash units, remember that the equipment itself can change—reflectors become tarnished, flash tubes worn, diffusers dirty etc. A flashbulb is always used brand new (then thrown away). Consequently it is worth testing the exposure effectiveness of your electronic flash from time to time.

If you have just recently bought some flash equipment, it will in any case be worth making some preliminary tests before shooting serious pictures. So begin by making a series of exposures with the flash using your usual film in your usual camera. This emphasis on 'usual' conditions may sound monotonous, but pictures do not depend upon camera, film and flash separately, but in combination. The correct guide number for a flash unit may sometimes prove to be different with another camera of differing optical properties (e.g. lens efficiency) or another brand of film, even if of the same speed.

As a starting point for such tests, work on the guide numbers supplied by the flash or film manufacturers. Then make further tests using both lower and higher guide numbers than the printed number. When using an electronic flash, always try to wait a few seconds after the power pack indicator lamp begins to glow. The condenser may not be quite fully charged at the very moment the indicator lamp lights.

As with all tests, remember the golden rule : never change more than one variable at a time. So avoid walking about taking one picture here and one there . . . sometimes at two yards, sometimes three and a half. The proper way is to place the camera on a tripod or other fixed spot. Choose an equally fixed position for the electronic flash, preferably at an exact number of feet for the subject, e.g., 10 ft.

The subject itself must not change during the test series. If you include a human figure, to check variations in skin tone rendering, keep him or her in the same position and if possible facing the same direction all the time. Change only the lens aperture from exposure to exposure, and after this by half a stop each time ; standardize everything else.

Make careful notes. In the first place record the distance between the flash and the main subjects such as the model's face. Also jot down the *f* number setting for each picture. And if you want to be quite sure that this information does not get mixed up include a piece of cardboard in with your test subject and write the lens aperture setting on it each time.

Imagine that we have taken a test series of our subject at a distance of 6 ft from the flash. The notes from the resulting pictures may read as follows:

Distance	Aperture	Guide no.	Results
6 ft	f8	48	Overexposed
,,	f10	60	Slightly over-exposed
,,	f11	66	Good face colour
,,	f14	84	Slightly under-exposed
,,	f16	96	Underexposed

We find our effective guide number by multiplying the distance and f number of the most successful shot, ignoring details such as minor decimals. In this case careful scrutiny showed that 66 was about right as a guide number. The results of this test show you how to deal with any other similar subjects, and give you a useful starting point for further tests under different conditions.

However, when you come across a considerably lighter toned subject it may be necessary to *reduce* exposure by $\frac{1}{2}$ or $\frac{3}{4}$ of a stop. If the subject is appreciably darker in general colouring, use a corresponding larger aperture.

Adjustments like these must be largely based on experience. You do the same sort of thing when shooting in daylight or with studio lamps, but again you have to start off by knowing the exposure required for a 'normal' subject. Our exposure series advances by only half a stop for each pair of pictures. This is because exposure latitude in artificial light (particularly flash) is quite small.

Perhaps you feel that it is extravagant to sacrifice an entire film just on tests, even though every professional photographer does the same. The point is that once you have fully tested your electronic flash indoors and your exposure meter out in daylight you have something definite to work on for almost every type of subject. You don't have to worry about guesswork.

The colour temperature of electronic flash units is approximately that of daylight, but varies slightly from make to make. Some give slight blue cast on daylight colour film. This can only be determined by practical test and corrected, if necessary, by the use of a pale yellow or pink filter.

'Open' Flash

There are occasions when you need to combine flash illumination and a long exposure time—perhaps even several seconds using the B setting. This may occur when you want to photograph the inside of a building, looking in through a window or doorway so that the latter forms a dark (but recognizable) foreground frame. You need full co-operation between photo-

199

grapher and his flash-holder assistant. The photographer calls out to the flash-holder at the moment he opens the camera shutter (set to B). The assistant immediately fires the flash, whereupon the photographer closes the shutter again. To be successful there should not be any other light sources present.

Fill-in Flash
One way of reducing the lighting contrast in subjects lit by the sun or other light source is to illuminate the shadows with flash. The shadow area must not of course be too large or too distant from the camera, because flash lighting does not carry very far. On the other hand, don't let the flash overpower the main light source—it should give about the same illumination as an ordinary reflecting surface.

The right balance between daylight and flash can be worked out using simple arithmetic. On page 15 we saw that a film can receive correct exposure in different ways. Mathematically speed/stop combinations of 500/4, 250/5·6, 125/8 and 60/11 (exposure value 13) all correspond to the same degree of exposure. Let us assume that any of these combinations is suitable for an outdoor portrait. We want to light the subject's shadow side. How near should the fill in flash be?

As explained on page 195, flash exposures are worked out with the help of guide numbers. If you know the flash guide number and the f number set on the camera for daylight conditions then you can calculate the correct flash-to-subject distance.

I would advise anyone working out a daylight/flash balance for the first time to draw up a table. Note down the exposure settings for the view—shutter speed in one column, lens f number in another. Then divide the guide number of the flash you are using by the f number and the result is the flash distance in fact.

The table may look something like this:

Daylight Shutter	Lens	Flash (guide no. 70) Flash distance
1/500 sec	$f4$	$17\frac{1}{2}$ ft
1/250	5·6	$12\frac{1}{2}$
1/125	8	$8\frac{1}{2}$
1/60	11	$6\frac{1}{2}$

If you have a diaphragm shutter and use electronic flash, any of these shutter speeds will do. A focal plane shutter may have to be used at a slower setting, see page 194.

We might use 125/8. The column for flash distances shows us that we have to locate the flash-head just under 9 ft from the subject.

If you use a flash bulb and your camera shutter is only X synchronized you will have to take the picture at 1/20 sec or slower. But an exposure of 1/30 sec out of doors on a sunny day calls for an aperture of $f16$ even with slow colour film. This would mean placing the flash within 4 ft or so of the subject, which may not be practical.

A combination of electronic flash and diaphragm shutter is usually the best means of providing fill-in flash in daylight. Remember too that the fill-in should be placed as closely in line with the lens as possible—otherwise it gives a visible shadow outline of its own. This would conflict with the general lighting scheme and make it look unnatural.

Flash Action Pictures

Shooting action pictures using flash often means working alone. You have to make sure that the flash lighting distance is correct for exposure and focusing is correct for subject distance. A rangefinder or an SLR camera helps because you can set the camera for a predicted distance e.g. 6 ft. You then move towards your subject, watching in the viewfinder as it grows increasingly sharp, and then shoot. This method is often easier than trying to focus and watch subject expression etc at the same time.

If your camera does not have a rangefinder or focusing screen, you can establish at what distance the image of a person (e.g. from hip to crown) just fills the viewfinder. Once this is discovered you keep the lens focused for the distance and shoot only when subjects appear this size in the finder. In both the above cases, the lens aperture will have to be set in accordance with the flash guide number, page 194.

As you can see, all these settings should be made before the event you are photographing actually occurs. Anyone who wants to play the role of press photographer has to be ready well in advance.

Incidentally, if you do much flash photography out of doors, make sure that moisture does not find its way into flash lead plugs or the camera itself. The presence of water may cause a short circuit which means that the flash will not work until everything has dried out again. If rain is forecast, plug in the leads and seal them over with adhesive tape.

Always use the correct batteries, and make sure that they are the right way up.

Batteries

The usual power sources for flash bulbs and amateur electronic flash units are batteries or accumulators. (But there are even battery-less bulbs.) Read the camera or flash instruction book to find out which battery you need for a built in flash unit or electronic flash. To be on the safe side, take the old battery to your dealer, when you have to get a new one.

Most modern batteries last for a year or more. But if your batteries were bought some time ago and you plan a trip to a location where they are difficult to obtain it will be essential to check battery power before leaving. Owners of CdS type exposure meters should do the same, as these meters too rely on battery power.

In the case of flash bulbs and cubes, the battery circuit is put to work from the time you put the flash source into the holder until the bulb burns out. Therefore, if you put the camera to one side with a bulb still in the holder, the battery will be left running

itself down. In fact batteries are more often run down by long storage than those occasions when you use them to fire flashes. You can find out whether a battery powered unit is working at full voltage by means of a test lamp

Accumulators for electronic flash units should be best fully charged all the time. It is a good habit to put the flash 'on charge' after an evening's photography, before you put it away—otherwise you forget how much recharging the accumulator needs. It is also very easy to forget to disconnect the charging unit (some types switch themselves off when fully charged). I have so often made this error that I now make a point of laying the unit on my bed to charge a suitable number of hours before bed-time. This way I cannot avoid disconnecting it! The number of hours needed for recharging varies according to the make and the number of flashes produced, so check the manufacturer's instructions.

Most electronic flash units have guide numbers lower than small flash bulbs. Other, more expensive types, give more light than amateur flash bulbs. It is obviously important before buying a flash unit to discover just what guide number it gives when combined with the film you use for flash photography. If you use the flash for black and white and colour make sure that it gives sufficient illumination for slow colour film.

Some electronic flash units can be powered direct from the mains as well as from accumulators. Where mains are available, this absolves you from worry about how many flashes you can produce. Be careful about the voltage of the supply—most flash units have transformer tappings ranging from 115v to 250v. If you have been drawing power at the lower voltage (e.g. on boats, cars etc) be sure to reset to 250v or you will blow your fuses when you plug into a domestic powerpoint again. In any case, it is wise to carry a few spare fuses with you when travelling. Make sure these are exactly the type to suit the unit. Most larger photographic shops have such fuses—and you may also find them stocked at radio stores. A few flash units use different fuses for different voltage ranges.

In the case of CdS meters, the more light which reaches the cell the more current is fed from the battery to the deflecting needle. (Only a small amount of light is needed to make the meter work.)

Meters without batteries have a type of cell which *generates* current to deflect the needle proportionally to the amount of light falling on the cell. This system requires a greater amount of light than a Cds meter, particularly at lowest needle deflection. Meters of this kind cannot therefore work in such low lighting conditions as the battery powered Cds types.

If you don't take pictures for a long period you should take out the batteries from the meter, camera or flash, and let them rest. *But remember to put them back in again before resuming photography*! Most amateurs find that batteries will last them at least a

Set mains flash units for the right voltage and carry the right spare fuse.

year. Their power output does not slowly decrease— they just suddenly stop working one day. Most meters have a built-in battery check circuit.

Bear in mind that batteries do not work very well in very cold conditions. During winter trips it will therefore be a good idea to protect both camera and meter against extremely low temperatures. Also a cold camera may not give the right exposure time.

Photolamps

For photographing indoors you may decide to use special photolamps instead of ordinary household lighting (page 123) because of the much higher light output they provide. A flood is perhaps a little more cumbersome to handle than a flash, but has the advantage that you can actually check the shadows and limits of illumination before you shoot. (These often appear as a surprise to the flash photographer.)

On the other hand, people may become annoyed, or at least self-conscious, under the very intense lighting from a high output lamp. This is often apparent in amateur movie films shot indoors. Photolamps used to be used in metal or cardboard reflectors, but most types sold today have built-in reflector coatings. These are given an 'R' in their reference numbers. The tungsten halogen lamp is a modern development which offers the same output as other types of photolamp, but is much smaller, does not discolour as it grows older and generally lasts longer. They are more expensive than normal photolamps. Check the technical data sheets for burning times and tilting angles.

You can use virtually any lamp for black and white photography. But to shoot in colour, the lamp must of course be suitable for the film type. Otherwise a colour cast will be produced unless you use the right filter. The instruction leaflet packed with the film will make recommendations, or ask your photographic dealer.

Some lamp packages carry exposure guide tables for photographers who do not possess exposure meters. As when using flash, these are based on the distance between light source and subject (not camera and subject).

Mounting and Storing Colour Transparencies

Reversal films come back from the processing laboratory either mounted in card or plastic frames or unmounted. With careful handling, miniature transparencies mounted in cardboard frames are quite suitable for projection. But if the projector used gets very hot, the film may curl and certain areas appear unsharp on the screen. Also, cardboard mounting without glass holds the film fairly rigid, easy to handle and store, but such mounting is no protection against scratches. Cardboard frames are ideal while you make up your mind which slides to keep and which to discard, but then it is worthwhile mounting the best ones more permanently.

If you intend to show the pictures a lot, they should be mounted between glass. There are now numerous types of quick-mounting plastic frames containing two thin pieces of glass to 'sandwich' the piece of film. When choosing a quick-mounting frame, see whether it is dust-proof, how it stands up to wear, and whether you can open the frame without damaging the transparency. If you use an automatic projector, check that the frame fits the projector and permits smooth slide changing.

When mounting, make sure that both sides of the film and the inner sides of the glass squares are free from dust. Otherwise the specks of dust will 'haunt' every show. The final dusting is best done by a camel hair brush. Specks of dust are clearly visible in oblique light. The operation is made easier if carried out in the inhalent stream of a nearby vacuum cleaner.

If the film lies bare between the glass, so-called 'Newton's rings' may arise. On the projection screen they look like shimmering patches of oil on a surface of water. Certain makes of slide glasses have a specially treated surface to prevent the formation of such ring patterns.

If the subject does not really fill the picture, you may want to mask off portions of the colour transparency. The simplest way is to stick pieces of black or 'chromium' adhesive tape over the parts of the picture to be hidden.

It may prove necessary to stick a piece of tape both on the front and the back of the frame in order to avoid light coming through the mask.

Avoid using many different types of frame, as they may be of different thickness and necessitate frequent adjustments of focus during projection. (Some modern automatic projectors simplify such adjustments by a motorized remote control focusing system.)

All lantern slides should be spotted—in other

words, marked with a spot in the bottom left hand corner of the frame (not the picture area!)—when the image is upright and the right way round. This helps to indicate which way round you have to insert the slide in the projector.

Slide frames and glasses are commonly available in two sizes : 2×2 in (5×5 cm) and $2\frac{3}{4} \times 2\frac{3}{4}$ in (7×7 cm). The former are used for mounting 24×24 mm, 24×36 mm and 40×40 mm colour transparencies. The masks of the frames cut down the picture area by about a millimetre in height and width. If you intend to show 40×40 mm transparencies (so-called 'super-slides') check that the projector does not cut off the corners of the slightly larger picture. Certain older 2×2 in projectors were intended solely for 24×36 mm pictures, either across or upright.

The $2\frac{3}{4} \times 2\frac{3}{4}$ in (7×7 cm) projectors are intended for colour slides taken with $2\frac{1}{4} \times 2\frac{1}{4}$ in (6×6 cm) roll film cameras.

Even larger sizes exist, mainly for lectures and similar purposes, but are gradually going out of use. 3×3 cm frames are becoming available for use with 'sub-miniature' camera formats (13×17 mm, 11×8 cm etc).

Sometimes when you open up a cardboard frame prior to remounting the transparency in a plastic/ glass frame you find the piece of film is longer than the glasses provided. If you try forcing the sandwich into the plastic frame the film may corrugate between the glass and look ugly when projected. This problem is solved by using a razor blade to shave off the small strip of surplus film sticking out from the glass sandwich.

Trim transparencies carefully to fit mounts.

Library Filing

Every photographer who takes lots of pictures sooner or later has problems with filing his slides. You need to find a system which makes it easy to pick out a particular picture of a certain country, or situation, or person etc.

The first requirement is to systematically label your slides in a way best suited to your photography. Every specialist will have a different method—the sports photographer for example perhaps categorizing according to each branch of athletics. whereas the botanist can use a scientific classification, and the traveller may classify his slides geographically. Try to avoid having any division which grows too large—break it down into smaller sections. Hence a particular country can be divided down into counties etc.

Transparencies mounted in card or plastic frames with matt-surfaced labelling areas can be written on by hand. Decide the most convenient orientation for your labels. Do you want to be able to view the picture right way up as you read the label—or is it better to read the label when the slide is loaded in the magazine ready for projection? (In the latter case the transparency must be upside down.)

Typed self-adhesive labels, of the type sold attached to backing sheets or tapes, are convenient to work with and easily read. They attach readily to cardboard, glass, metal or plastic. Alternatively you can make more durable captions by scratching direct onto a metal or plastic mount with an etching needle. This, at least, ensures that an important label does not peel off or become obliterated. I sometimes make my exposure notes in this way. (You can easily read the note at the right light angle.)

Sometimes, of course, a picture can be filed under either of two headings. There is no reason why it should not carry two labels, but physically it can only be stored in one place. If for example you have a picture of Lavender in your botanic section and need it in your France section too, you file a piece of 2 × 2 card in the France file carrying a cross reference to the slide in the other box.

Another way to file is to write down two reference numbers for each transparency—one for the actual picture and one for the box in which it is kept. This information is written up in an alphabetical register which then contains exact information for locating any picture. The advantage is that you can register the same transparency under any number of headings.

In schools and other institutions where many people have access to the same pictures, the problem is to ensure that everyone puts the slides back in the right

SAND 33b

E 250/5.6

R 250/8

SCOTLAND SKYE
NORTH OF PORTREE

Aluminium mounts can be permanently marked with an etching needle, to supplement adhesive labels. (E: exposure, R: reflected light reading, D: incident light reading).

places. One way around this is to paint the upper edges of a series of slides all the same colour—the colour being related to the box in which they are stored. Within the box itself you can check all slides are returned (and in correct order) if you draw a thick black diagonal line across the top edge of the complete set.

A rather space-consuming but efficient way to file is to use transparent plastic sheets made with twenty or so pockets to contain individual mounted transparencies. Sheets are stored in a ring binder, carton, or suspended in a filing cabinet. When you hold up the sheet to a light source you are able to view a whole collection of pictures at once. Unfortunately this is one of the most expensive filing systems.

Again, your filing system may be conditioned by the way you show your slides. Most modern projectors accept magazines of slides for automatic showing. The magazine has a separate compartment for each slide, and so can act as a filing system in its own right. Each magazine can be devoted to one particular type of subject—a country, a holiday, the products of a company, and so on. This assumes that each show has the same function and type of audience, and therefore needs the same sequence of pictures; although if you have some spare magazines, you can make up special selections from your 'standard' magazine stored programmes.

Don't forget to consider the audience. So many of the holiday pictures your own family enjoy seeing may well bore outsiders. Maybe you can be more fastidious for these audiences and edit the slides down to 50% or even less.

One new type of projector even allows you to re-

arrange the order of slides at any time during a show. The machine has buttons which allow the projection of any slide in the magazine. By checking his list of pictures, the lecturer can produce the right images on the screen in any sequence he requires.

There is increasing interest in showing several transparencies at one time—using several projectors and either one or several screens. The audience can then directly compare, say, a plan of a town and a bird's eye view of the actual buildings. A tour of a factory these days often starts off with a slide show giving visitors a general introduction to what he will actually see. The projector may be linked up to a tape recording and the slide sequence used for group after group without any more complex attention than switching on and off.

Projection

Having taken so much trouble to produce good colour transparencies it is worth while ensuring that they are seen at their best. Here are some of the rules of good projection.

1. Use a properly blacked out room or a specially prepared daylight projection screen. This is often neglected, particularly in schools and meeting halls where the authorities allocate large sums for buying good projectors but forget that they would function twice as well without the light streaming in through poorly obscured windows. People overlook the fact that pictures are often projected during daylight hours.

2. Choose a projector which does not itself spill light in all directions. The best way to select a machine is to compare various models in a darkened room. Projectors spilling light are liable to dazzle the projectionist, so that he is unable to see whether he has got the image properly sharp on the screen.

3. Avoid having smoke in the room. Tobacco smoke contains dust-like particles which hang like tiny reflectors in the beam of the projector. This has an effect on the image similar to the blue haze in a distant landscape. The worst offenders are smokers who sit close to the projector and blow clouds of smoke directly into the light beam.

4. Make sure that the lens surface is clean. Give the projector a thorough clean-out from time to time.

5. Have a sufficiently powerful projection lamp. A 100 watt type may be satisfactory for projecting in a small room, but for anything larger a 250 watt lamp will probably be needed. On the other hand don't use a stronger lamp than the machine is designed to carry. A motorized cooling system is usually essential for lamps of 250 watts or over, otherwise excessive heat may damage your transparencies. If you are buying a projector specifically for a large hall it ought to be equipped with a strong lamp and an efficient fan.

6. Check the correct adjustment of the lamp. Read over the instructions (if any) carefully and see that:
 (a) The lamp filament is at right angles to the lens axis.
 (b) The lamp is correctly centred.
 (c) The filament image and its reflection interlace properly when projected onto a translucent sheet of paper immediately in front of the lens (Otherwise you are not utilizing the full output of the projector.)

To adjust a projection lamp, place a piece of paper over the projection lens. On switching on, the lens projects an image of the lamp filament onto the paper;

Prepare slide presentations on a light box.
Use a magnifier to ensure that they are sharp.

this image should be dead in the centre of the lens opening. Some projectors supply accessories, such as a pinhole slide and a translucent lens cap, to facilitate lamp focusing. Now adjust the lamp position (usually by an external screw or knob) until you see a second filament image, formed by the reflector behind the lamp, interlaced between the coils of the direct filament image.

You can move the lamp adjustment screws while the lamp is burning, but as the filament wires are at their most brittle when hot it may be wiser to make adjustments after it has cooled, and then try its position again. Don't leave this lamp checking until your audience has actually assembled—do it beforehand when there is more time. Lamp position really needs re-checking every time the lamp is changed.

Whilst on the subject of hot lamps, always take the utmost care in moving a projector when the lamp is warm. Also protect the machine from being knocked —for example by members of the audience leaving after the show.

These warnings apply mostly to older projectors or very powerful projectors with large lamps—the type with hanging spiral filaments. Today's projectors utilising small tungsten halogen lamps have a more compact light source and are easier to adjust. Nevertheless read over the instructions carefully. Notice particularly how a lamp should be changed, and keep the instructions together with a spare lamp in the projector carrying case.

7. Check that the concave mirror behind the lamp is in good condition. If bits of the reflective coating begin flaking off have it re-silvered. Metal mirrors can be re-polished.

8. The projection screen should be as flat and clean white as possible. The simplest screen (although also the most awkward to handle) is some form of wallboard painted with several coats of matt white emulsion paint. When the paint becomes discoloured or dirty the board can be sandpapered and re-painted.

A square screen is usually best because you can show both upright and horizontal slides. Rectangular cine screens are less suitable for slide projection for this reason. A wide range of collapsible screens is available at various prices. Beaded surface types give brilliant pictures. On the other hand beaded screens are more suitable for long narrow rooms, because they reflect most of the light directly back towards the projector. Image brilliance falls off rapidly if you look at the screen obliquely. Screens for viewing in full room lighting are available to use when black-out is impossible, but such screens are very expensive, and have a narrow viewing angle.

A bed-sheet is the last resort. It must not however show folds or creases. It will probably need ironing and if possible should be tensioned and stretched against a flat wall.

Picture Commentaries

Most slide shows contain too many pictures. Of

course it can be hard to decide which ones to thin out, but you must remember that the attention of the audience soon dwindles if there are too many half interesting pictures.

Give the audience an opportunity to look at a picture and make up their own minds about it before you start speaking. Every time a new image appears on the screen you, of course, know its contents well, but to the audience it is something new. A simple picture with few details is quickly comprehended, but you must allow extra time for the audience to 'read' an image containing a lot of information. Don't become irritated by audience participation—their comments at least indicate that they are interested.

As for your own commentary, try to avoid stating the obvious—making points which only duplicate what can be seen on the screen. An automatic projector that can be operated remotely by cable allows better interplay of speech and picture. You can more accurately judge the right pauses between pictures needed by the audience when you are facing them. If you come to short sequences of pictures, these can be projected rather quickly because each one is intended to be a continuation of the one before. There are also occasions when you can change pictures half way through a sentence to create a particular carefully timed effect—but then the picture must immediately relate to what was said.

The predominant colour of pictures also has some importance. After showing a series of pictures which all have warm tones, a predominantly blue-green transparency has a certain 'shock' effect. This is because the eyes of the audience have become conditioned to the warm colours and find the cold colours more of a contrast than they would be if both transparencies were side-by-side on a viewing box.

When using colour transparencies as teaching aids you must always allow plenty of time for questions and discussions about picture contents. It is also a good idea sometimes to run through the illustrations again briefly at the end of the session, so that they provide a sort of visual summary to your talk.

Index